MARY CASSATT

Mary Cassatt

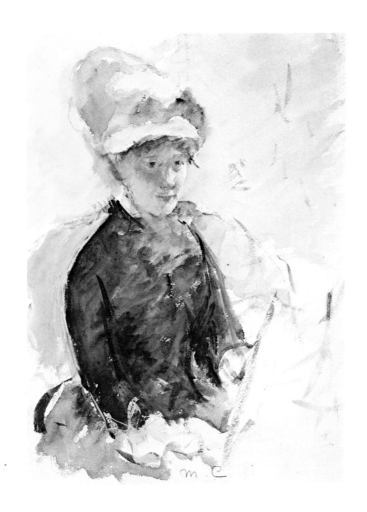

by Jay Roudebush

CROWN TRADE PAPERBACKS · NEW YORK

Title page: SELF-PORTRAIT, c. 1880
Watercolor on paper, 13″ × 9½″ (33 × 24 cm)
National Portrait Gallery, Smithsonian Institution, Washington, D.C.

Series published under the direction of:
MADELEINE LEDIVELEC-GLOECKNER

Published by Crown Trade Paperbacks, 201 East 50th Street, New York, New York 10022.
Member of the Crown Publishing Group.

Random House, Inc. New York, Toronto, London, Sydney, Auckland

CROWN TRADE PAPERBACKS and colophon are trademarks of Crown Publishers, Inc.
Originally published in hardcover by Crown Publishers, Inc., in 1979.

Printed in Italy - Poligrafiche Bolis S.P.A., Bergamo

Library of Congress Cataloging-in-Publication Data
Roudebush, Jay.
Mary Cassatt.
(Crown art library)
Translation of: Cassatt.
1. Cassatt, Mary, 1884–1926—Criticism and
interpretation. 2. Painting, American.
3. Painting, Modern—19th century—United
States. 4. Painting, Modern—20th century—
United States. I. Title. II. Series.
ND237.C3R6813 1988 759.13 88-1188

ISBN 0-517-88371-6

10 9 8 7 6 5 4 3 2 1

First Paperback Edition

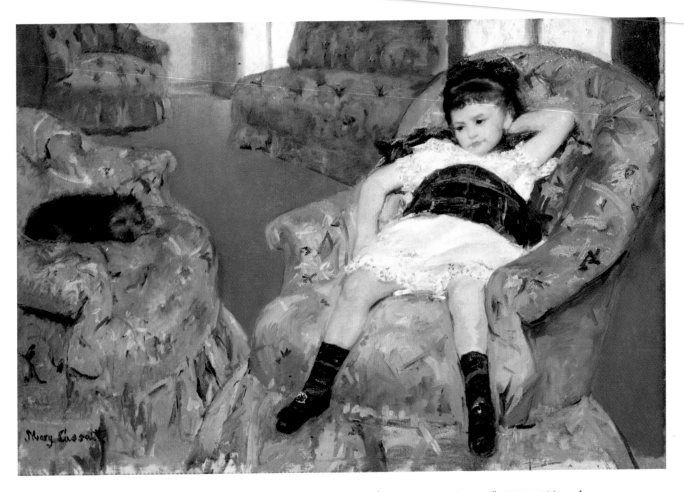

LITTLE GIRL IN A BLUE ARMCHAIR, 1878. Oil on canvas, 35″ × 51″ (89 × 130 cm)
Collection: Mr. and Mrs. Paul Mellon, Upperville, Virginia

« I am American. Simply and frankly American. » *

A curious beginning. Why did Mary Cassatt, who had achieved so much during the course of a long and eventful career, choose those words to introduce herself to her first biographer? She was sixty-eight years old when Achille Segard called upon her in 1912, and had lived most of her adult life in France. She had received her first professional recognition from the Paris Salon, had been invited to join an art movement which was quintessentially French, and had been awarded the coveted Legion of Honor. Yet she wished to impress upon Segard — himself French — that she was American, the native of a country where she had often been slighted or simply ignored.

* Segard, A., *Un peintre des enfants et des mères, Mary Cassatt*, p. 2.

Perhaps Cassatt recognized American qualities in herself, qualities that did not bear transplanting despite the hospitality of the French. Certainly her hosts were often bemused at her practice of using rude peasant women and their children as models, it did not accord with their Gallic sense of elegance. And yet Cassatt, in her «simple and frank» manner, sought not elegance but strength, finding beauty in a mother's immutable love for her child rather than in some fleeting concept of style.

Cassatt was a paradoxical figure who somehow reconciled the contradictions in her life and made them work. How else does one explain a prim and proper Philadelphia spinster who was also an impassioned defender of a revolutionary art movement, a childless painter whose hallmark is maternal themes? Her sense of propriety was so acute that she once advised an agent for her good friend Henry O. Havemeyer to exercise caution in the purchase of a Titian nude, as it would be seen by Mr. Havemeyer's daughters. The same Mary Cassatt was capable of language that was nowhere nearly as delicate as her sensibilities.

She was a strong-willed individual and she came from a country built by strong-willed individuals, people who made their own rules and lived by them. In that context Mary Cassatt's opening remark to Segard makes sense.

She was born in 1844, the fourth surviving child of Mr. and Mrs. Robert Simpson Cassatt of Allegheny City (now Pittsburgh), Pennsylvania. Her father made enough money through investments to indulge his penchant for moving, and as a consequence the Cassatt household was in an almost continuous state of upheaval during her infancy.

American medicine was in only a slightly less primitive state than American culture in the 1850's, and Mr. and Mrs. Cassatt seem not to have hesitated when doctors advised them to seek a European «cure» for Robbie, the second son, who had been struck by a mysterious illness. In 1853 the family sailed for Europe and settled in Paris.

We may assume that Mrs. Cassatt, who spoke French fluently and who admired French culture, saw to it that her children accompanied her on frequent trips to the Louvre. To ten-year-old Mary it must have truly seemed a palace, filled with wonderful treasures. It is easy to imagine her pausing to watch, fascinated, as one of the many copyists who frequented the Louvre put the finishing touches to his canvas.

The Cassatts' next move led them to Germany so that the eldest son, Alexander, could continue his studies in technical engineering in Heidelberg and Darmstadt. Their sojourn was abruptly cut short by young Robbie's death, and the saddened family returned to America in 1855.

Between 1861 and 1864, Cassatt grew from adolescence to young womanhood while enrolled in the Pennsylvania Academy of Fine Arts in Philadelphia. The academy — an American model of its European counterparts — offered the prescribed classical curriculum of the day. Such a program of study would seem today to be stultifying, emphasizing as it did the endless copying of dusty plaster casts, but it appears to have suited Cassatt well enough, for it was during this period that she made up her mind to become an artist. She also decided to continue her studies in Europe, insisting — and rightly so — that she would have to cross the Atlantic if she were to properly study and learn from the old masters. America had little to offer in the form of public or private collections of art.

Robert Simpson Cassat had violently objected to his daughter's choice of a career as a painter, an unorthodox and faintly scandalous notion in that Victorian era. «I would rather see you dead,»[*] he told her at one point, but he eventually relented, perhaps mollified by the

[*] Segard, A., *op. cit.*, p. 5.

fact that his wife would serve as Mary's escort and see to it that their daughter was properly «set up» in Paris. Although it was not uncommon for daughters of the American *haute bourgeoisie* to attend fashionable finishing schools in Europe, they were invariably wrapped in a protective cocoon of family and friends. The Cassatts no doubt felt that they could afford to indulge Mary's whim as long as the proprieties were observed.

As an apparent concession to her anxious parents, Cassatt dutifully enrolled in the atelier of Charles Chaplin, a fashionably bland academic painter. She soon abandoned his tutelage, however, in favor of independent study at such institutions as the Louvre and the Ecole des Beaux-Arts. It was the last formal training of her career. «One does not need to follow the lessons of an instructor,» Cassatt told Segard years later, «the teaching of museums is sufficient.» *

Cassatt spent four years in Europe, and it was during this period that she made the transition from art student to professional artist. This remarkably swift change of status came about as a result of welcome news from the Paris Salon: one of her paintings, *The Mandolin Player* (1868, coll. Anthony D. Cassatt), was accepted for the Salon's annual exhibition. As Paris was the undisputed center of the Western European art world and as the Salon was the final arbiter of artistic taste, Cassatt had good reason to be proud of her accomplishment. If she thought that such recognition would vindicate her choice of a career in the eyes of her family, she was mistaken; there was a decidedly condescending note in her brother Alexander's letter to his fiancée, Lois Buchanan, when he wrote:

> «Mary is in high spirits as her picture has been accepted for the annual exhibition in Paris. You must understand that this is a great honor for a young artist and not only has it been accepted but it has been "hung on the line." ** I don't know what that means but I suppose it means it has been hung in a favorable position. Mary's art name is "Mary Stevenson" under which name I suppose she expects to become famous, poor child.» ***

Cassatt did indeed use «Mary Stevenson» as her «art name» when she signed her submissions to the Salon in the late 1860's and early 1870's. Stevenson was her middle name, and may have been used because it sounded more «American» than Cassatt.

Stylistically, *The Mandolin Player* is reminiscent of the 17th century Realists whom Cassatt greatly admired and whose work she assiduously studied. A simply dressed young Italian girl stares pensively off to the left, seemingly in the act of playing a mandolin. She is bathed in a soft light and is seated against a plain dark background. The reflective mood of this composition contrasted favorably with the mannered allegorical works which were much in vogue at the time, and probably helped to catch the attention of the members of the Salon jury.

The rapid momentum of Cassatt's career was interrupted temporarily by the outbreak of the Franco-Prussian war in 1870, which forced her to return briefly to Philadelphia. As soon as possible she braved the Atlantic crossing (ocean voyages always made her violently

* Segard, A., *op. cit.,* p. 8.
** To be «hung on the line» meant, as Alexander Cassatt correctly surmised, that one's work was hung at eye level, a special honor. It was customary at the time to cover the walls of the exhibition halls with paintings; works which the jury considered of lesser importance were often «skied,» or hung above eye level.
*** Quoted by John E. Bullard in *Mary Cassatt, Oils and Pastels.*

ill) and returned to Europe, this time to Parma, to study the works of Correggio and Parmigianino. It is likely that she had developed an interest in these two artists during her previous four-year stay in Europe and wished to learn more about · their work firsthand. While in Parma she also learned the intaglio printmaking techniques of etching and aquatint from Carlo Raimondi, an instructor at the local academy. Though Cassatt concentrated on oil painting during the early years of her career, she would later put her training in printmaking to good use.

She was twenty-six years old when she arrived in Parma, and spoke little, if any, Italian. The citizens of Parma were accustomed to the presence of foreign artists and art historians, but the sight of this serious and hard working American *signorina* clamoring up and down ladders to study frescoes in dimly lit cathedrals must have caused them some amusement. Cassatt coped with whatever loneliness she might have experienced by the rigorous regimen she imposed upon herself. She also found time to travel to Spain, visiting Madrid and Seville. While in Seville she completed a canvas entitled *Pendant le Carnaval*, which was accepted by the Salon of 1872. *Pendant le Carnaval* (Philadelphia Museum of Art) was one of several paintings with Spanish motifs which she produced in the early 1870's, reflecting an interest in such masters as Velasquez, Goya and Murillo as well as such contemporary figures as Manet, whose « Spanish » canvases she had probably seen during her early years in Paris.

Torero and Young Girl (see p. 10) was accepted by the Salon of 1873, an event which must have reassured her that the initial success she had enjoyed with *The Mandolin Player* and *Pendant le Carnaval* was no happy accident. Before returning to Paris to pursue her career in earnest she visited Belgium and the Netherlands to study paintings by Rubens and Hals. One of her studies from this period, a copy of Hals's *Meeting of the Officers of Cluveniers-Doelen* (see p. 9), was a particular favorite of hers. Years later she often was to show this copy to aspiring young artists who would visit her, encouraging them to learn, as she did, from the old masters.

The Paris that greeted Mary Cassatt in 1873 was still reverberating from the shock waves caused by the affair of the « Salon des refusés » a decade earlier. Manet had become, albeit reluctantly, the most controversial and abused artist of the day, the leading exponent of a style of painting which was labeled « ugly and repulsive » by a hostile press and public. Though few realized it at the time, the stranglehold that the Salon had so long held on art was slowly but inexorably being loosened by a handful of artists who were willing to defy convention in the cause of artistic freedom.

One of the more significant manifestations of this new spirit was the opening, in April, 1874, of an exhibition by a group of artists who labeled themselves « The Anonymous Cooperative Society of Artists, Sculptors, Engravers, etc., Endowed with Variable Capital and Personnel, » more familiarly known to us by a pejorative label which eventually stuck: « Impressionists. » The exhibit, which was hung by Renoir in the studio of the photographer Nadar, featured 165 works by 30 artists, including Degas, Monet, Pissarro and Boudin.

Ironically, Manet, who played such an important role in opening the door to modern painting, shied away from joining his more adventuresome contemporaries. « Manet seems determined to remain aloof, » Degas scornfully wrote to a fellow artist whom he sought to recruit for the « Exposition des indépendants. » « I definitely think that he is more vain than intelligent, » he added. *

* Degas, E., *Letters*, Nº 12, 1874.

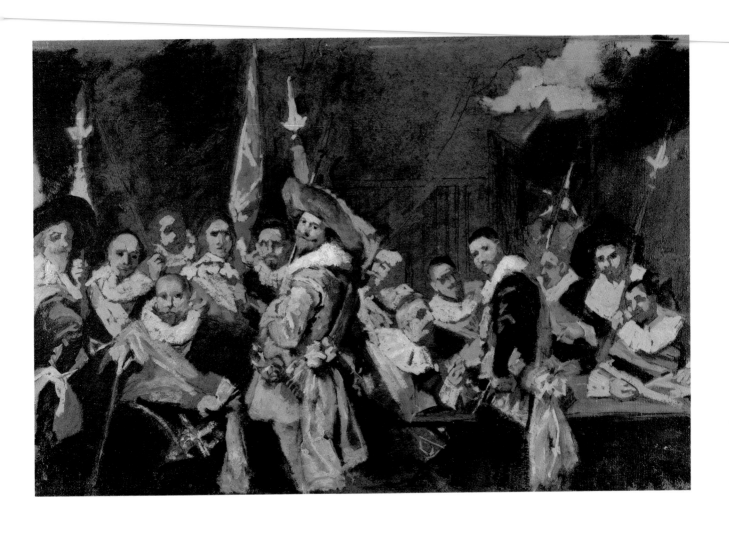

COPY AFTER FRANS HALS, c. 1873. Oil on canvas, 18¼″ × 28½″ (46.3 × 72.3 cm)
Collection: Mrs. Percy C. Madeira Jr., Berwyn, Pennsylvania

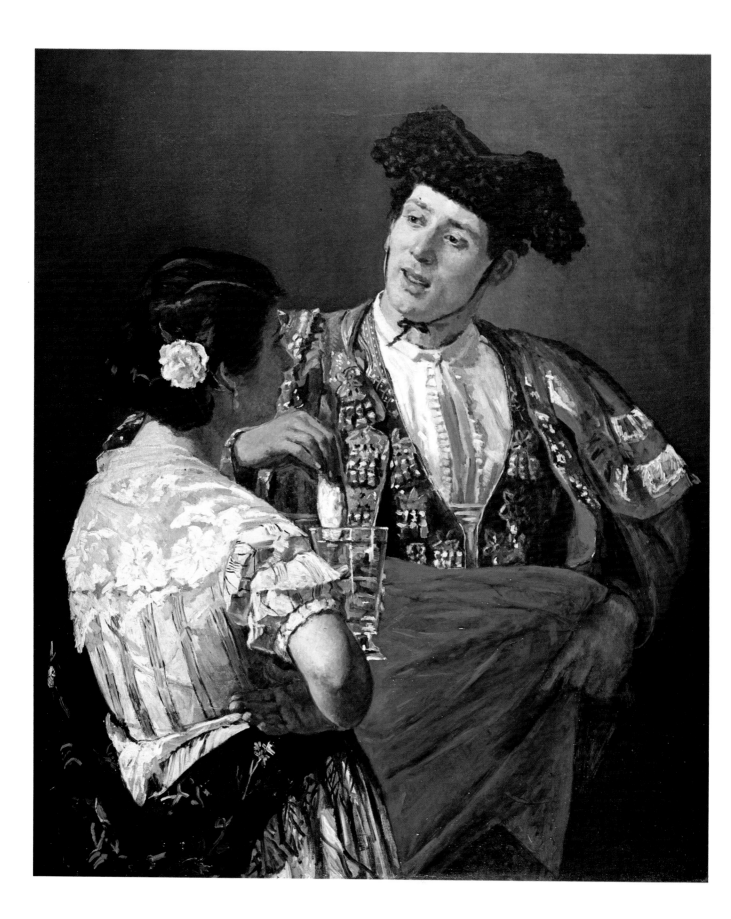

A Musical Party
1874
Oil on canvas
38″ × 26″
(96.4 × 66 cm)
Museum of the
Petit-Palais, Paris
▷

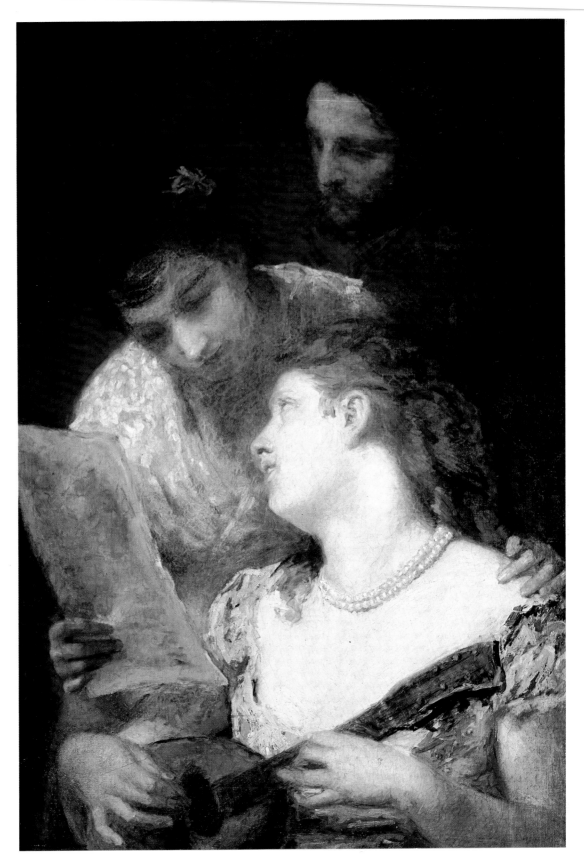

◁
Torero and
Young Girl, 1873
Oil on canvas
39⅝″ × 33½″
(101.2 × 85.1 cm)
Sterling and
Francine Clark
Art Institute
Williamstown
Massachusetts

POPPIES IN A FIELD, c. 1874–1880. Oil on wood, 10½″ × 13⅝″ (26.4 × 34.5 cm)
Philadelphia Museum of Art. Bequest of Charlotte Dorrance Wright

The first exhibition of the Impressionists was well attended, but the members of the press and public who crowded into the second-floor studio in the Rue Daunou were either amused or unfailingly hostile, and the venture was by no means a commercial success.

If the Impressionists were generally ignored and seldom patronized at the onset of their careers, one might well wonder how they survived. The image of the starving artist who lives on little but inspiration is truly more romantic fiction than fact. As an artist of independent means, Cassatt was the exception rather than the rule, and even Degas, whose lineage was aristocratic, was all but impoverished by a family debt.

Credit for the initial survival of the Impressionists must go in large part to the dealer Paul Durand-Ruel, who sustained many of them at a time when there were few buyers to be found, and who hosted two group shows and a number of solo exhibits in his Paris gallery.

At one point he was threatened with bankruptcy, and only Cassatt's timely intervention helped save him. She also helped to find him buyers among her countrymen, by referring clients and by encouraging him to sell in the United States.

Durand-Ruel did arrange for the first exhibition of Impressionist art in the United States in 1886, and opened a gallery two years later in New York. Although his faith in the Impressionist was eventually vindicated, his early support was an act of rare courage and insight. It is characteristic of the milieu in which Cassatt found herself that she and Degas should become acquainted with each other through their art long before they were to actually meet in person. «How well I remember... seeing for the first time Degas' pastels in the window of a picture dealer on the Boulevard Haussmann,» she recalled years later. «I used to go and flatten my nose against that window and absorb all I could of his art. It changed my life.»

Given her intense interest in contemporary art, Cassatt was probably among the crowds who attended the first Impressionist exhibition. Unlike the majority of the people in attendance, she did not go to scoff. She went to learn.

Though he no longer submitted work to the Salon, Degas was interested enough in the 1874 exhibition to stroll through the Salon's galleries one day in the company of his friend Joseph Tourny. Tourny had met Cassatt when both were studying Hals's work in Haarlem, and may have first called Degas' attention to a lively and engaging canvas by Cassatt entitled *Portrait of Madame Cortier* (1874, Maxwell Galleries, San Francisco). Degas was impressed. «C'est vrai,» he remarked to Tourny, «Voilà quelqu'un qui sent comme moi.» *

Three years would pass before Degas, again in the company of Tourny, would call upon Cassatt at her studio. Whether by design or by accident, his timing proved to be perfect.

Cassatt made another important and lasting acquaintance during this period, when she was introduced to Louisine Waldron Elder, a young American who was attending a fashionable Parisian finishing school. Later, as Mrs. Henry O. Havemeyer, the wife of a prominent American industrialist and art collector, she recalled that first meeting:

> «I remember that when I was a young girl... a lady came to visit Madame del Sarte, where I was a pensionnaire, and I heard her say that she could not remain to tea because she was going to Courbet's studio to see a picture he had just completed and then she spoke of him as a painter of such great ability that I at once conceived a curiosity to see some of his pictures.»

* «It's true. There is someone who feels as I do.»

Though there was an age difference of more than ten years between them, the two became fast friends, and Louisine Elder quickly came to share her fellow American's enthusiasm for French art:

« I was about sixteen years old when I first heard of Degas, of course through Miss Cassatt. She took me to see one of his pastels* and advised me to buy it... it was so new and strange to me! I scarcely knew how to appreciate it, or whether I liked it or not, for I believe it takes special brain cells to understand Degas. There was nothing the matter with Miss Cassatt's brain cells, however, and she left me in no doubt as to the desirability of the purchase and I bought it on her advice. »

As Cassatt's appreciation for the new art grew and began to manifest itself in her work, it was almost inevitable that she should eventually run afoul of the Salon's conventions. In 1875 she submitted two canvases, one of which was evidently rejected because it was too bright. She carefully toned down the background, submitted it the following year, and saw her suspicions confirmed when the painting was accepted by the Salon of 1876.

This incident must have convinced her that she could no longer avoid the choice between her principles and the dictates of the Salon. From our present perspective such a decision would not appear terribly difficult, but it must be remembered that Cassatt was preparing to break from the one institution which imparted legitimacy to an artist's work. Without its support she had no reason to expect that she could successfully continue her professional career.

In 1876 and 1877 the Impressionists continued to exhibit their work, courageous acts in light of the lack of popular and financial support with which they had to contend. We may be almost certain that Cassatt attended these showings and that they probably inspired her to try her hand at *plein air* painting. One small oil from this period, *Poppies in a Field* (see p. 12), is highly reminiscent of similar works by Monet and Renoir, suggesting that she had reached the final phase of her transition from academic painting to a style which was frankly imitative of Impressionism. Such a transition is especially notable when one compares *Poppies in a Field* with *A Musical Party* (see p. 11), which was executed approximately one year earlier.

It should be pointed out that artists did not necessarily place as great a degree of emphasis on originality in Cassatt's day as they do at present, and it was perfectly acceptable to work under the influence of a *maître* as long as one did him justice. Her borrowing of stylistic elements was not merely slavish imitation; in each case — and there were many — she carefully analyzed the work of artists whom she admired, and subsequently employed those elements compatible with her own style, thereby producing a distinctive body of work while synthesizing influences from a number of different sources.

Her union with the Impressionist cause was made official by Degas' imprimatur. He visited her studio one afternoon in 1877 and invited her to join the Independents.** Cassatt herself described that fateful meeting to Segard:

* The pastel was a *Répétition de Ballet*, and is believed to be the first example of Impressionist art to enter the United States.

** Degas thoroughly detested the term « Impressionist » and never applied it to himself.

In the Omnibus, c. 1891
Preliminary drawing for the print, crayon and pencil on paper, 14³/₈″ × 10⁵/₈″ (36.5 × 27 cm)
National Gallery of Art, Washington, D.C. The Rosenwald Collection

«I accepted with joy. Finally I would be able to work with absolute independence and without concern for the eventual judgment of a jury! I already knew who my masters were. I admired Manet, Courbet and Degas. I rejected conventional art. I began to live...»*

This meeting began a long and close association between Degas and Cassatt, one based on mutual respect and a shared affinity for beauty and culture. While other artists withered at Degas' waspish epigrams, the spirit, intelligence and talent of the American *mademoiselle* earned his unfailing admiration. In her memoirs, Louisine Havemeyer recalled a conversation in which she pressed her friend for details of Degas' personality:

«Tell me more about him.»
«Oh my dear, he is dreadful! He dissolves your will power,» she said. «Even the painter Moreau said to Degas after years of friendship, that he could no longer stand his attacks: "Voyons, Degas, il faut que je mène ma vie! que nous ne nous voyons plus!"»**
«I led her on to tell me more by asking, "How could you get on with him?"»
«Oh,» she answered, «I am independent! I can live alone and I love to work. Sometimes it made him furious that he could not find a chink in my armor, and there would be months when we just could not see each other, and then something I painted would bring us together again and he would go to Durand-Ruel's and say something nice about me, or come to see me himself. When he saw my *Boy before the Mirror* (see p. 83), he said to Durand-Ruel: "Where is she? I must see her at once. It is the greatest picture of the century." When I saw him he went over all of the details of the picture with me and expressed great admiration for it, and then, as if regretting what he had said, he relentlessly added: "It has all of your qualities and all of your faults — c'est l'Enfant Jésus et sa bonne anglaise."»***

Cassatt was perceptive enough to see beneath Degas' cynical and assured manner a sensitive human being whose uncompromising standards would not allow him to be less than totally honest, however great the cost. Both had devoted their lives to art and each recognized in the other the implicit rewards and sacrifices of such devotion.

One of Degas' more prosaic and revealing letters concerns an errand he undertook on behalf of his American protégée. It is addressed to «M. Le Compte Lepic, supplier of good dogs,» and asks him to find «this distinguished person, whose friendship I honor,» a Belgium griffon from his kennel. «It is a young dog that she needs,» added Degas, «so that he may love her.»****

* Segard, A., *op cit.*, p. 8.
** «See here, Degas, I must lead my life! Let us no longer meet!»
*** «...it is the Infant Jesus and His English Nurse.»
**** Degas, E., *op. cit.*, Nº 131, undated.

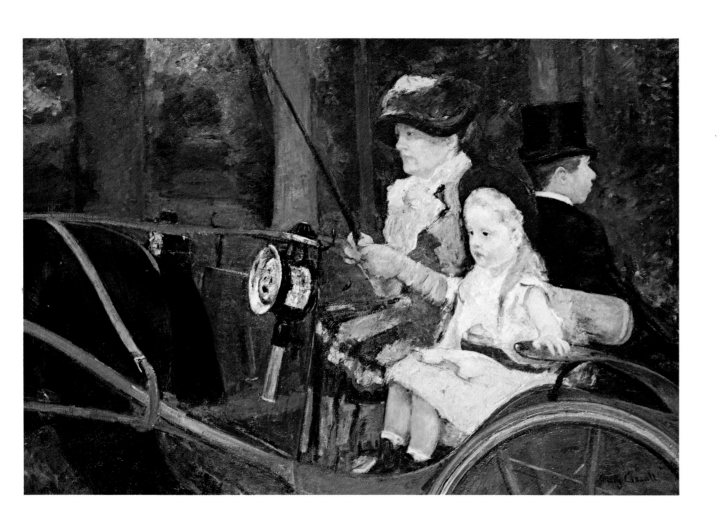

WOMAN AND CHILD DRIVING, 1879. Oil on canvas, 35¼″ × 51½″ (89.3 × 130.8 cm)
Philadelphia Museum of Art. Purchased: The W. P. Wilstach Collection

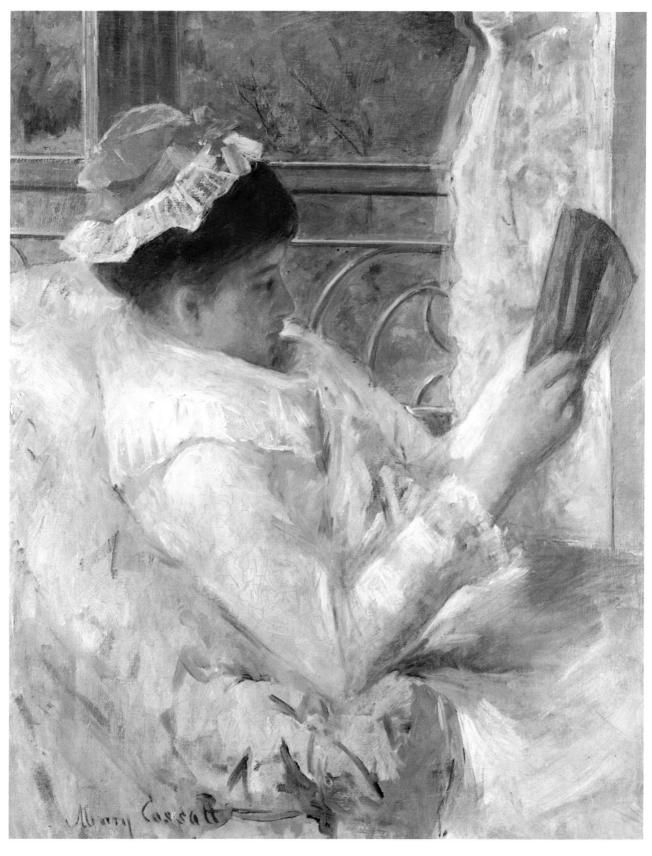

WOMAN READING (LYDIA CASSATT), 1878. Oil on canvas, 32″ × 25½″ (81.3 × 64.7 cm)
Norton Simon Foundation, Los Angeles

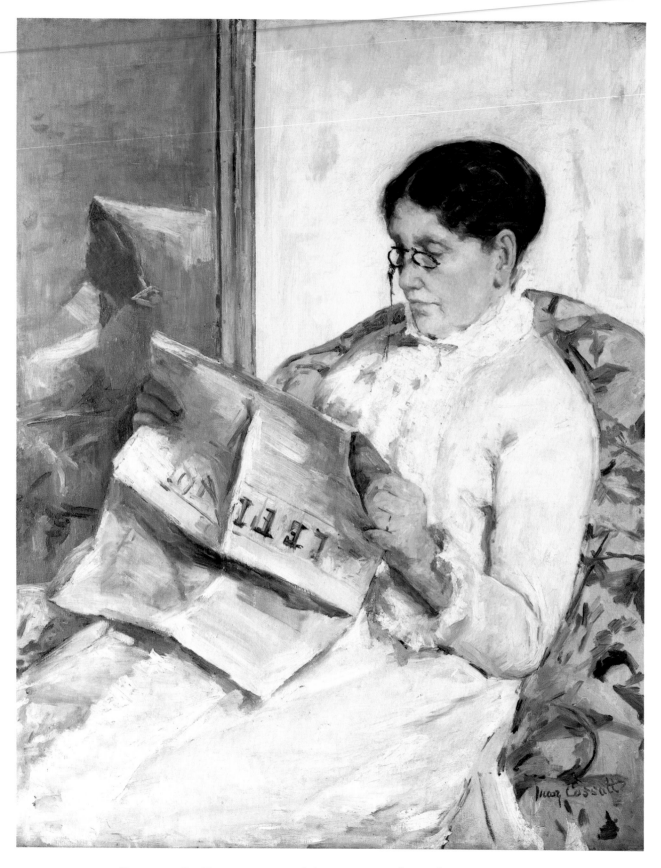

READING «LE FIGARO», 1883. Oil on canvas, 41″ × 33″ (104 × 83.7 cm)
Private Collection

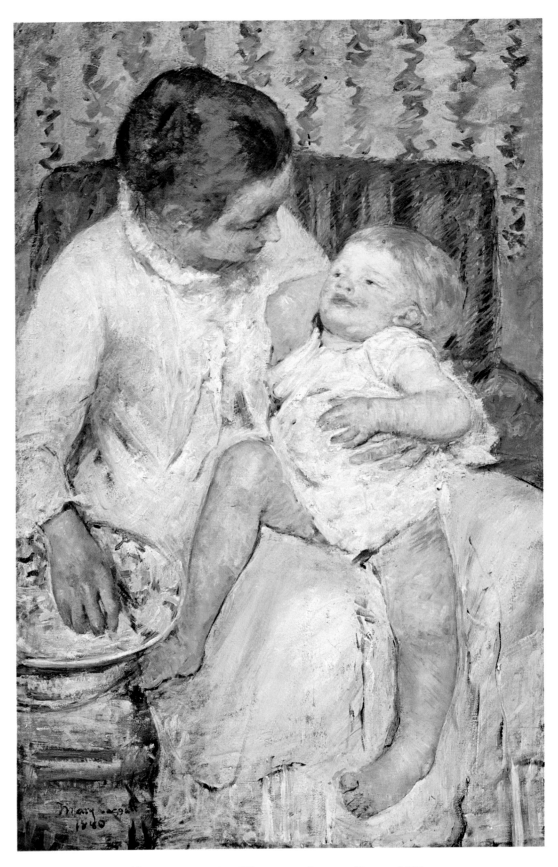

MOTHER ABOUT TO WASH HER SLEEPY CHILD, 1880.
Oil on canvas, 39½″ × 25¾″ (100 × 65.5 cm)
Los Angeles County Museum of Art. Bequest of Mrs. Fred Hathaway Bixby

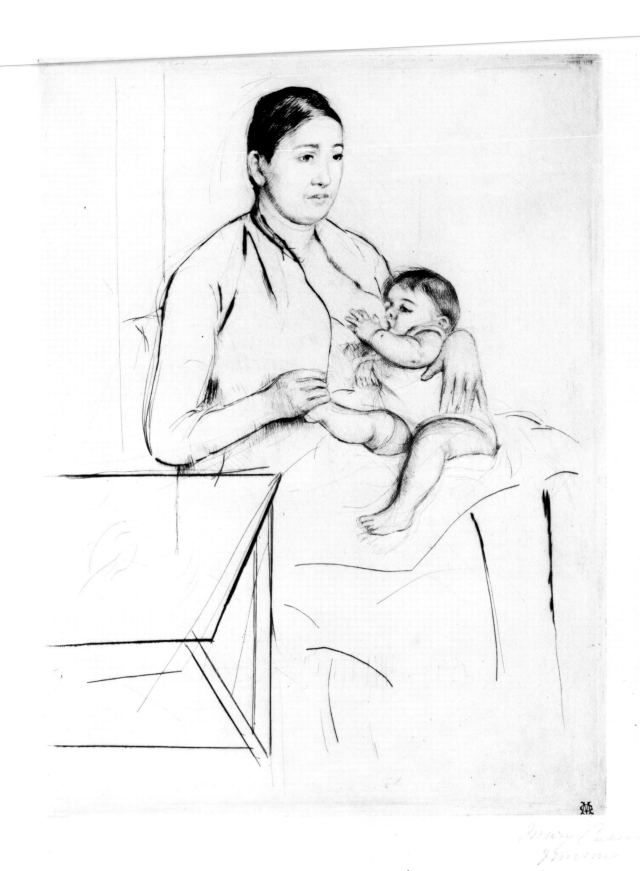

Nursing, c. 1891. Drypoint, 9¼″ × 6¹⁵/₁₆″ (23.5 × 17.6 cm)
The Metropolitan Museum of Art, New York

Like many committed bachelors, Degas could be plainly stuffy about women at times, and it took Cassatt to put him in his place. One anecdote she shared with Segard reveals how deftly she countered one of his maddeningly condescending gestures, not with tears or arguments, but with action. As they were looking at a painting by a mutual friend one day, she remarked that it had no style. Degas began to laugh and shrugged his shoulders as if to say, « Just look at these women who presume to pass an opinion on art! Do they really imagine they know what "style" is? »

The gesture stung, and prompted Cassatt to devise a plan which would teach her mentor not to underestimate the opposite sex. « She found a very ugly model, » relates Segard, « a sort of vulgar looking servant. She had her pose in a shift next to her dressing table, in the act of a woman preparing to retire... the expression is stupid... »

When Degas saw the resultant painting, *Girl Arranging her Hair* (see p. 48), he quickly forgot his misgivings about women: « What drawing! What style! »* he wrote to Cassatt without irony, and promptly acquired it for himself. It remained with him until his death.

Several years later, while admiring a series of color prints Cassatt had executed for her first solo show, Degas again allowed his prejudice to manifest itself, but in this instance at his own expense: « I am not willing to admit that a woman can draw that well, » he remarked to a friend.

The year 1877 proved to be significant for Cassatt in more ways than she might have anticipated. While members of her family had been to Paris to visit her, it is unlikely that she had planned to have them on hand permanently. Nonetheless, Robert Simpson Cassatt, Mrs. Cassatt and Mary's older sister, Lydia, left Philadelphia for Paris, where Mr. Cassatt had decided to retire. Though she was a dutiful daughter and sister and loved her family deeply, Cassatt may have felt a twinge of resentment at the additional burden their care thus imposed upon her. For the next eighteen years she would be forced to cope with the responsibilities of running a household and advancing her career.

The correspondence that passed back and forth between Cassatt's parents and her brothers, who had remained in the United States, speak of her career and the attendant recognition she received in proud, if somewhat bemused tones, as if they still had trouble taking her career seriously. She also kept encouraging her brothers to invest in art, but aside from a few purchases by Alexander, her efforts were to little avail. In plain fact the Cassatts did not know quite what to make of Mary. She remained largely a curiosity to her family, a much-beloved but slightly eccentric spinster who was driven by some force which they could not understand.

In the late 1870's Cassatt began to produce a body of work which clearly demonstrated the extent of her break from the academic traditions of the Salon and her grasp of the lessons she had been learning from Degas and others. Two paintings dated 1878, *Woman Reading (Lydia Cassatt)* (see p. 18) and *Little Girl in a Blue Armchair* (see p. 5) set the stage for what would become increasingly familiar themes: young women or children in relaxed and quiet poses. In the case of Lydia, the brushwork and color are still in the Impressionist mode, though the strong diagonal line of the sitter's body gives us a hint of Cassatt's subsequent passion for structure in her compositions.

* Segard, A., *op. cit.*, pp. 184–185.

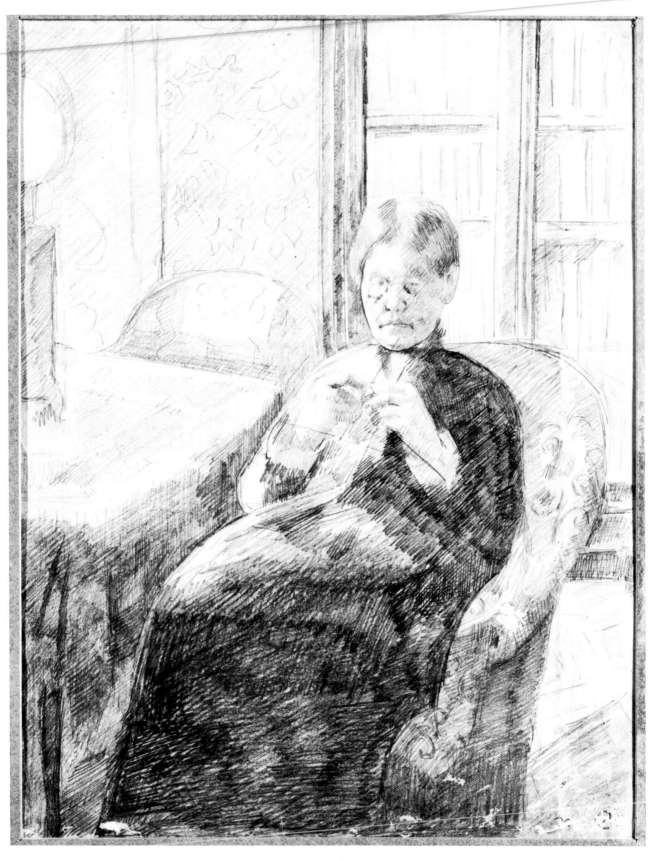

Drawing for «Portrait of an Old Woman Kritting», c. 1881.
Pencil on paper, 11½" × 8¾" (29.2 × 22.2 cm)
The Metropolitan Museum of Art, New York. Gift of Mrs. Joseph du Vivier

Little Girl in a Blue Armchair is especially noteworthy as it is (to our knowledge) the only work by Cassatt upon which Degas himself worked. In a letter to the dealer Ambroise Vollard, she described the painting and commented on Degas' contribution:

«It was the portrait of a child of a friend of Mr. Degas. I had done the child in the armchair and he found it good and advised me on the background and he even worked on it. I sent it to the American section of the big exposition (1878) and they refused it. As Mr. Degas had found it to be good, I was furious, all the more so since he had worked on it. At that time this appeared new and the jury consisted of three people of which one was a pharmacist!»*

Perhaps the most striking thing about this painting is its use of negative space: the irregularly shaped gray peninsula which thrusts its way through the blue armchairs in the foreground. While the brushwork, particularly in the pattern of the upholstery, is handled loosely, one would have to stretch the definition of the term «Impressionist» to label it as such. Both her study of the old masters and the influence of Degas, himself a modern disciple of Ingres, would not permit her to totally abandon draftsmanship in favor of sensory impressions.

It is reasonable to assume that Degas influenced Cassatt's choice of media as well as her style of painting, for both artists executed a number of works in pastel. They appreciated the freedom that pastel allowed as well as the richness that could be attained by building up successive layers of color. Ever anxious to extend the limits of his medium, Degas performed a number of experiments with pastel, such as moistening it with steam or with turpentine to achieve an impasto-like effect. He and Cassatt both began to apply fixative to their work at various stages of development in order to keep the layers of color purer and more intense. This technique, notes Breeskin, also helped to make their pastels «more durable than those of less knowledgeable artists for whom the medium is likely to be fragile and chalky.»**

If we wish to find a suitable example of Degas' influence on Cassatt at the onset of their relationship, we need look no further than her pastel (c. 1879) entitled *Lydia Leaning on her Arms, Seated in a Loge* (see p. 37). *Lydia* was one of a series of drawings and paintings she executed of women at the theater, and employs a number of devices which become increasingly familiar in her later work: the strong diagonal line of the sitter's body, the use of a mirror to show the figure from two angles simultaneously, and the interplay between the curves of the chair and the curving lines of the body. It is the vibrant color and lively yet controlled use of pastel, however, which most clearly reveals Cassatt's debt to her mentor.

A comparison of *Lydia* with *At the Opera* (see p. 35), painted a year later, reminds us of Cassatt's remark to Segard concerning her masters. She had not entirely given up Manet's influence in favor of Degas. Unlike the Impressionists both Cassatt and Degas used black in their palettes, and her bold use of black in the form of the woman (and the sketchy treatment of the background figures) can be traced to similar works by Manet. Cassatt's conscious use of *repoussoir* is clearly revealed in the preliminary drawing (see p. 36) for this work.

* Vollard, A., *Recollections of a Picture Dealer*, p. 180.
** *Mary Cassatt, Pastels and Color Prints*, Exhibition catalogue, p. 17.

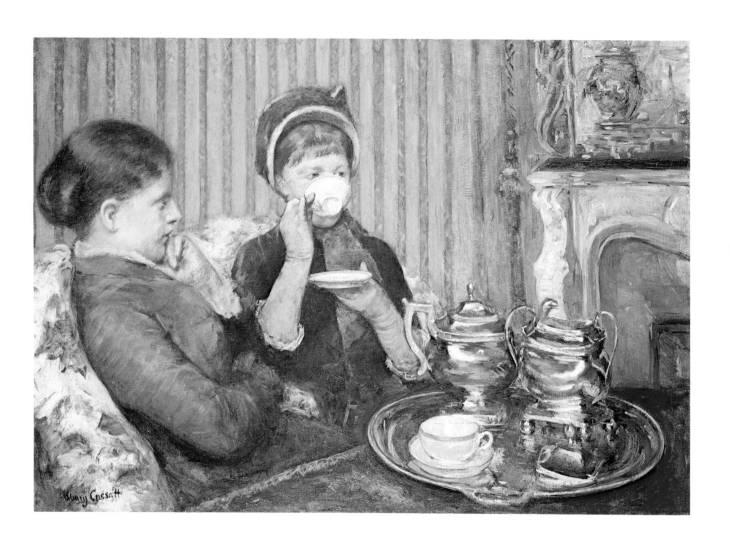

A Cup of Tea, 1880. Oil on canvas, 25½″ × 36½″ (64.7 × 92.7 cm)
Museum of Fine Arts, Boston. The Mary Hopkins Fund

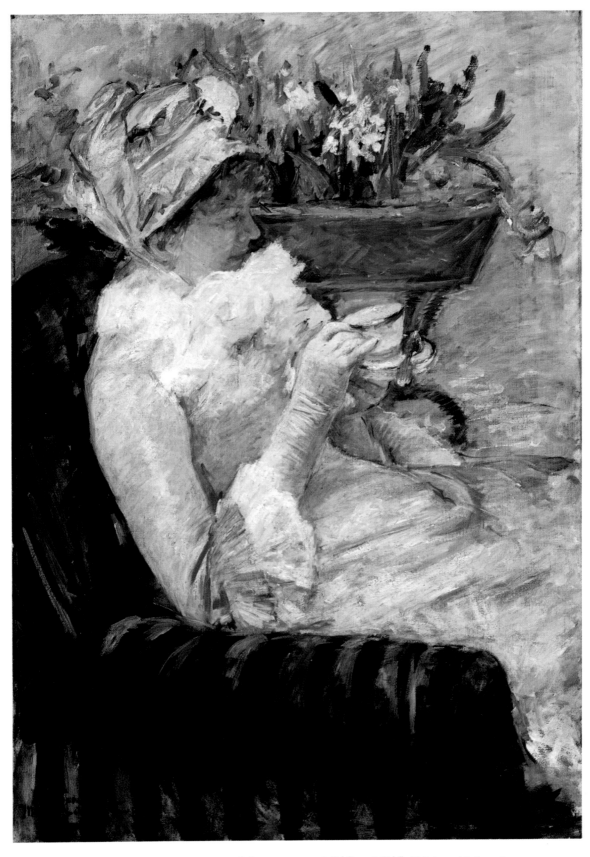

THE CUP OF TEA, 1879. Oil on canvas, 36⅜″ × 25¾″ (92.3 × 65.5 cm)
The Metropolitan Museum of Art, New York. Anonymous Gift

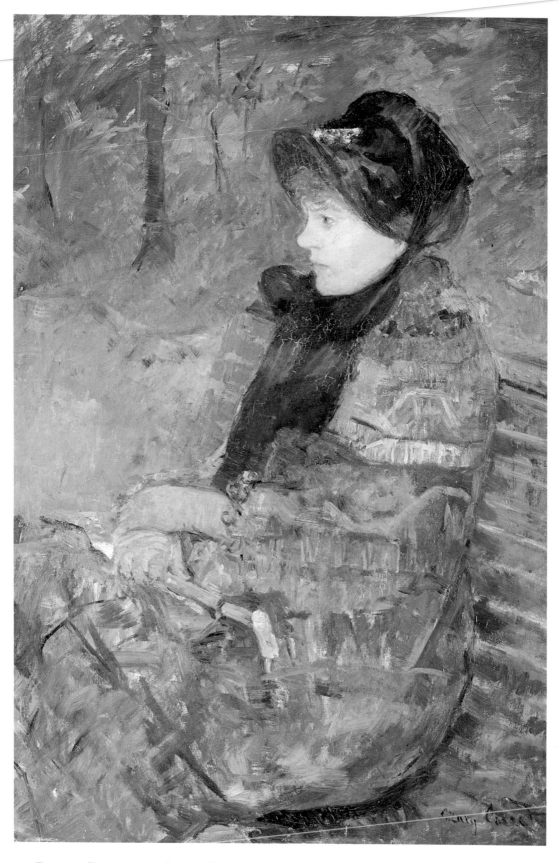

PROFILE PORTRAIT OF LYDIA CASSATT, 1880. Oil on canvas, 38″ × 26″ (93 × 66 cm)
Museum of the Petit-Palais, Paris

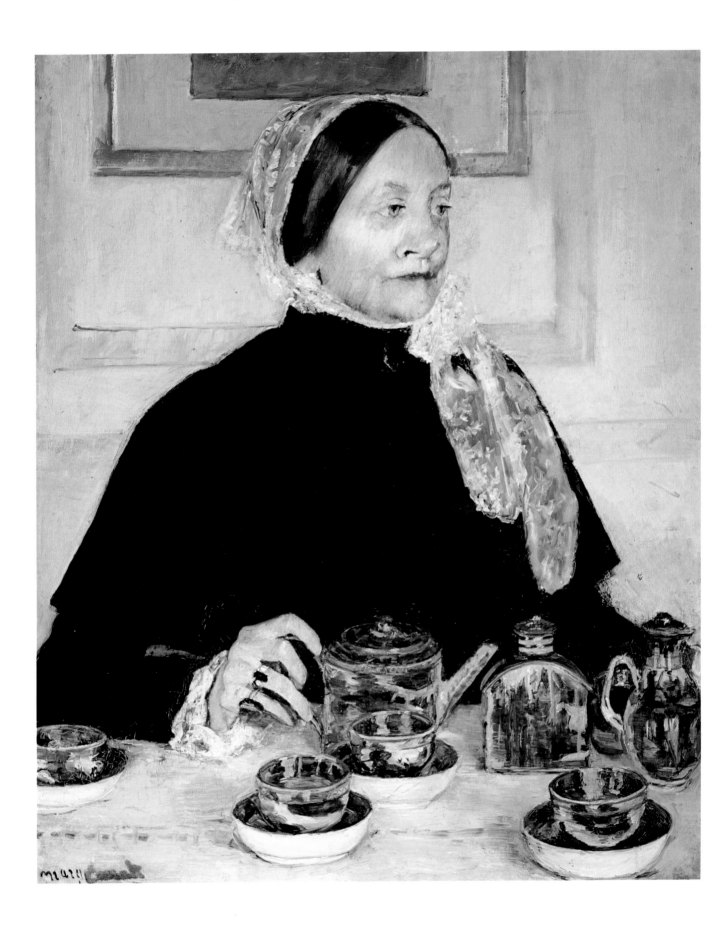

WOMAN WITH A DOG
1883
Oil on canvas
39⁷/₁₆″ × 26⁵/₈″
(100.3 × 67.7 cm)
Corcoran Gallery of Art
Washington, D.C.
▷

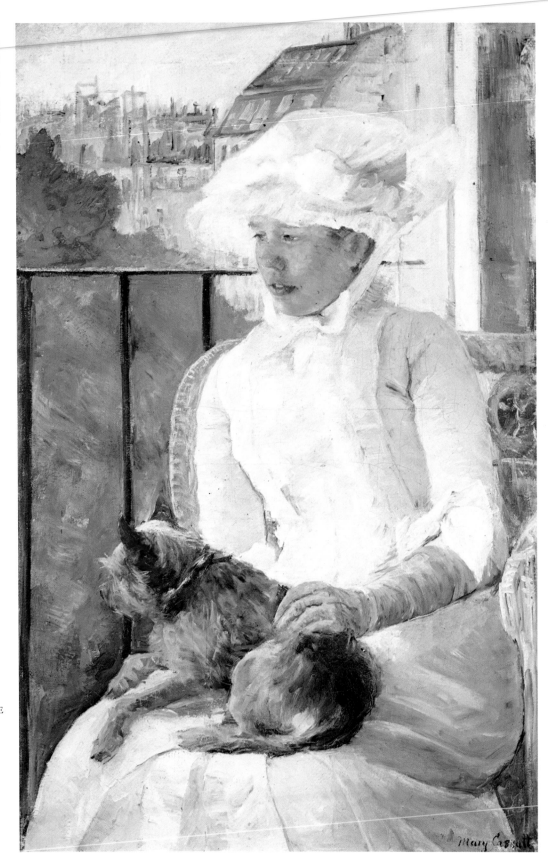

◁

LADY AT THE TEA TABLE
1883–1885
Oil on canvas
29″ × 24″
(73.4 × 61 cm)
The Metropolitan
Museum of Art
New York
Gift of the Artist

29

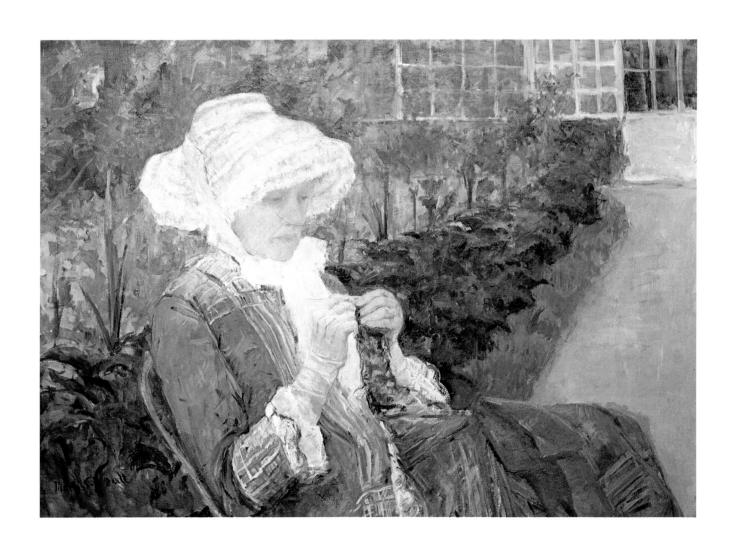

Lydia Crocheting in the Garden at Marly, 1880
Oil on canvas, 26″ × 37″ (66 × 94 cm)
The Metropolitan Museum of Art, New York. Gift of Mrs. Gardner Cassatt

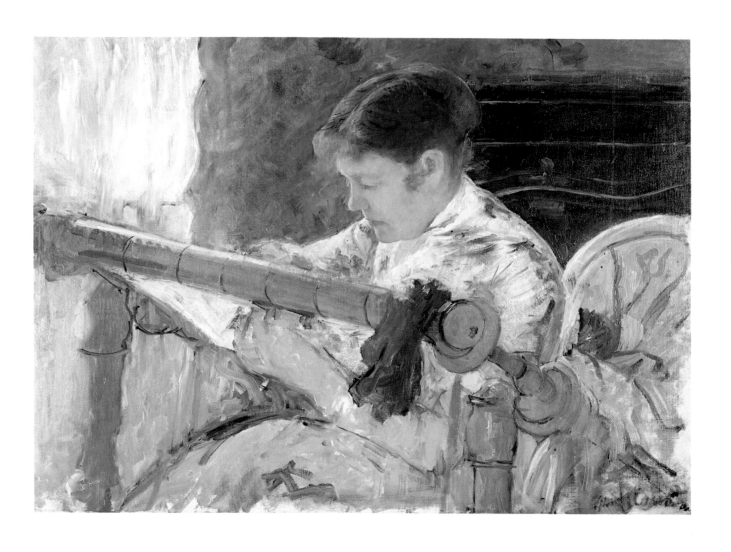

LYDIA WORKING AT A TAPESTRY FRAME, c. 1881
Oil on canvas, 25¾″ × 36¼″ (65.5 × 92 cm)
Flint Museum of Arts, Flint, Michigan. Gift of the Whiting Foundation

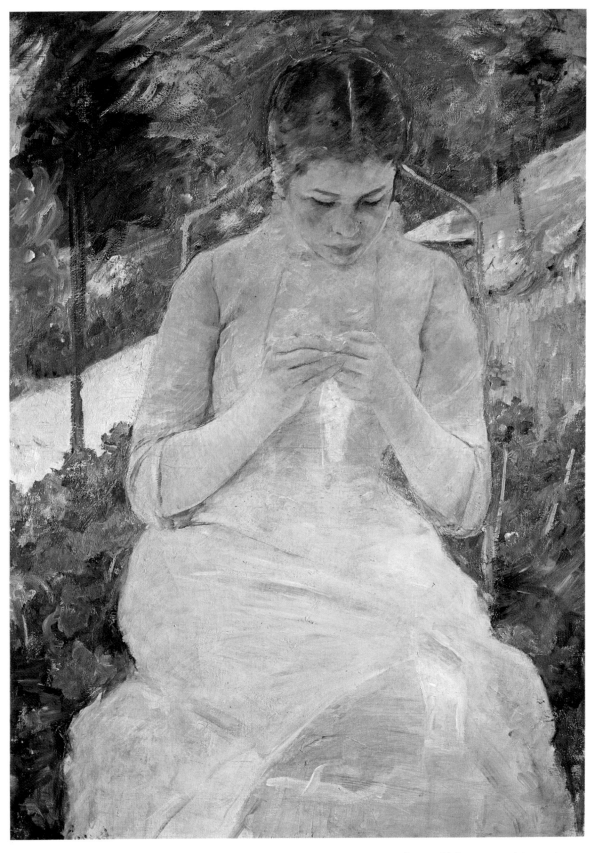

YOUNG WOMAN SEWING IN A GARDEN, c. 1886. Oil on canvas, 36″ × 25½″ (91.5 × 64.7 cm)
Jeu de Paume Museum, Paris

Two other paintings from this period suggest Cassatt's affinity for themes centered around the languid rituals of women. *The Cup of Tea* (see p. 26) is stylistically reminiscent of *Woman Reading*. The soft colors and fluid brushwork show further development of the Impressionist influence. *A Cup of Tea* (see p. 25) is much more tightly modeled and is more representative of what was becoming Cassatt's mature style. The familiar figure of Lydia is once again present, but in this instance is accented by the woman on the right, whose face Cassatt has boldly concealed behind a tea cup. The vertical lines of the wallpaper and the flowered chintz of the sofa add pattern and rhythm, as do the lines of the oddly tilted tea service (still in the possession of the Cassatt family) and the curve of the mantel.

A Cup of Tea was shown in the fifth Impressionist exhibit and was the subject of some favorable attention from critic J. K. Huysmans: *

> « It remains for me now, having arrived at the work of M. Degas which I saved for the end, to speak of the two lady painters of the group, Miss Cassatt and Madame Morizot [sic]. A pupil of Degas, Miss Cassatt is evidently also a pupil of English painters, for her excellent canvas, two women taking tea in an interior, reminds me of certain works shown in 1878 in the English section.
>
> « Here it is still the bourgeoisie, but it is no longer like that of M. Caillebotte; it is a world also at ease but more harmonious, more elegant. In spite of her personality, which is still not completely free, Miss Cassatt has nevertheless a curiosity, a special attraction, for a flutter of feminine nerves passes through her painting that is more poised, more peaceful, more capable than that of Mrs. Morizot, a pupil of Manet. »

The period 1879–1880 was a busy one for Cassatt. In addition to her rigorous daily regimen of painting and attending to the needs of her household, she began preparations to join Degas and several of the Impressionists in their plans to publish a journal of original prints, to be called « Le Jour et La Nuit. » With the characteristic enthusiasm and energy with which she undertook all new ventures, she set to work at once. « Mlle Cassatt is trying her hand at engravings, » Degas wrote to Pissarro in 1880, « They are charming. » ** Degas himself, however, began to waver. « We must discuss the journal, » he wrote to Felix Bracquemond. « Pissarro and I together made various attempts of which one by Pissarro is a success. At the moment Miss Cassatt is full of it. Impossible for me with my living to earn, to devote myself entirely to it yet. » ***

The end result was that « Le Jour et La Nuit » was never published, but the preparations did at least allow Cassatt to reacquaint herself with the techniques of intaglio printmaking, a medium which she had largely ignored since her studies with Carlo Raimondi in Parma nearly ten years before.

With *Woman and Child Driving* (see p. 17) Cassatt began to employ the asymmetry and severe cropping which Degas favored in his compositions. Lydia is depicted driving a carriage, accompanied by a little girl (Odile Fèvre, one of Degas' nieces) and a groom, whom

* Huysmans, J. K., *L'art moderne*, p. 112.
** Degas, E., *op. cit.*, N° 33, 1880.
*** *ibidem*, N° 31, 1879–1880.

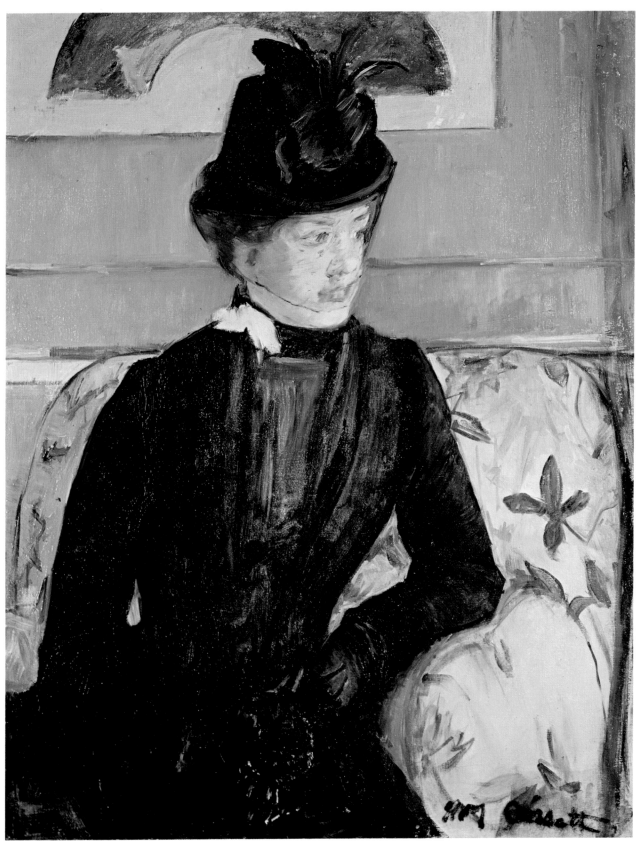

PORTRAIT OF A YOUNG WOMAN IN BLACK, 1883. Oil on canvas, 31½″ × 25¼″ (80 × 64 cm)
On permanent loan from the Peabody Institute to the Baltimore Museum of Art

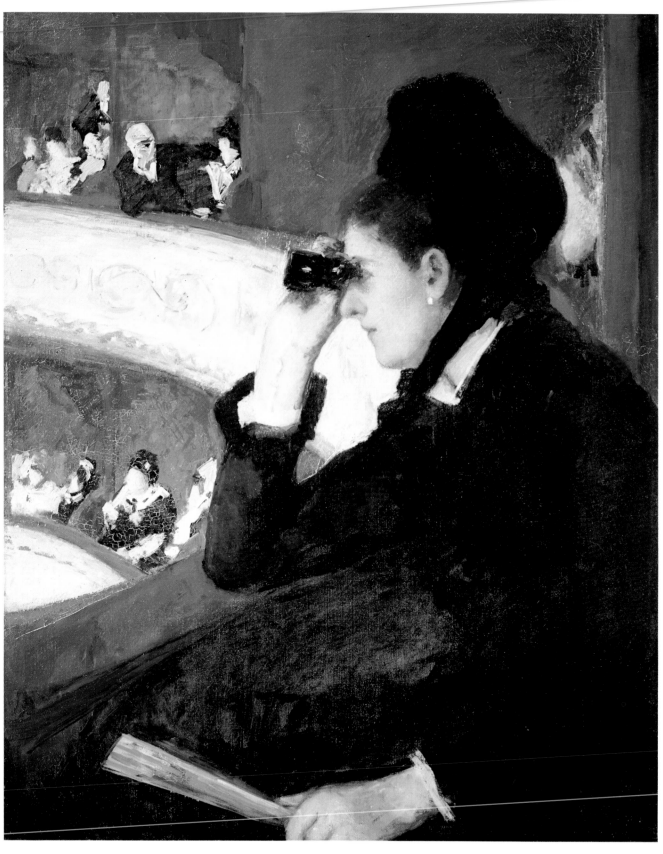

AT THE OPERA, 1880. Oil on canvas, 32″ × 26″ (81.3 × 66 cm)
Museum of Fine Arts, Boston. The Charles Henry Hayden Fund

Study for «At the Opera», 1880. Soft pencil on paper, 4″ × 6″ (10.2 × 15.3 cm)
Museum of Fine Arts, Boston. Gift of Dr. Hans Schaetter

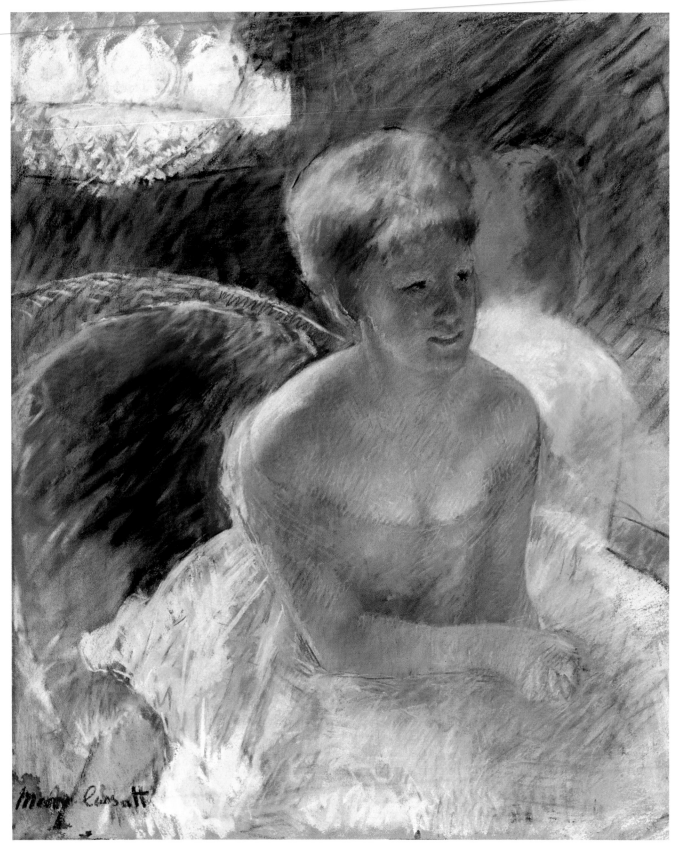

Lydia Leaning on her Arms, Seated in a Loge, c. 1879. Pastel on paper, 21⅝″ × 17¾″ (55 × 45 cm)
Nelson Atkins Museum, Kansas City, Missouri. Anonymous Gift

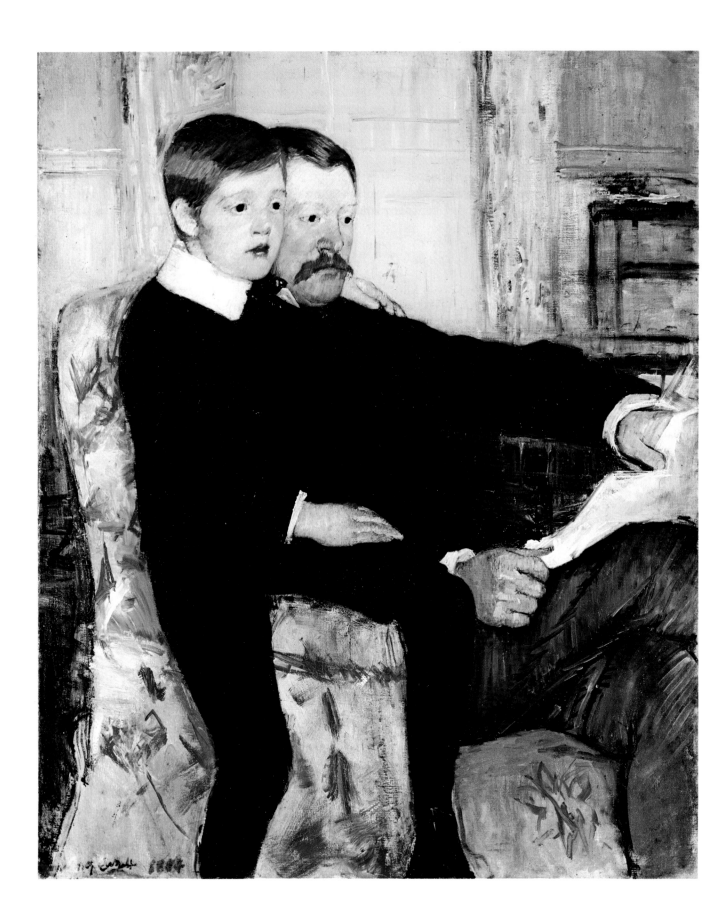

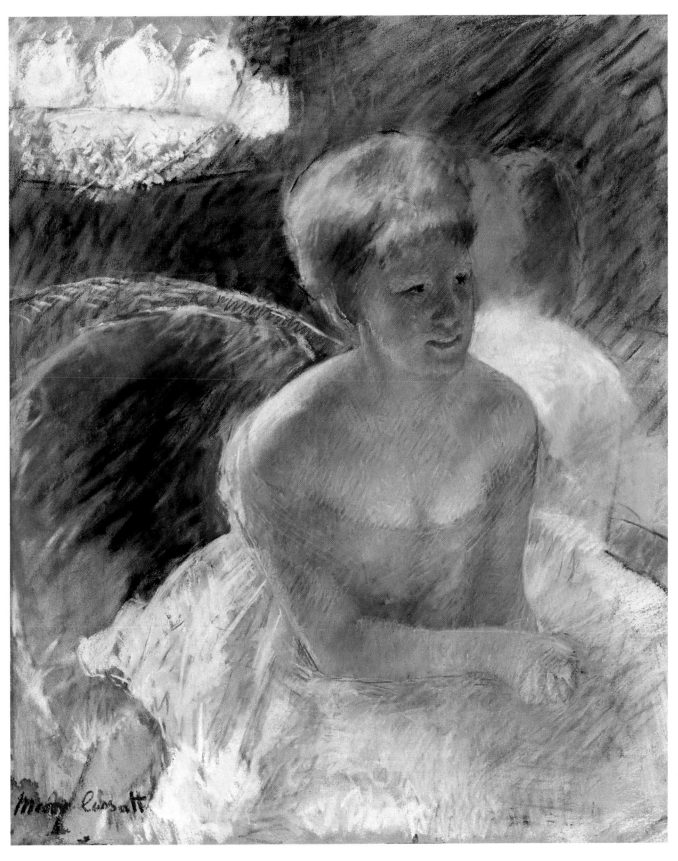

LYDIA LEANING ON HER ARMS, SEATED IN A LOGE, c. 1879. Pastel on paper, 21⅝″ × 17¾″ (55 × 45 cm)
Nelson Atkins Museum, Kansas City, Missouri. Anonymous Gift

we see only in profile. Though the subjects are ostensibly in the act of motion, their dour expressions and stiff poses resemble not so much a spontaneous, joyous outing as a carefully composed and self-conscious family photograph.

The theme that is most frequently associated with Cassatt — maternity — is one that first appeared in 1880, and seems to coincide with a lengthy visit from her older brother and his family. While Alexander Cassatt and his wife remained in Paris, their four children spent a good part of the summer with their aunts and grandparents in the country, at Marly-le-Roi. No doubt the older Cassatts were delighted to see their grandchildren, and « Aunt Mary » took advantage of the occasion to execute a number of paintings and drawings of her nieces and nephews as well as a formal portrait of her brother.

From this period comes *Mother about to Wash her Sleepy Child* (see p. 20), generally regarded as Cassatt's first comprehensive treatment of the mother-and-child theme, and a work that beautifully captures the exuberance and freshness of youth. Like Whistler, whom she knew and admired, Cassatt was intrigued by the variations which could be attained within a given value, usually white. *Mother about to Wash her Sleepy Child* is but one of a number of paintings thus analyzed.

The interruptions of her nieces and nephews did not keep Cassatt from taking advantage of the fine summer weather to complete two excellent portraits of her sister, *Lydia Crocheting in the Garden at Marly* (see p. 30) and *Profile Portrait of Lydia* (see p. 27). Degas was evidently pleased by her progress, for that October he wrote a friend, « The Cassatts have come back from Marly. Mlle Cassatt is settling in a ground floor studio which does not seem too healthy to me. What she did in the country looks very well in the studio light. It is much stronger and nobler than what she had last year. »

On April 2, 1881, the sixth group exhibition opened and was again reviewed by Huysmans. Though generally critical of the Impressionists he was unstinting in his praise of Cassatt:

> « I wrote last year that most of Miss Cassatt's canvases recalled the pastels of Degas and one of them derived from modern English masters.
>
> « From these two influences has come an artist who owes nothing any longer to anyone, an artist wholly spontaneous and personal. Her exhibition is composed of children, interiors, gardens, and it is a miracle how in these subjects, so much cherished by the English, Miss Cassatt has known the way to escape from sentimentality on which most of them have foundered, in all their work written or painted.
>
> « Oh! those babies, good heavens, how their portraits can exasperate me! Such a crew of English and French daubers have painted them in such stupid and pretentious poses!
>
> « For the first time, thanks to Miss Cassatt, I have seen effigies of ravishing youngsters, quiet bourgeois scenes painted with a delicate and charming tenderness...
>
> « Two other pictures, one called *The Garden** where in the foreground a woman reads while on a diagonal behind her there

* *Lydia Crocheting in the Garden at Marly.*

are masses of green dotted with red geraniums with a border of dark Chinese nettles extending as far as the house. The other, called *Tea*, in which a woman dressed in pink, smiling, seated in an armchair, holds a teacup in her gloved hands, adding to this tender, contemplative note the fine sense of Parisian elegance. And it is a special indication of her talent that Miss Cassatt, who, I believe, is an American, paints French women for us. But in houses so Parisian she puts the friendly smile of an "at home." She achieves in Paris something that none of our painters could express, the happy contentment, the quiet friendliness of an interior.» *

It was typical of Cassatt not to allow such praise to turn her head. Ambroise Vollard made a special point of noting her aversion to «pushing» her work in public. «One day at an exhibition,» he wrote, «they were fighting for and against the Impressionists.

« "But," said someone, speaking to Mary Cassatt without knowing who she was, "you are forgetting a foreign painter that Degas ranks very high."

« "Who is that?" she asked in astonishment.

« "Mary Cassatt."

«Without false modesty, quite naturally, she exclaimed, "Oh, nonsense!"

« "She is jealous," murmured the other, turning away.» **

The exhibition of 1881, while encouraging from Cassatt's point of view, was marred by increasing acrimony among the participants, many of whom took umbrage at Degas' high-handed manner. «This man (Degas) has gone sour,» compained Caillebotte in a letter to Pissarro. «He doesn't hold the big place he ought according to his talent and, although he will never admit it, he bears the whole world a grudge.» ***

As a result of the dispute — most of it centered around the question of membership in the seventh exhibition — several artists refused to participate, choosing instead to return to the Salon. Pissarro tried in vain to keep peace among the warring factions, but the arguments rose to such a pitch that Degas finally announced he would not participate, and Cassatt loyally joined him.

On November 7, 1882, her beloved sister Lydia died from Bright's disease, a kidney infection which had plagued her for years. It is fitting that Cassatt's last painting of her sister, *Lydia Working at a Tapestry Frame* (see p. 31), is also her finest, a masterpiece of color and composition. It is a work of subtle contrasts, the tightly modeled upper half of the canvas set off by the loose and sketchy quality of the lower, the light from the window on the left balanced by the dark form of the dresser on the right.

In the final analysis *Lydia Working at a Tapestry Frame* captivates us not by subtleties of composition, however, but for the same reason that we are captivated by Vermeer's ability to capture a luminous moment in time. It is an outstanding tribute to the patient and gentle nature of Lydia Cassatt, who so frequently served as a model for her sister.

Lydia's death brought Alexander Cassatt and his family back to France once again, a visit that on this occasion was clouded by grief. Cassatt coped with her sorrow in the only way she knew, through her work.

* Huysmans, J. K., *op. cit.*, pp. 231–234.
** Vollard, A., *op. cit.*, p. 181.
*** Rewald, J., *History of Impressionism*, p. 348.

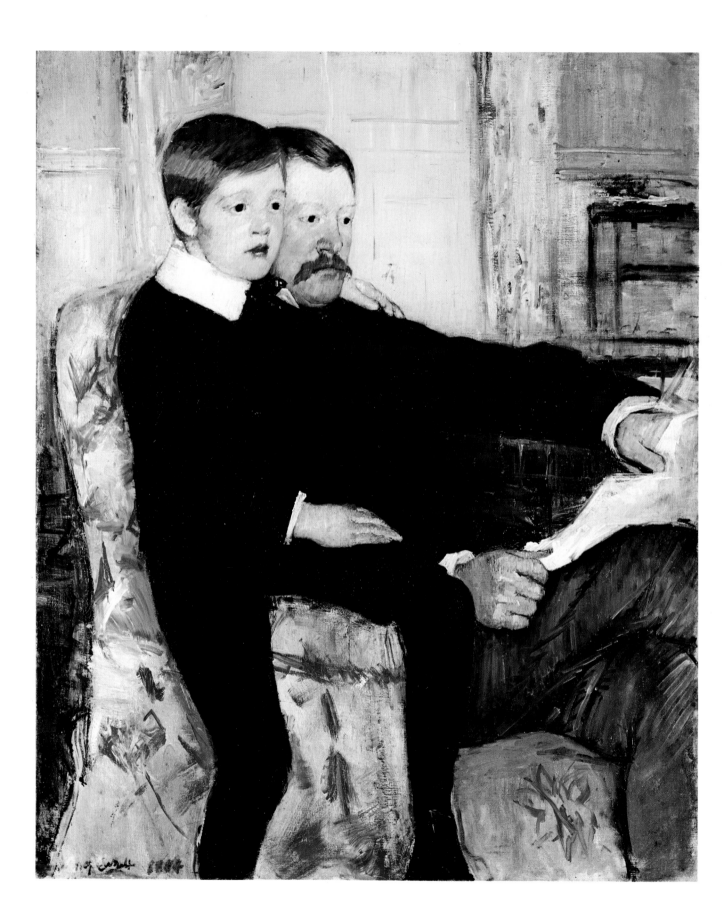

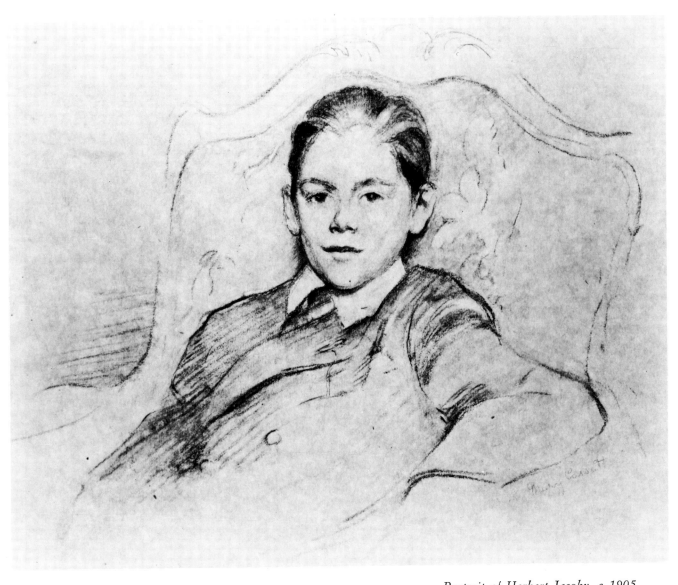

Portrait of Herbert Jacoby, c.1905
Pencil and watercolor on rice paper, 8″ × 10″ (20.3 × 25.5 cm)
Collection: Everett D. Reese, Columbus, Ohio

◁
ALEXANDER J. CASSATT AND HIS SON, ROBERT KELSO CASSATT, 1884
Oil on canvas, 39″ × 32″ (100 × 81.2 cm)
Philadelphia Museum of Art
The W. P. Wilstach Collection and Gift of Mrs. William Coxe Wright

Céleste Seated on a Park Bench, c. 1899. Drypoint, II final state, 11″ × 7″ (28 × 17.7 cm)
Philadelphia Museum of Art
Gift of R. Sturgis Ingersoll, Frederic Ballard, Alexander Cassatt, Staunton B. Peck, and Mrs. William Potter Wear

Reflection, c. 1890. Drypoint, V state, 10¼″ × 6¹⁵/₁₆″ (26 × 17.6 cm)
The Metropolitan Museum of Art, New York
Bequest of Mrs. H.O. Havemeyer. The H.O. Havemeyer Collection

Mary Cassatt

44

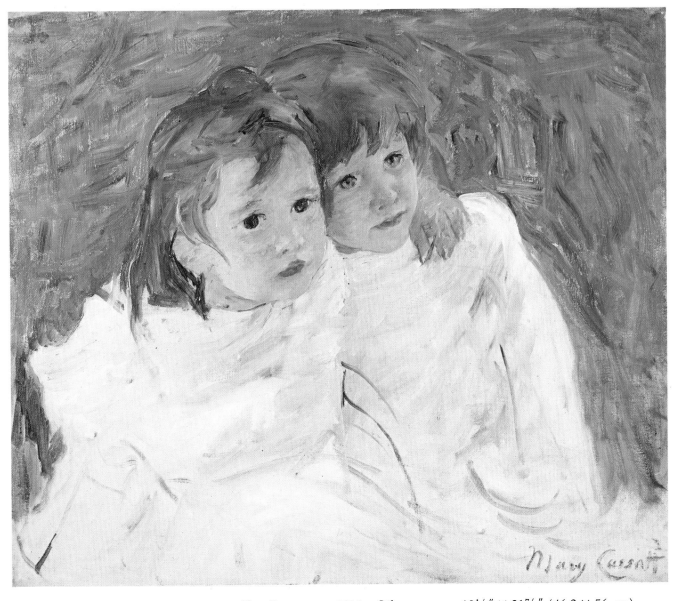

THE SISTERS, c. 1885. Oil on canvas, 18¼″ × 21⅞″ (46.2 × 56 cm)
Glasgow Art Gallery

◁
Jeannette in a Floppy Hat Leaning against a Chair, c. 1904
Drypoint, 8½″ × 5⅞″ (21.5 × 15 cm)
Philadelphia Museum of Art
Gift of Mrs. Charles P. Davis and Gardner Cassatt in memory of Mary Cassatt

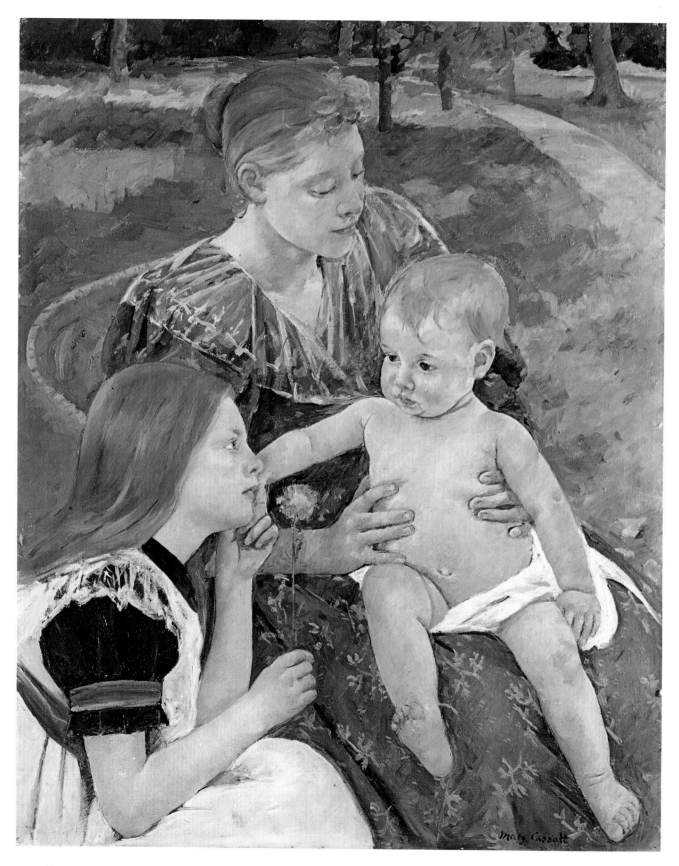

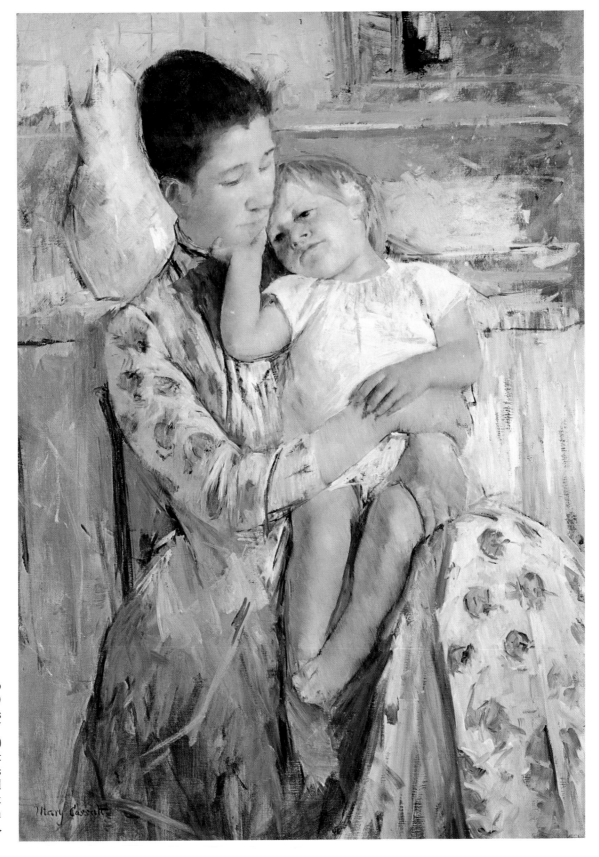

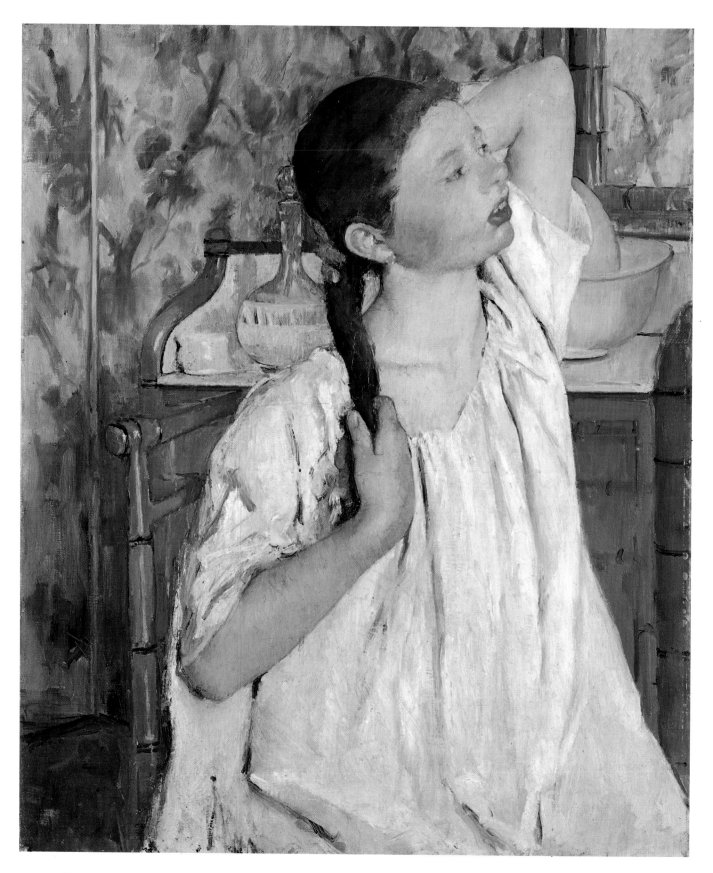

THE BATH
c. 1891
Oil on canvas
39½″ × 26″
(100.3 × 66 cm)
Art Institute
of Chicago
The Robert
A. Waller Fund
▷

◁
GIRL ARRANGING
HER HAIR
1886
Oil on canvas
29½″ × 24½″
(75 × 62.2 cm)
National Gallery
of Art
Washington, D.C.
Chester Dale
Collection

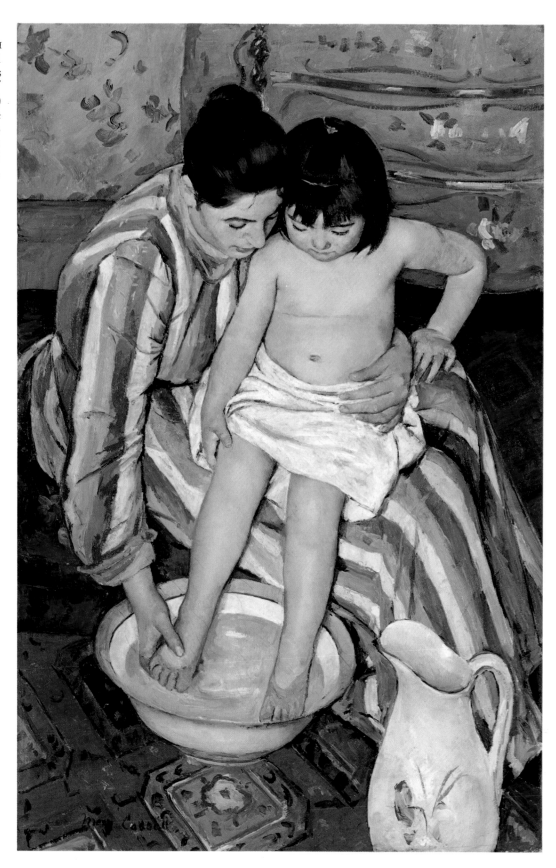

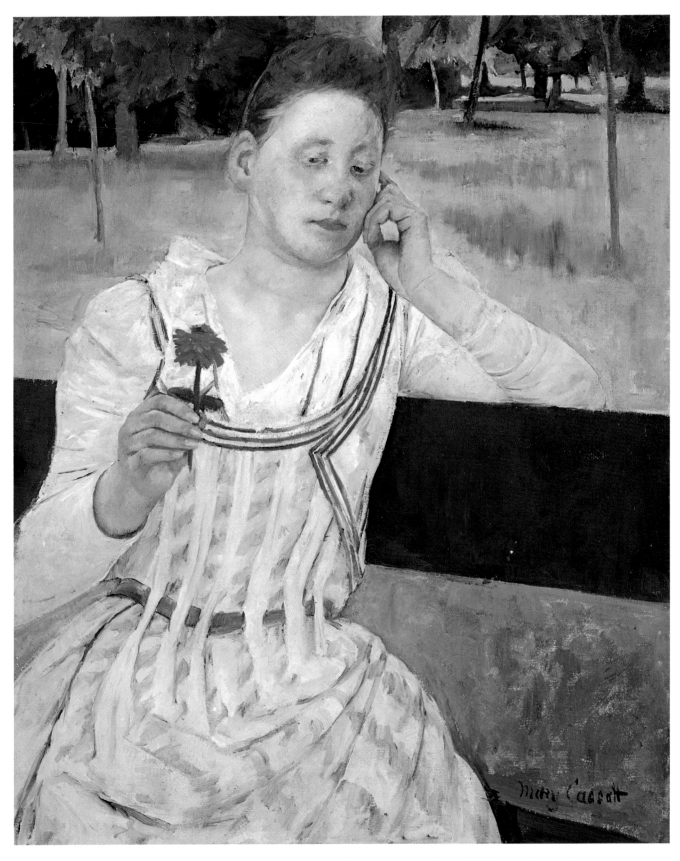

WOMAN WITH A RED ZINNIA, 1891. Oil on canvas, 29″ × 23¾″ (73 × 60.5 cm)
National Gallery of Art, Washington, D.C. Chester Dale Collection

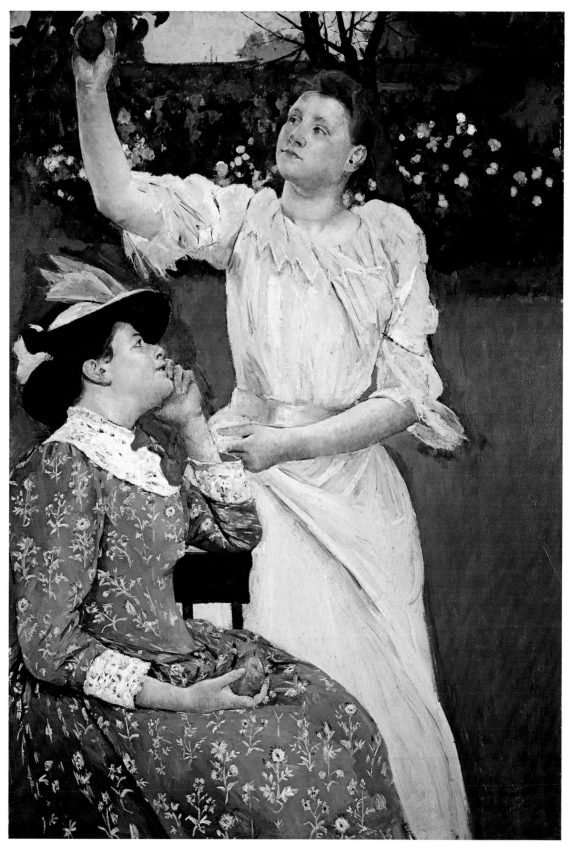

YOUNG WOMEN PICKING FRUIT, 1891. Oil on canvas, 52″ × 36″ (132 × 91.5 cm)
Museum of Art, Carnegie Institute, Pittsburgh, Pennsylvania

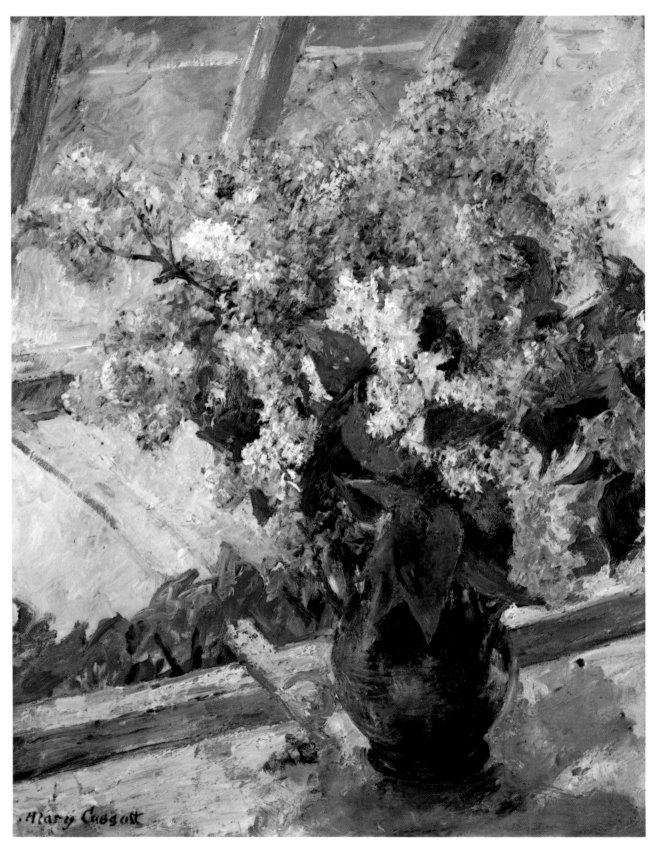

LILACS IN A WINDOW, c. 1889. Oil on canvas, 24¼″ × 20″ (61.6 × 51 cm). Private Collection

«How we try for happiness, poor things,» she wrote to Louisine Havemeyer years later, «and how we don't find it; the best cure is hard work — if only one has the health for it you do that.» From her brother's visit came several drawings and prints of her nephews and nieces, particularly nine-year-old Robbie, and yet another portrait of Alexander Cassatt.

Cassatt was soon left in search of other models, and she therefore turned to the household staff for help. *Susan Seated Outdoors* (see front cover) and *Woman with a Dog* (see p. 29) are two fine paintings of a young woman believed to be the cousin of Mathilde Vallet, Cassatt's faithful housekeeper.

Cassatt's mother is the subject of one of her finest portraits, entitled *Reading Le Figaro* (see p. 19), completed in 1883. It is particularly daring in the severely limited palette which she employed, and suggests that Whistler's experiments in a similar vein (his famous *Portrait of the Artist's Mother* was displayed at the Paris Salon in 1883) may have inspired this dramatic departure from her usual tonality.

Another stylish oil from this period is *Portrait of a Young Woman in Black* (see p. 34).

One portrait that Cassatt began late in 1883 was not completed until two years later, and was not well received by the sitter's family. *Lady at the Tea Table* (see p. 28), a portrait of Mrs. Robert Moore Riddle (a first cousin of Mrs. Robert Simpson Cassatt), was originally painted to acknowledge a gift of Canton blue china that the Cassatts had received from Mrs. Riddle's daughter. It is a masterfully executed and insightful study, but the family, whom Mrs. Cassatt described as «not very artistic,» took an instant dislike to the portrait, maintaining that the nose was out of proportion.

Though modest enough by nature, Cassatt did not take kindly to criticism from amateurs. She hid the canvas away in a closet where it remained until it was subsequently discovered by Mrs. Havemeyer. She recognized its quality and insisted that it be exhibited, predicting (correctly) that it would receive the praise it deserved.

This incident may have helped to reinforce Cassatt's aversion to commissioned works. Years later she did relent and painted several commissioned portraits in pastel, but she preferred to use members of her family or anonymous peasant women and their children as models.

Thanks to some success in the sales of her paintings and financial support from her brother Alexander, Cassatt could afford time away from her work, a situation which became increasingly common as her mother's health deteriorated. Mrs. Cassatt suffered greatly from a weak heart and rheumatism, and in the hopes of improving her condition she and her daughter escaped from the winter cold of Paris in 1883. They headed for the southern coast of Spain and remained there until the following spring.

Further interruptions resulted from the need to find suitable quarters in Paris, so that 1884 proved to be a most unproductive year. Cassatt did find time to sit for a portrait by Degas (coll. André Meyer, New York), but she was disappointed in the result and secretly sought to dispose of it. Unlike Mrs. Riddle's daughter she was not about to share her disappointment with the artist.

Toward the end of 1884 her brother Alexander and nephew Robert made another of their frequent visits, and Cassatt took advantage of their presence to execute a rare double portrait of father and son (see p. 40).

In *Lydia Working at a Tapestry Frame*, Cassatt had literally split the canvas in half, symbolizing the choice that confronted her at the time between Impressionism on the one

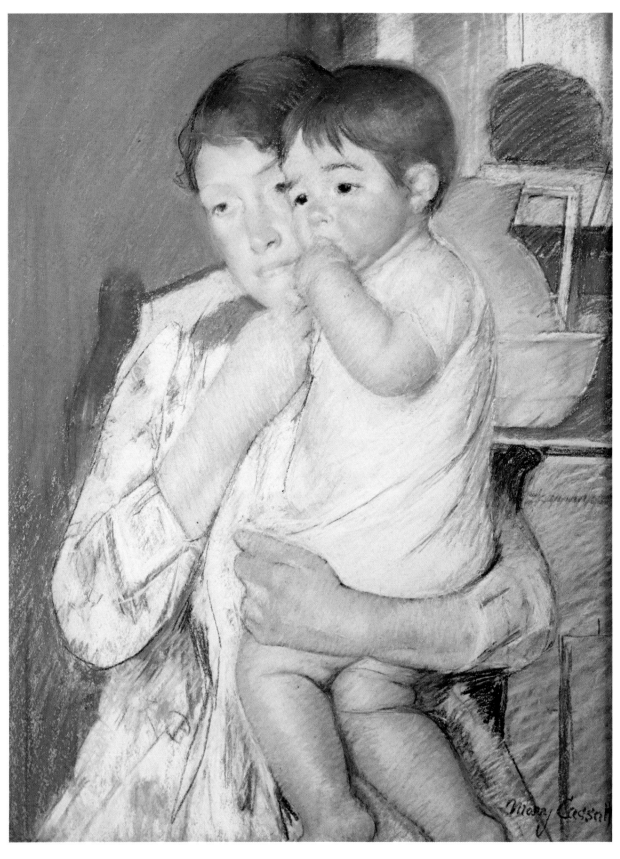

Baby on his Mother's Arm, Sucking his Finger, 1889. Pastel on paper, 25″ × 19″ (63.5 × 48.2 cm)
Louvre Museum, Paris

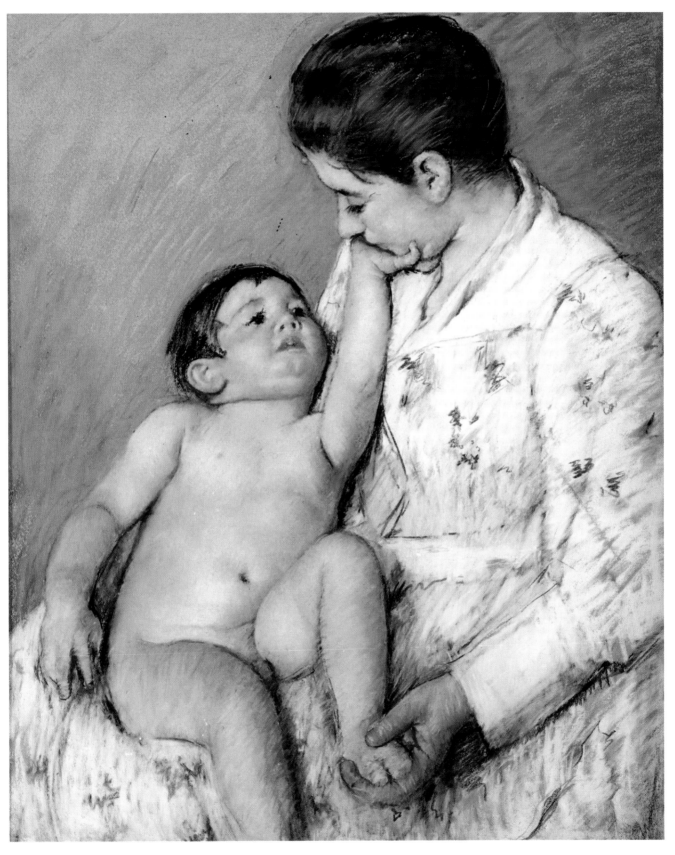

BABY'S FIRST CARESS, 1891. Pastel on paper, 30″ × 24″ (76.2 × 61 cm)
New Britain Museum of American Art, Connecticut. Harriett Russell Stanley Fund

hand and «classicism» on the other. By 1886, when she painted *Young Woman Sewing in the Garden* (see p. 32), *The Family* (see p. 46) and *Girl Arranging her Hair*, she had evidently opted in favor of a «classical» emphasis on form. The firmer modeling of her figures may reveal her interest in the works of Holbein, whom she had come to admire. Certainly her study of the baby in *The Family* suggests all the precision and economy of a Holbein drawing, and the underlying structure in *Girl Arranging her Hair* is plainly visible. Cassatt did retain some elements of Impressionism in her brushwork, but usually employed such brushwork as a foil to the figures which dominated her compositions.

While Durand-Ruel was busy arranging for his major Impressionist exhibit at the American Art Association in New York — the first such exhibit in the United States — Cassatt and her colleagues were feverishly making preparations for the eighth (and last) group show, which opened on May 15, 1886, at a rented studio on the Boulevard des Italiens. Despite the customary bickering among the participants Degas was persuaded to contribute several works, including two pastels in which Cassatt served as the model. The sensation of the exhibit, however, was Seurat's *A Sunday Afternoon on the Island of the Grande Jatte*, which, together with other Pointillist canvases by Signac and Pissarro, brought a predictable wave of public outrage and/or amusement.

Durand-Ruel returned to Paris in late June with the encouraging news that his exhibit had aroused friendly interest among the Americans. Though sales had not been great he agreed with Cassatt that there was an untapped and potentially great market for his artists' work in the United States.

In 1887 Cassatt and her parents moved once again, this time to an apartment at 10, rue de Marignan which featured the amenities of an elevator (considered essential in light of Mrs. Cassatt's bad heart) and central heating. Cassatt kept this apartment as her Paris residence for the rest of her life.

In 1888 her work was interrupted by a riding accident in which she sustained a broken leg and a dislocated shoulder. No doubt the accident was doubly galling: she was an avid horsewoman and was told that further riding was out of the question, and her injuries must have made work of any sort extremely tiresome and painful.

Her output during the period 1887–1890 was relatively small, though she was able to complete several outstanding variations on the mother-and-child theme, among them *Baby on his Mother's Arm* (see p. 54) and *Mother and Child* (see p. 47), as well as a rare still life, *Lilacs in a Window* (see p. 52).

One of the most pronounced influences on late 19th century French art came not out of the mainstream of European civilization but from the island Empire of Japan, which had only recently (since 1853, with the arrival of Commodore Perry's Pacific Squadron in Yedo Harbor) opened its doors to the West. As early as 1862 a shop in the Rue de Rivoli called «La Jonque Chinoise,» run by a Madame De Soye, began to sell examples of oriental art to a growing number of Parisian connoisseurs and collectors — among them Degas — and by 1878 a Japanese pavilion at the Paris World's Fair was attracting huge crowds.

Japanese art proved to be an endless source of fascination and inspiration for the Impressionists. Its refined line and unique concept of space especially appealed to Degas and Cassatt, who began to employ many of its conventions in their work.

In April, 1890, a major exhibition of Japanese prints was held at the Ecole des Beaux-Arts. As might be expected, it had a profound effect on Cassatt. She had been polishing her printmaking skills on and off for over a decade, ever since she had begun to

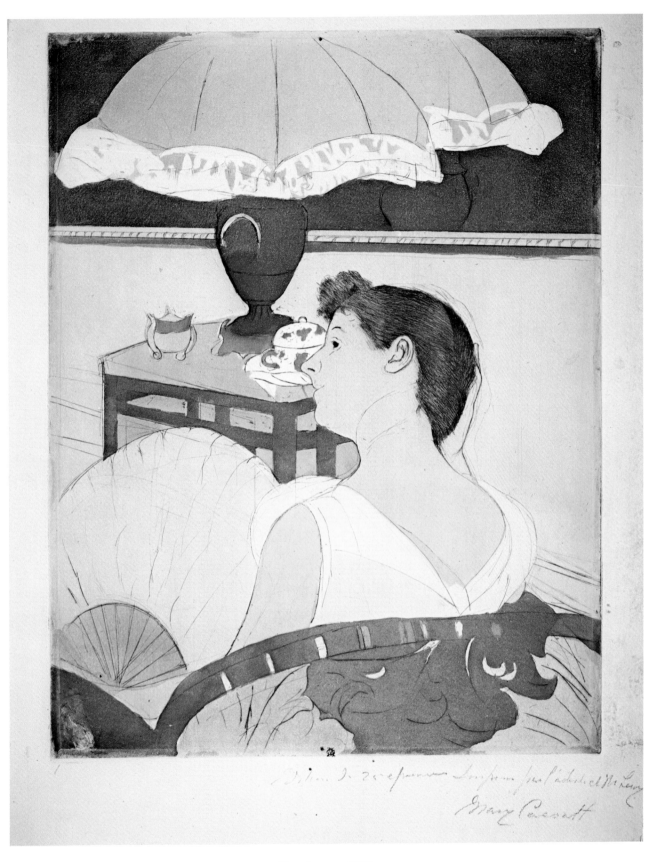

THE LAMP, 1891
Color print with drypoint, softground and aquatint, 13⅝″ × 8¹⁵⁄₁₆″ (34.5 × 22.7 cm)
Worcester Art Museum, Massachusetts. Bequest of Mrs. Kingsmill Marrs

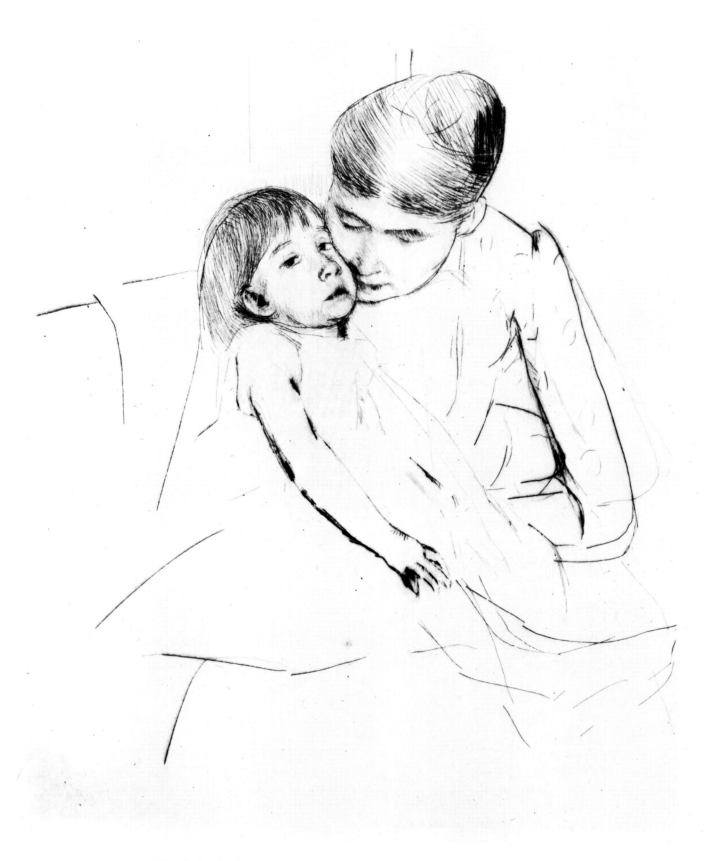

The Sick Child, 1889. Drypoint, 5⅝" × 4" (14.3 × 12 cm)
Philadelphia Museum of Art. Purchased: Temple Fund

Mother Berthe Holding her Child, 1889. Drypoint, 9³⁄₈″ × 6¹⁄₄″ (24.8 × 16 cm)
Philadelphia Museum of Art. Purchased: Temple Fund

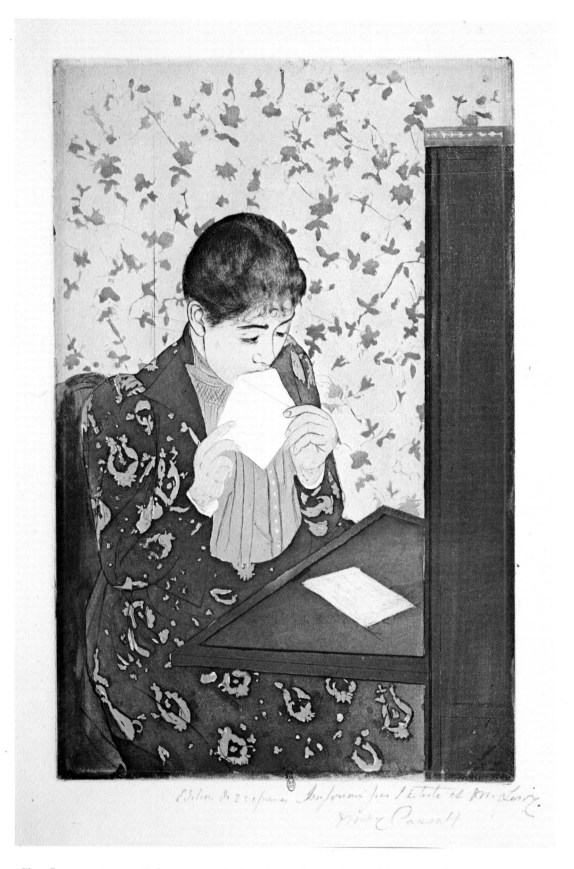

THE LETTER, 1891. Color print with drypoint and aquatint, 13⅝″ × 8¹⁵/₁₆″ (34.5 × 22.7 cm)
Bibliothèque Nationale, Paris

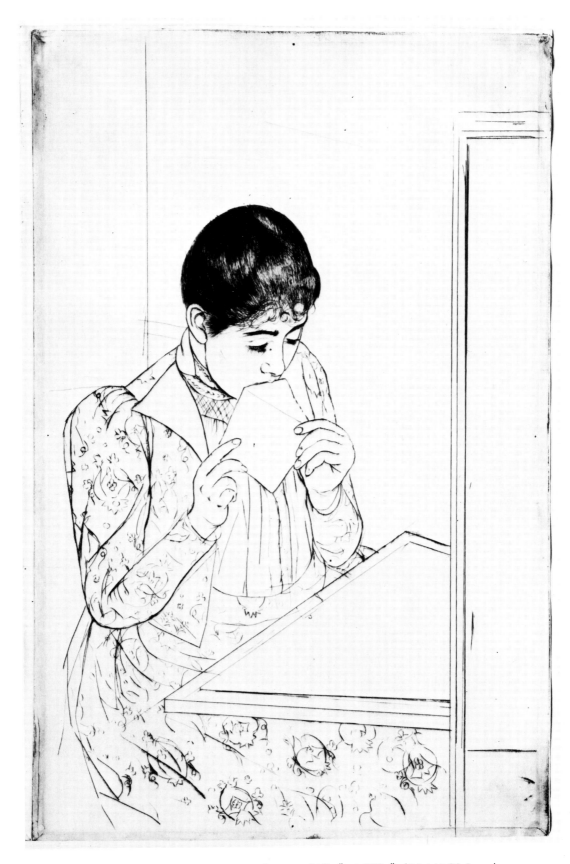

The Letter, 1891. Drypoint, I state, 13⁹/₁₆″ × 8¹⁵/₁₆″ (34.4 × 22.8 cm)
The Metropolitan Museum of Art, New York. Gift of Arthur Sachs

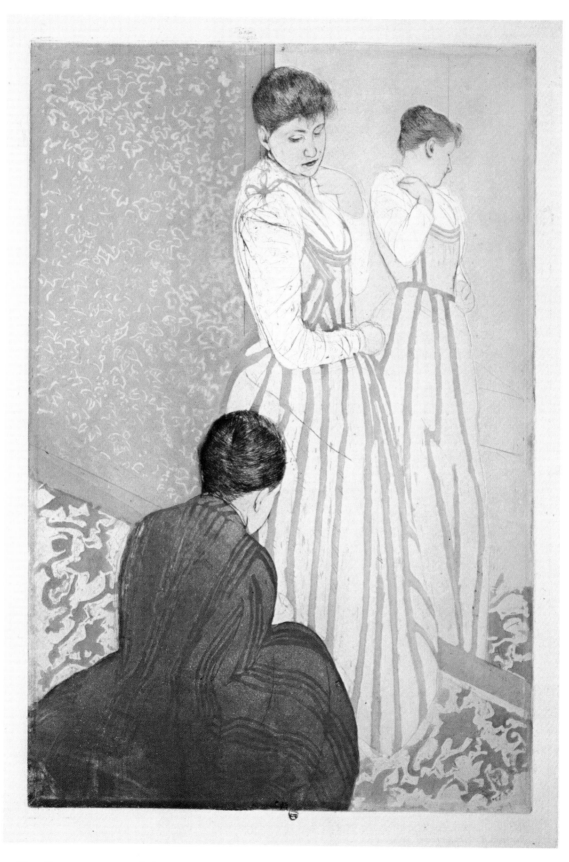

THE FITTING, 1891. Color print with drypoint and aquatint, 14¾″ × 10⅛″ (37.5 × 25.7 cm)
Bibliothèque Nationale, Paris

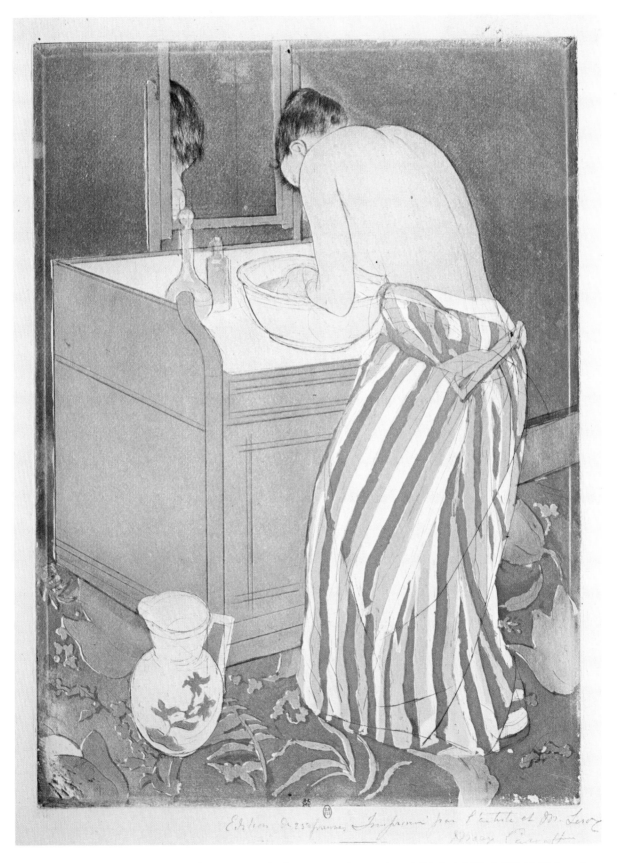

WOMAN BATHING, 1891. Color print with drypoint and aquatint, 14⁵/₁₆″ × 10⁹/₁₆″ (38 × 26.8 cm)
Bibliothèque Nationale, Paris

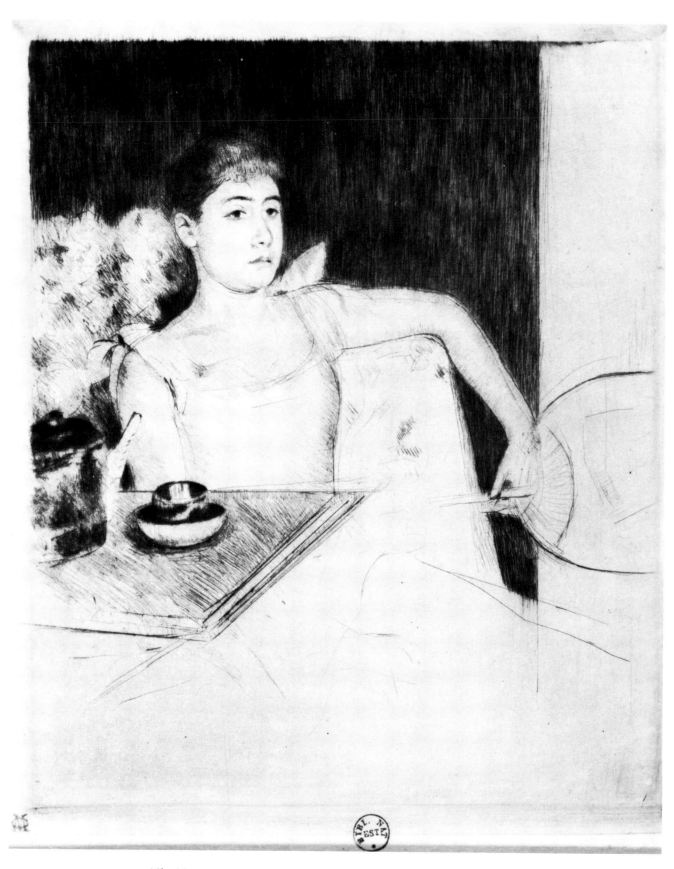

The Tea, 1890. Drypoint, V state, 7 ¹/₁₆″ × 6¹/₈″ (18 × 15.5 cm)
Bibliothèque Nationale, Paris

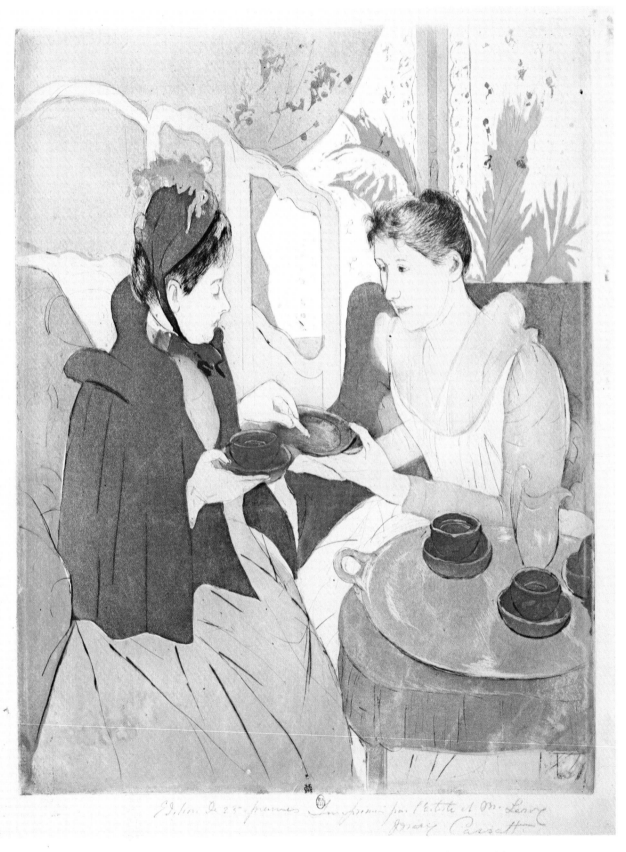

AFTERNOON TEA PARTY, 1891. Color print with drypoint and aquatint, 13½″ × 18⅛″ (34.4 × 46 cm)
Bibliothèque Nationale, Paris

prepare work for the ill-fated « Le Jour et La Nuit. » The exhibit at the Ecole des Beaux-Arts served to pose an inspirational challenge: could she adapt the sinuous floating line and delicate color of Japanese woodcuts to intaglio?

That summer she rented a studio, engaged a printer named Le Roy to assist her, and set to work. The graphic techniques that she chose to use all come under the general heading of intaglio (Italian: « to cut »), which is probably the most tedious and exacting of the various methods available to produce prints. A smooth metal plate, traditionally copper, is incised either by hand or with the help of acid. Ink is then rubbed into the incised lines and the surface of the plate is wiped clean. When the metal is covered with a slightly damp piece of paper and run through an etching press, the pressure of the rollers in the press squeezes the ink out of the plate and onto the damp paper.

In drypoint, the lines are scratched directly into the plate with a sharp tool. Since the tool acts rather like a plow, it raises a low metal furrow, or « burr, » on either side of the drypoint line. The burr traps some of the ink that is rubbed across the plate and gives drypoint engravings a characteristically soft, almost fuzzy line. (See pp. 72, 77).

In soft-ground etching a preliminary drawing is worked up on a piece of paper and is then placed over a metal plate which has been coated with a soft, acid-resistant substance called a « ground. » When the drawing is traced over with a sharp pencil, ground is pulled off the plate wherever the lines are drawn. The plate is then placed in an acid water bath that literally « eats » away the exposed lines, thus rendering it suitable for printing.

The third intaglio technique which Cassatt used is called aquatint, and is generally used to add tones or textures to a print, rather than lines. In this technique the artist uses an acid-resistant varnish to block out those areas of the metal plate which are not to be etched. He then places the plate, face up, into a box to which a small bellows has been attached. As the bellows is pumped it stirs the air inside the box and fills it with fine grains of rosin which eventually settle and leave a dusty film on the surface of the plate. When the metal is heated, each of the particles of rosin melts and forms a tiny, acid-resistant bead. The printmaker can obtain different tonal values by varying the amount of rosin he uses and by controlling the time that the plate is in the acid bath.

Cassatt described her work in a letter which she wrote to Mr. Samuel Avery of the Metropolitan Museum in 1903:

> « ... I have sent with the set of my colored etchings all of the " states " I had. I wish that I could have had more but I had to hurry on and be ready for my printer when I could get him. The printing is a great work; sometimes we worked all day (eight hours) both as hard as we could and we only printed eight or ten proofs in the day. My method is very simple. I drew an outline in drypoint and transferred this to two other plates, making in all three plates, never more, for each proof. Then I put an aquatint wherever the color was to be printed; the color was painted on the plate as it was to appear in the proof ... » *

* Breeskin notes that the intervening twelve years between the time Cassatt produced her prints and wrote her letter to Avery « ... were sufficiently long time to have caused her to forget the important role that soft-ground played in the description of the process. » See exhibition catalogue, *op. cit.*, p. 38.

The result of this considerable labor was a series of ten color prints which formed the centerpiece of the first solo show at Durand-Ruel's in April, 1891. (See pp. 57, 60, 62, 63, 65, 68). This series is justly regarded by Cassatt scholars as an artistic and technical *tour de force*, perhaps her finest single achievement. The challenge of grafting the atmospheric qualities and compositional elements of Japanese graphics onto the world of the European haute bourgeoisie has been achieved with remarkable success, thanks to Cassatt's sensitivity and consummate draftsmanship. It is doubtful whether any other artist of her time would have been capable of such an endeavor.

As if to acknowledge her debt to the art which served as the inspiration for her series of color prints, she added an amusing note by giving several of her models decidedly oriental features, a device which is especially noticeable in *The Letter* (see p. 60).

Cassatt had waited until she was 46 years old before she held her first solo exhibit. She had worked long and hard to prove herself worthy of being considered the equal of her male contemporaries, to demonstrate that gender was for all intents and purposes irrelevant when it came to matters of art. The keen edge of exhilaration and satisfaction that she ought to have felt and so much deserved was dulled, however, by an act of provincialism. A group of artists, many of whom had exhibited with Cassatt in the group shows, formed an organization called the «Société des peintres-graveurs français,» and limited their membership to native Frenchmen. This excluded the American Cassatt as well as Pissarro, who was born in the West Indies. While members of the Société held their group show in the large gallery at Durand-Ruel's, Cassatt and Pissarro simultaneously held individual exhibits of their work in smaller adjacent rooms. The week before their exhibit was to open, Pissarro wrote to his son Lucien:

> «My dear Lucien: It is absolutely necessary, while what I saw yesterday at Miss Cassatt's is still fresh in my mind, to tell you about the colored engravings she is to show at Durand-Ruel's at the same time as I. We open Saturday, the same day as the patriots,* who, between the two of us, are going to be furious when they discover right next to their exhibition a show of rare and exquisite works.»**

Although the four paintings and the series of ten color prints she exhibited received praise from Degas and a few others, sales and critical acclaim were not overwhelming, and a subsequent exhibit in New York proved equally disappointing. Cassatt had had a taste of independence, however, and was now ready to make a name for herself, not as «a pupil of M. Degas,» but as an artist in her own right.

Robert Simpson Cassatt died in December, 1891. Though he was mourned deeply his departure had no practical effect on the Cassatt household, which his daughter had ably managed since her sister and parents had arrived to stay years before.

As was her custom Cassatt found relief from sorrow in her work. Despite the relative success which she enjoyed in France she had sought for years to gain recognition in America

* Pissarro used the term sarcastically.
** Pissarro, C., *Letters to his Son Lucien*, ed. John Rewald, p. 158.

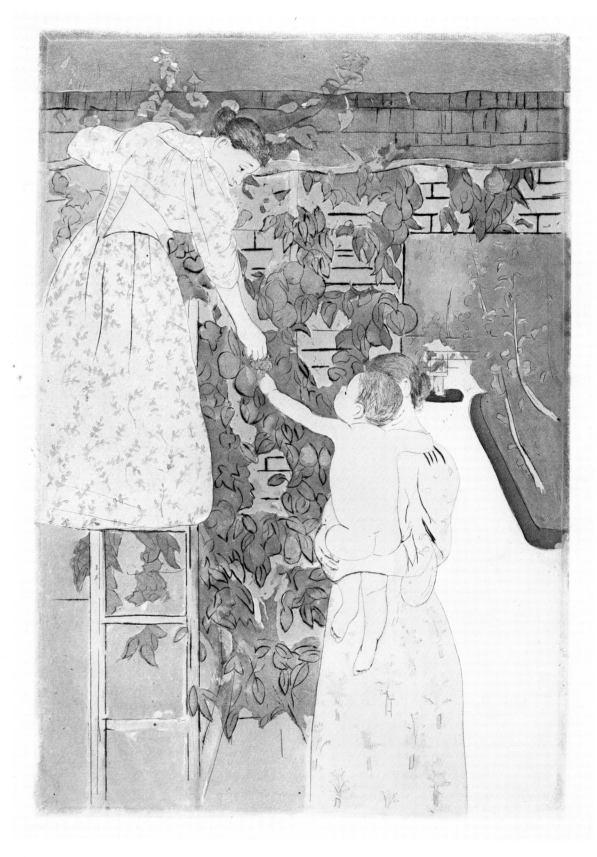

GATHERING FRUIT, c. 1893. Color print with drypoint and aquatint, 16$^{11}/_{16}$″ × 11$^{11}/_{16}$″ (42.5 × 29.7 cm)
Collection: Mrs. Adelyn D. Breeskin, Washington, D.C.

as well. It is hardly surprising, then, that she accepted a commission to execute a mural for the 1893 Chicago World's Fair when it was offered her. The scale of the mural — which was to be placed on the south tympanum of the Woman's Building — was far larger than any she had hitherto employed, and must have seemed a dramatic departure from the intricate work of the color prints upon which she had spent most of the previous year.

In recognition of their increasingly important role in modern American society, the Woman's Building was to be designed by a woman architect and decorated by woman artists. The subject of Cassatt's assignment was « Modern Woman,» while the tympanum opposite hers, to be painted by Mary Fairchild MacMonnies, was to be labeled « Primitive Woman.»

The idea of climbing up and down scaffolding in order to paint the fifty-foot expanse of canvas designed for the mural struck Cassatt as unnecessary, and she therefore arranged to have a huge trench dug in the floor of her studio. This allowed her to work at ground level and move the canvas up and down as needed. Rather than paint heroic figures in order to fill the allotted space, she designed a rather wide ornamental border and divided the composition into three panels, which she labeled *Young Women Picking the Fruits of Knowledge and Science, Young Girls Pursuing Fame,* and *Music and Dance.*

Whatever hopes and expectations she might have had about her new venture went unrealized. The mural was skied approximately forty feet from ground level so that Cassatt's slightly less than life-sized figures could hardly be appreciated. Even more disturbing to her must have been the news that the murals were either lost or destroyed when the Chicago World's Fair closed. To this day no trace of them has been found.

The Chicago experience was unpleasant enough to keep Cassatt from ever again attempting mural work, though the scale of her paintings did enlarge slightly for a time, most notably in *The Boating Party* (see back cover). One of her best known and most highly regarded canvases, *The Boating Party* was executed while Cassatt and her mother spent the summer of 1894 in the south of France, at Antibes.

Of all her works *The Boating Party* is perhaps the boldest and most imbued with its own *élan vital*. Cassatt has achieved a hitherto unsurpassed degree of success in locking together the large, flat planes of color which distinguish this work. The Van Gogh — like clash of yellow and blue and the severe foreshortening add a jarring note to what is otherwise the model of a family excursion. Although she very likely would have denied it, *The Boating Party* took Cassatt to the farthest limits of her sense of « modernity ». The forms have been reduced to their simplest components until it is quite possible to see them as abstractions.

It was Cassatt's practice to seek relief from the city's summer heat by renting a retreat in the country or near the seashore, and a considerable amount of her time each winter and spring was taken up with the business of finding suitable quarters for herself and her family. Accordingly she began to look about for a permanent summer residence, one that would be comfortable and convenient to Paris.

In 1892 she purchased Château Beaufresne, a 17th century manor house in the valley of the Oise, near Beauvais. For the rest of her life she divided most of her time between Château Beaufresne and her apartment on the Rue de Marignan in Paris.

Cassatt's relationship with Degas, meanwhile, had cooled. Even his most loyal friend had come to realize that his caustic remarks could inhibit as well as inspire. The strain was great enough to keep her from seeking his advice while she was working on the murals for the Chicago World's Fair, even though she was sorely tempted to do so. A later incident,

The Stocking, 1890. Drypoint, 10¼" × 7⁵/₁₆" (26 × 18.6 cm)
The Metropolitan Museum of Art, New York
Bequest of Mrs. H.O. Havemeyer. The H.O. Havemeyer Collection

The Bath, 1891. Drypoint, 12⁷/₁₆″ × 9³/₄″ (31.5 × 24.7 cm)
Philadelphia Museum of Art. Gift of Mrs. Binney Hare

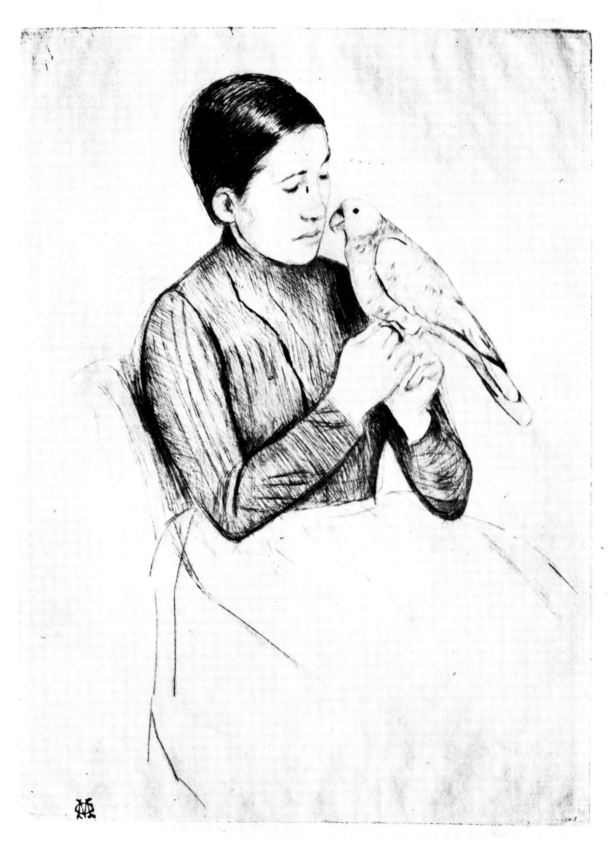

The Parrot, 1891. Drypoint, IV state, 6³/₈″ × 4¹¹/₁₆″ (16.2 × 12 cm)
The Metropolitan Museum of Art, New York. Gift of Arthur Sachs

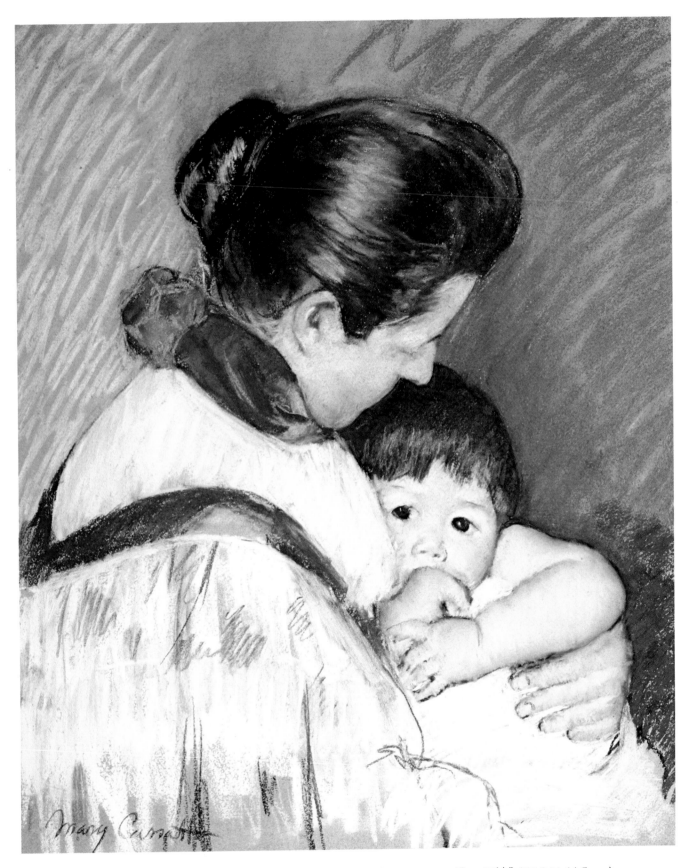

SLEEPY THOMAS SUCKING HIS THUMB, 1893. Pastel on paper, 21″ × 17½″ (53.3 × 44.5 cm)
Foundation E. G. Bührle, Zurich

in which Degas made a slighting reference to her work through a mutual acquaintance, so hurt her feelings that she stopped seeing him for years thereafter.

The early 1890's saw Cassatt at the height of her creative powers, producing outstanding and original works in rapid succession. *Maternity, With Baby Observing* (coll. Jennipher J. Gregg, Jacksonville, Florida), *Baby's First Caress* (see p. 55), *The Bath* (see p. 49), *In the Garden* (see p. 81), and *Sleepy Thomas, Sucking his Thumb* (see p. 73) all demonstrate that she had not yet exhausted the inherent possibilities of the mother-and-child theme. In *Young Women Picking Fruit* (see p. 51) and *Woman with a Red Zinnia* (see p. 50) Cassatt has depicted women of her generation who, like her, have retained the bloom of healthy vitality.

Her professional career continued to flourish, at least in France. A comprehensive individual show was held at Durand-Ruel's Paris galleries in 1893, and this time consisted of 98 works. The exhibit was successful enough for Cassatt and Durand-Ruel to agree that she was ready for her first solo show in the United States, and two years later her works were hung in Durand-Ruel's newly opened New York gallery. Once again her dream of earning recognition from her countrymen went unrealized; sales were disappointing and attendance was sparse. « I am very much disappointed that my compatriots have so little liking for my work, » she wrote to her friend Mathilda Brownell, expressing a sentiment that for her had become bitterly familiar.

Four days before Christmas, 1895, Mrs. Robert Simpson Cassatt died and was buried beside her husband in a family vault near Château Beaufresne. The heavy mantle of responsibility that Cassatt had so long worn was lifted. She was free at last to do as she pleased. Ironically, the period of her greatest productivity would coincide with the time that she had spent caring for her family. She was fifty-one years old at the time of her mother's death and would live for another thirty years, but after 1895 both her productivity and the quality of her work began to suffer. There were still occasional flashes of the brilliance which she had once demonstrated: *Portrait of a Woman with a Fan* (see p. 78), *Little Anne Sucking her Finger* (see p. 85), and her delightful *Breakfast in Bed* (see p. 84) are examples that unfortunately began to prove the exception rather than the rule.

The void that was left by her mother's death was filled to some extent by the presence of the Havemeyers, who were in Europe in 1895–96, and who no doubt helped to sustain Cassatt in her worst moments. She and Louisine Havemeyer had kept up their friendship over the years since they had first met and were now as close as sisters. The affection that she felt for her own mother is reflected in a tender and engaging pastel portrait of Mrs. Havemeyer and her daughter Electra (coll. Dr. and Mrs. Fletcher McDowell, New York); Cassatt's characteristically detached objectivity is replaced here by a warm and personal statement.

Perhaps the disappointment of her individual show in New York finally convinced her that she would have to make her contribution to the advancement of art in her seemingly indifferent native country by taking a new tack. Rather than seeking success as an artist she would use her taste and influence to help build great public collections of art in the United States. This idea was one that she had espoused before, and one in which she was no doubt encouraged by Louisine Havemeyer.

As if to re-establish old ties with her roots, she suffered the Atlantic crossing in order to visit « home » (which now meant her brothers Alexander and Gardner and their

families) in 1898, the first such visit in 28 years. Even then she was not to be spared humiliation at the hands of her countrymen. The « Philadelphia Ledger » greeted her arrival with less than passing interest:

> « Mary Cassatt, sister of Mr. Cassatt, president of the Pennsylvania Railroad, returned from Europe yesterday. She has been studying painting in France and owns the smallest Pekingese [sic] dog in the world. »

Cassatt's reaction to this slight is not recorded, but we may be sure that she had a few choice words to say about the reporter's ignorance of painting and of dogs.

After visiting her family and executing a few commissioned portraits of friends, Cassatt returned to Europe and began making plans to accompany the Havemeyers on a « shopping trip » through Italy and Spain. In 1901 she met them in Genoa and they immediately set off, with Cassatt in the lead. « Miss Cassatt had the " flair" of an old hunter, » wrote Louisine Havemeyer, « and her experience made her as patient as Job and as wise as Solomon in art matters; Mr. Havemeyer had the true energy of a collector while I — well, I had the time of my life. »

Cassatt was prescient enough to realize that Europe was still a bargain hunter's paradise, artistically speaking. If one had the knowledge, money and stamina to ferret out works by masters from various periods, some of whom were not yet in vogue, fantastic bargains could be found. During the ensuing decade she channelled much of the energy that she had devoted to her own work into her role as agent-advisor to the Havemeyers. Upon her advice they acquired an enormous collection of 19th century French art as well as works by artists such as Goya, El Greco and Titian. *

Much of the work that Cassatt produced between 1900–1922 was competent but lacked the freshness of vision and creative spark which had distinguished her earlier œuvre. Her paintings and pastels were more often than not of sweet-faced young girls, such as *Young Girl Reading* (see p. 87) or her *Sketch of Ellen Mary Cassatt* (see p. 88). There is no one explanation as to why she allowed her previously high standards to lapse. Very likely she was exhausted from the emotional strain of having lost her sister and parents within a span of less than twenty years. She and Degas saw little of each other, and she was kept busy with her work on behalf of the Havemeyers.

During much of her career Cassatt was what we would refer to today as an « artist's artist ». With a few exceptions she was not given a great deal of attention in critical reviews and her sense of propriety kept her from the public eye. This is not to say that she was not pleased and flattered by recognition, simply that she did not actively seek it.

In 1904 her growing reputation began to manifest itself in the form of various honors and awards, including, at long last, recognition from her « compatriots. » The Pennsylvania Academy awarded her the Lippincott Prize of $300 at its 73rd annual exhibition for her painting entitled *Caress* (National Collection of Fine Arts, Smithsonian Institution). True to her principles Cassatt politely declined the award, reminding the members of the Academy

* Many of these paintings were subsequently donated to the Metropolitan Museum and other public collections.

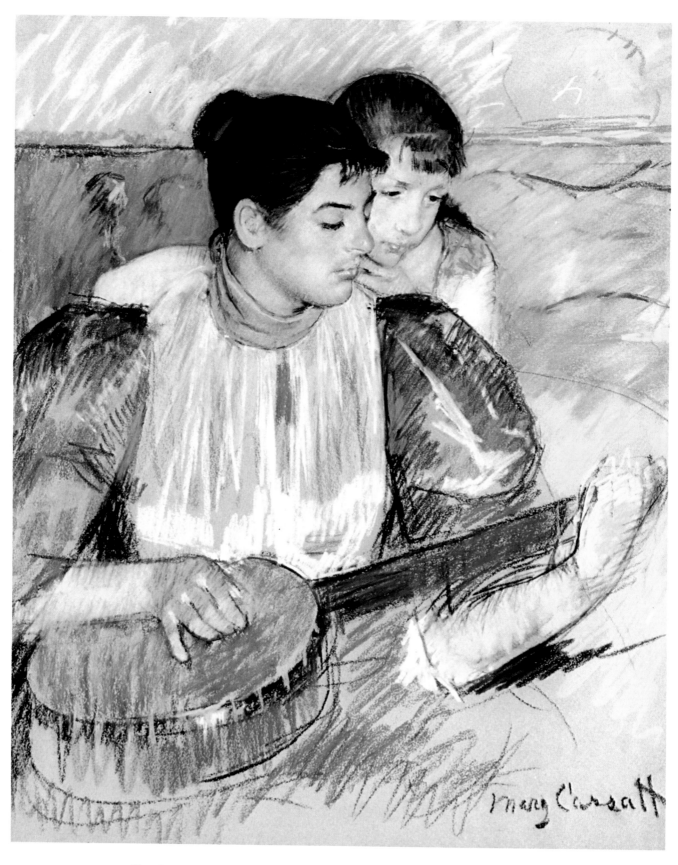

THE BANJO LESSON, 1894. Pastel on paper, 28″ × 22½″ (71 × 57.2 cm)
Virginia Museum of Fine Arts, Richmond, Virginia

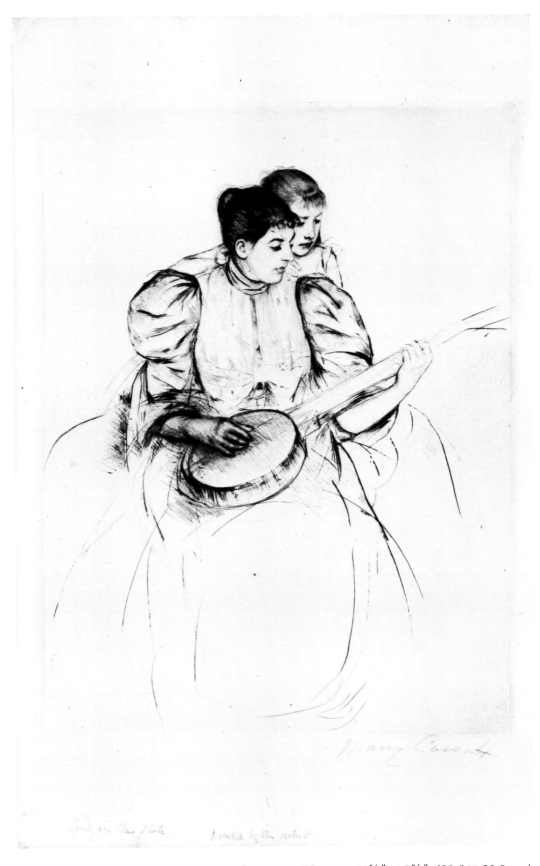

The Banjo Lesson, 1894. Drypoint and aquatint, II state, 11⅝″ × 9⅜″ (29.5 × 23.8 cm)
Minneapolis Institute of Arts. The Ladd Collection, Gift of Herschel V. Jones

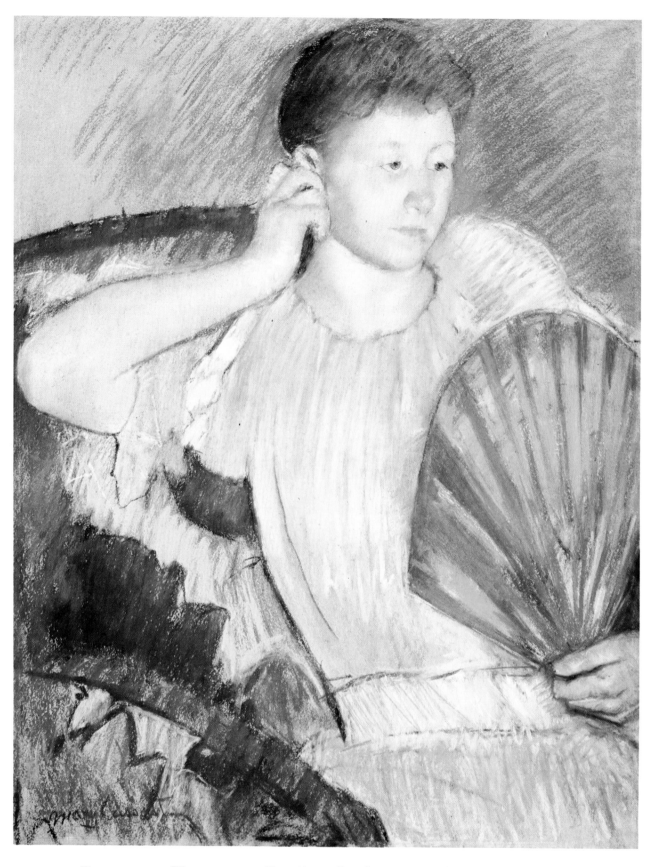

PORTRAIT OF A WOMAN WITH A FAN, 1895. Pastel on paper, 26″ × 20″ (66 × 51 cm)
Collection: Mrs. Ellen M. Schuppli, Avon, Connecticut

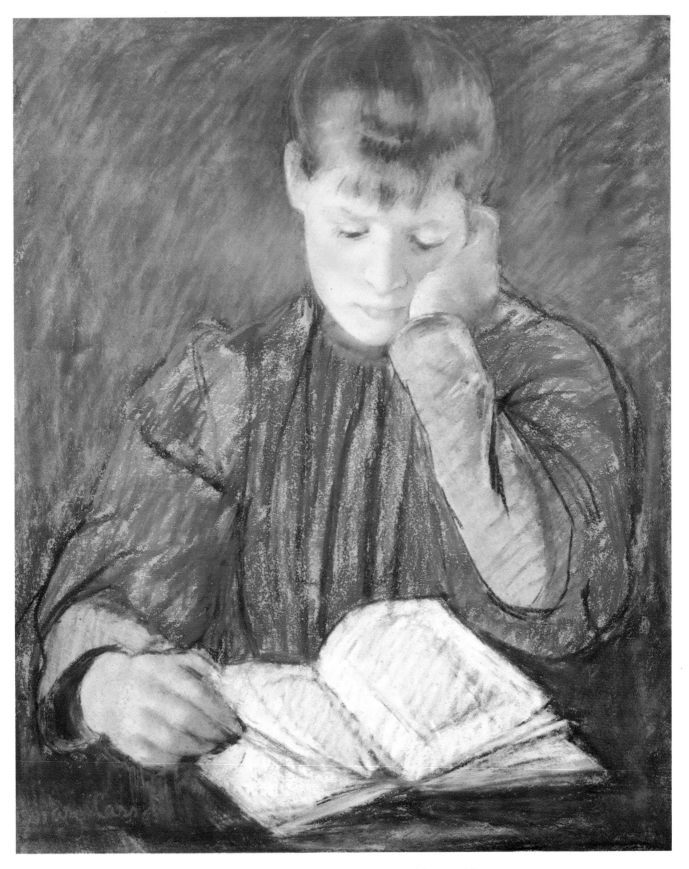

THE PENSIVE READER, c. 1894. Pastel on paper, 20⅝″ × 17¼″ (52.5 × 43.8 cm)
Collection: Mr. and Mrs. Joseph H. Hirshhorn, Washington, D.C.

of the pledge she took when she joined the Independents: « no jury, no medals, no awards.

One honor she happily accepted, however, was the *Légion d'honneur*, which was conferred upon her by the French government late in 1904.

As Cassatt entered her 60's she remained active and alert despite the toll that the passing years were taking on her, her family and friends. In December, 1906, her brother Alexander died, and one year later she was stunned to receive a cable from Louisine Havemeyer informing her of Mr. Havemeyer's death.

Only her brother Gardner remained from her immediate family, and in the fall of 1908 she made her last visit to the United States to visit him and his family. While they were together they made plans for an extensive trip across central Europe and through the eastern Mediterranean.

Two years later Gardner Cassatt and his family joined her in France and they set off on their trip. Despite her aversion to voyages by water, Cassatt agreed to climax their itinerary with a sail up the Nile in an Egyptian *dahabeah*. The trip ended in tragedy, however, as Gardner Cassatt became gravely ill and was rushed back to Paris. He died there on April 5, 1911.

Her brother's death precipitated a nervous breakdown for Cassatt, and her own ill health gradually prevented her from seeking solace in work, as she had so often done before. In 1912 she began to develop cataracts on her eyes, a condition that worsened as the years passed.

The work of her later years, such as *The Crochet Lesson* (see p. 86), was characterized by a deterioration in the draftsmanship which had once been her hallmark. Her pastels were executed with broad, slashing strokes and the colors assumed a greater and greater degree of stridency.

One cheering note during this period was the news that her *alma mater*, the Pennsylvania Academy of Art, had awarded her a Gold Medal of Honor. As the award was in recognition of her contributions to art rather than a « prize, » Cassatt accepted.

With the onset of World War I Cassatt was forced to evacuate Château Beaufresne (which was in the war zone) for the relative safety of Grasse. Even more upsetting to her was the forced separation from Mathilde Vallet, the faithful housekeeper upon whom she greatly relied.

Shortly before the end of the war she attended Degas' funeral, and subsequently wrote a description to Louisine Havemeyer:

> « Of course you have seen that Degas is no more. We buried him on Saturday, a beautiful sunshine, a little crowd of friends and admirers, all very quiet and peaceful in the midst of this dreadful upheaval of which he was barely conscious. You can well understand what a satisfaction it was to me to know that he had been well cared for and even tenderly nursed by his niece in his last days...» *

At the end of the war Cassatt was able to return to Château Beaufresne and was reunited with Mathilde. Her final years were lonely ones. She became an expatriate in time

* Cassatt herself had made these arrangements when she had heard that Degas was ill and alone.

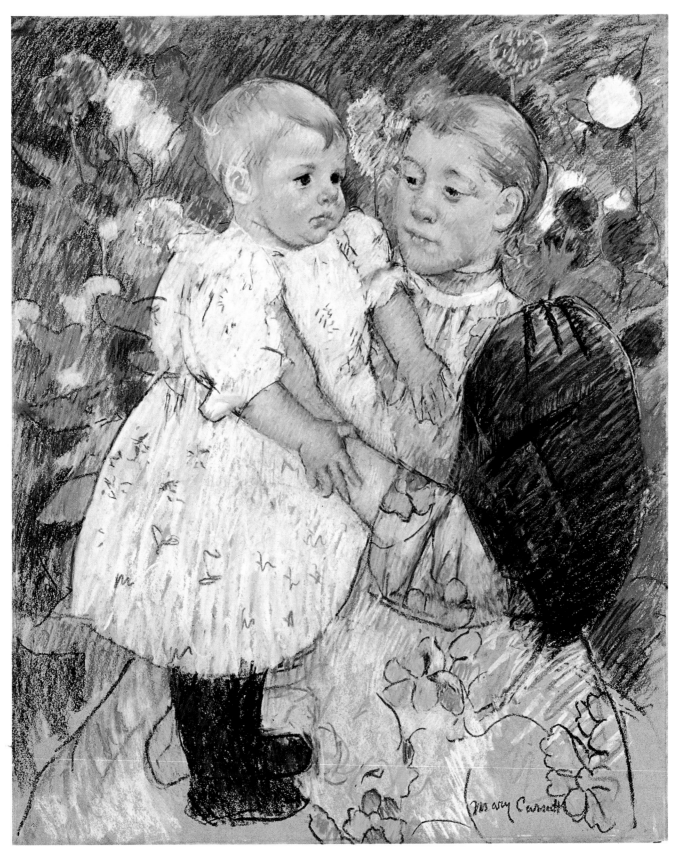

IN THE GARDEN, 1893. Pastel on paper, 28¾″ × 25⅝″ (73 × 65 cm)
Baltimore Museum of Art. The Cone Collection

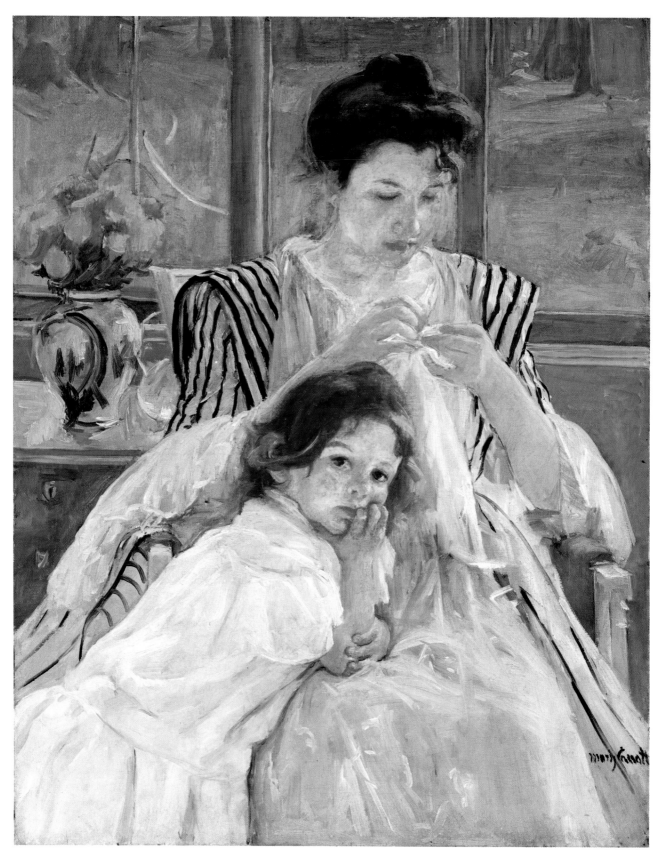

YOUNG MOTHER SEWING, 1902. Oil on canvas, 36¾″ × 29″ (92.3 × 73.7 cm)
The Metropolitan Museum of Art, New York. Bequest of Mrs. H. O. Havemeyer

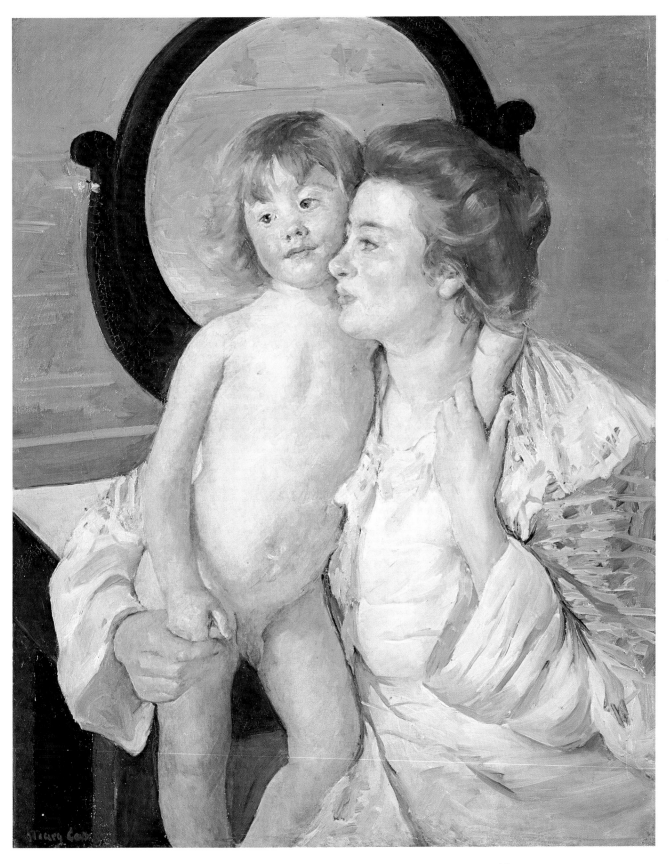

MOTHER AND BOY (THE OVAL MIRROR), 1901. Oil on canvas, 32⅛″ × 25⅞″ (81.7 × 66 cm)
The Metropolitan Museum of Art, New York. Bequest of Mrs. H.O. Havemeyer. The H.O. Havemeyer Collection

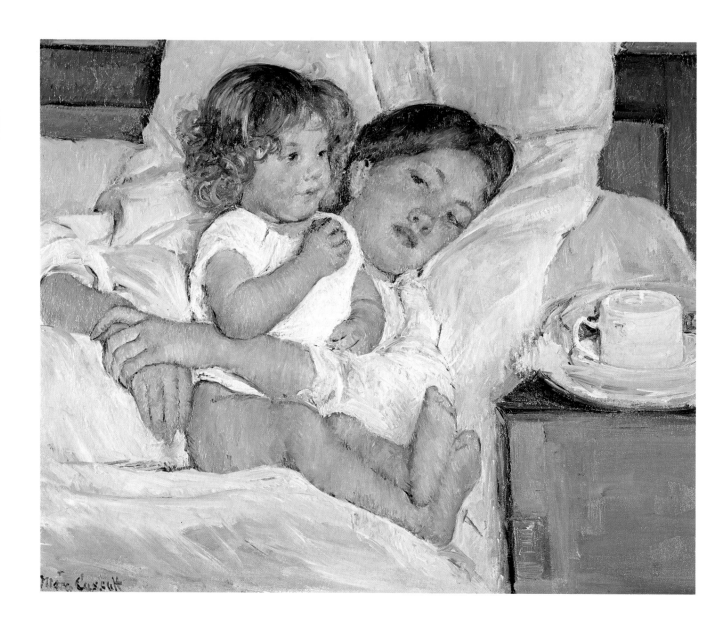

BREAKFAST IN BED, 1897. Oil on canvas, 25⅝″ × 29″ (65 × 73.6 cm)
Virginia Steele Scott Foundation, Pasadena, California

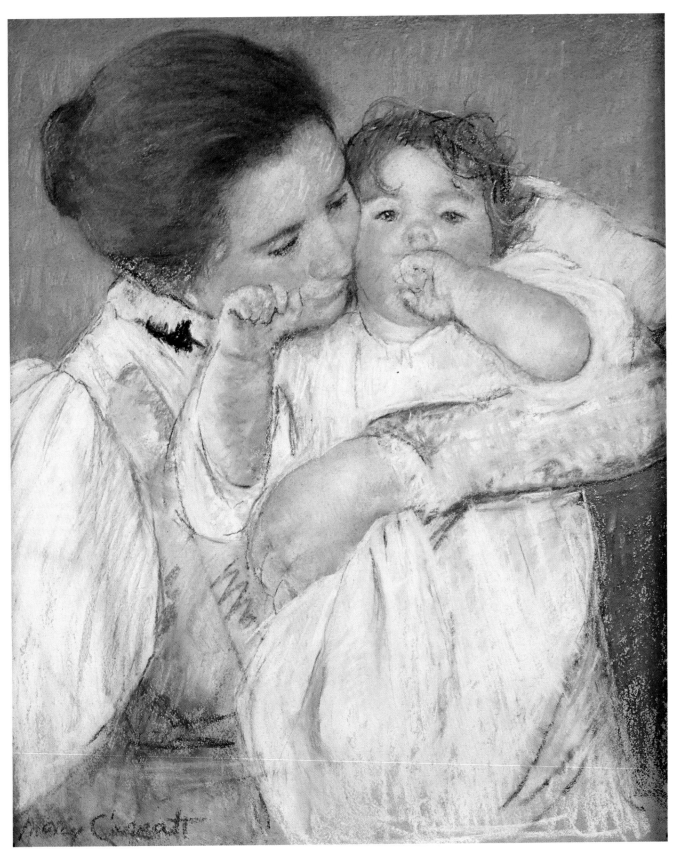

LITTLE ANN SUCKING HER FINGER, EMBRACED BY HER MOTHER, 1897
Pastel on beige paper, 21¾″ × 17″ (55.3 × 43.2 cm). Jeu de Paume Museum, Paris

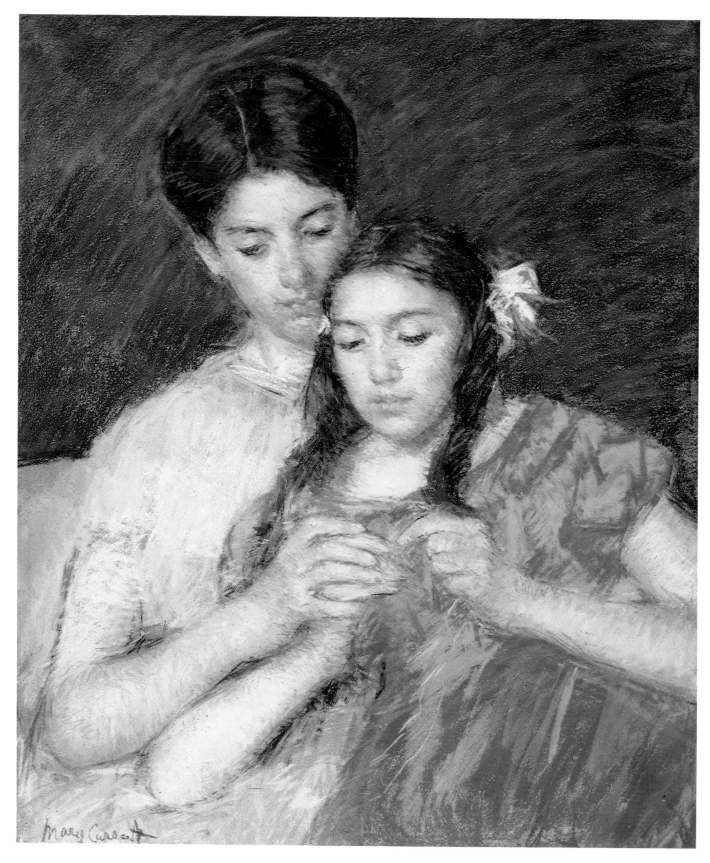

THE CROCHET LESSON, 1913. Pastel on paper, 30⅛″ × 25½″ (76.5 × 64.7 cm)
Private Collection

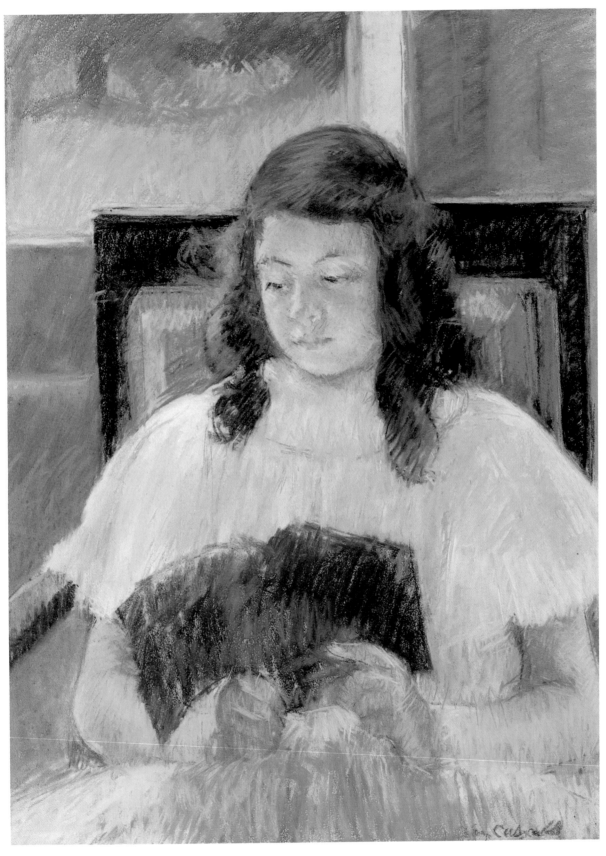

YOUNG GIRL READING, c. 1900–1910. Pastel on oatmeal paper mounted on linen, 25⅝″ × 19¾″ (65 × 50 cm)
Seattle Art Museum. Gift of Mr. and Mrs. Louis Brechemin

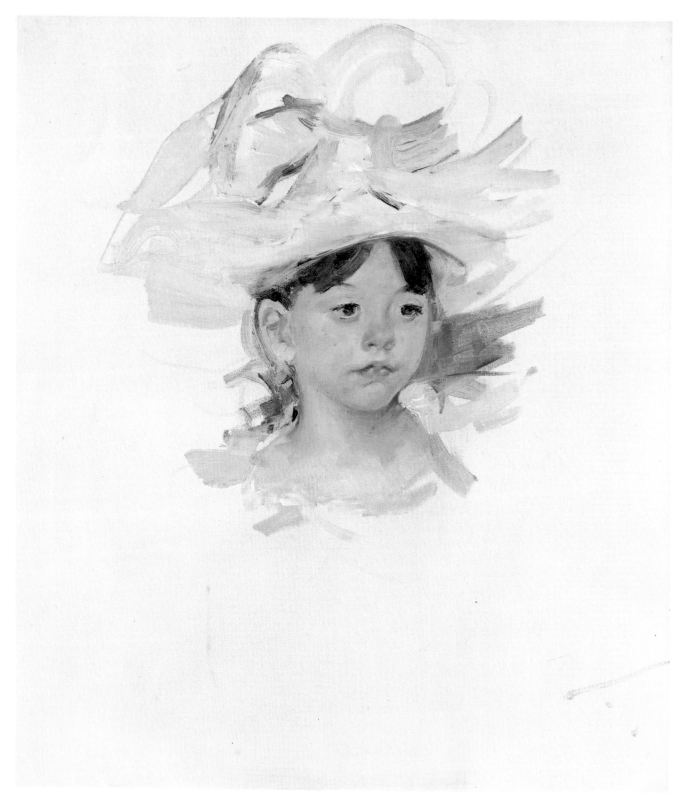

SKETCH OF «ELLEN MARY CASSATT IN A BIG BLUE HAT», c. 1905. Oil on canvas, 24″ × 22″ (61 × 56 cm)
Collection: Mrs. Percy C. Madeira Jr., Berwyn, Pennsylvania

and space, overtaken by a world for which she little cared and which she little understood; she lapsed into a routine in which one day was virtually indistinguishable from the next.

Cassatt especially enjoyed her daily outing in the Renault landaulet which she had owned since 1906, insisting that it be kept in perfect working order. «We were not allowed a breakdown,» recalled her chauffeur, Armand Delaporte, in a letter to Cassatt's biographer Frederick Sweet. Despite her blindness she was so keenly aware of direction that she severely reprimanded Delaporte one day for changing their accustomed route to St. Cloud.

Her infrequent visitors, at least those who had known her in better times, were shocked at the thin, garrulous old woman who greeted them when they came to call. One such visitor was Forbes Watson, who found Cassatt:

> «...blind and lonely, unreasonable and vituperative, still a burning force and a dominant personality, capable of a violent burst of profanity in one breath and, with the next, of launching into a plea to save the coming generation of American art students from turning into café loafers in Paris...
>
> «"When I was young it was different," she appealed in a harrowing tone, touched with regret and apology, "Our museums had no great paintings for the students to study. Now that has been corrected* and something must be done to save our young American artists from wasting themselves over there." She waved her stick vaguely in the direction of the left bank.»**

George Biddle, who first made Cassatt's acquaintance while a young art student in Paris, wrote fondly of her shortly after her death:

> «If it is possible to love a purely detached enthusiasm, then I loved this prim old Philadelphia lady. How slim and upright she would sit in her white serge jacket and lace cap, her shawl sometimes spread over her knee, as she poured tea in the apartment in the Rue de Marignan — the wheezy, chocolate-eyed griffons subsiding in a coma of indigestion about her chair. And then as she caught on fire with some idea, her eyes blazed and narrowed, her capable bony hands jerked hither and thither... As the time to depart approached I would retreat step by step to the door...»***

Mary Stevenson Cassatt died at Château Beaufresne on June 14, 1926. Although it rained on the day of her funeral there was a large turnout by the local citizenry, including a band from a nearby village. Only a few of those present to honor her remembered Cassatt

* Cassatt was no doubt alluding to her own role in pushing for great public collections of art in the United States.
** *Mary Cassatt*, Whitney Museum, New York 1932.
*** *The Arts*, vol. 10, July-December 1926.

as anything more than the generous but aristocratic old woman who took her daily drive in the familiar Renault landaulet. A handful of her old friends were able to reach the area in time for the funeral, one of them Ambroise Vollard, who wrote:

> «In the cemetery, after the last prayers, the pastor, according to Protestant custom, distributed to those present the roses and carnations strewn upon the coffin, that they might scatter them over the grave. Looking at this carpet of beautiful flowers, I fancied Mary Cassatt running to fetch a canvas and brushes.»

No doubt she would have been pleased at that idea.

<div align="right">

Jay Roudebush

</div>

PORTRAIT OF MADAME A. F. AUDE AND HER TWO DAUGHTERS, 1899
Pastel on grey paper, 21⅜″ × 31⅞″ (54.3 × 81 cm). Private collection, Paris

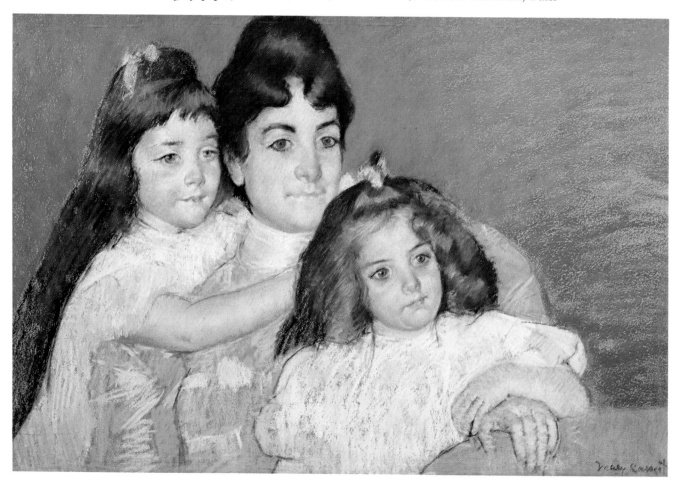

BIOGRAPHY

1844 Born May 22, in Allegheny City, Pennsylvania, fourth surviving child of Mr. and Mrs. Robert Simpson Cassatt.

1851 Family moves to Europe, settling in Paris. They remain in Paris two years.

1853–1855 Family moves to Heidelberg and Darmstadt. Brother Robbie dies and family returns to America.

1861–1865 Enrolled as a student at the Pennsylvania Academy of Fine Arts.

1866 To Paris, enrolling briefly in atelier of Charles Chaplin.

1868 First Salon acceptance with *The Mandolin Player.*

1870 Forced to return to Philadelphia by outbreak of Franco-Prussian war.

1871 To Parma, Italy, to study paintings of Correggio and Parmigianino. Also studies printmaking with Carlo Raimondi at local academy.

1872 Second Salon acceptance with *Pendant le Carnaval.*

1873 Travels to Madrid, Seville, Belgium and the Netherlands, studying Spanish, Flemish and Dutch masters. Third Salon acceptance with *Torero and Young Girl.* Settles permanently in Paris, where she meets Louisine Waldron Elder (later Mrs. Henry O. Havemeyer).

1874 First exhibition of the Impressionists. *Portrait of Madame Cortier* accepted by Salon and praised by Degas.

1877 Meets Degas and is invited to join the Impressionists. Parents and sister Lydia arrive in Paris to settle permanently.

1879 Participates in fourth Impressionist exhibition. Works with Pissarro and Degas on journal of original prints, to be called « Le Jour et La Nuit. »

1880 Participates in fifth Impressionist exhibition. Brother Alexander Cassatt and family pay extended visit.

1881 Participates in sixth Impressionist exhibition.

1882 Her sister, Lydia, dies. Joins Degas in refusing to participate in seventh Impressionist exhibition.

1886 Participates in eighth — and last — Impressionist exhibit. Duurand-Ruel organizes Impressionist show in New York.

1890 With Degas visits great exhibition of Japanese prints at Ecole des Beaux-Arts. Begins work on a series of ten color prints.

1891 First individual show at Durand-Ruel's, Paris, featuring ten color prints, two oils and two pastels. Father, Robert Simpson Cassatt, dies.

1892 Begins work on mural for Chicago World's Fair. Purchases Château Beaufresne, at Mesnil-Théribus, Oise.

1893 Major individual show at Durand-Ruel's, Paris, consisting of 98 works.

1895 Major individual show at Durand-Ruel's gallery in New York. Mother, Mrs. Robert Simpson Cassatt, dies.

1898 First visit to United States since 1870.

1901 Extended trip through Italy and Spain with Mr. and Mrs. H. O. Havemeyer, advising them on purchase of paintings.

1904 Made a *Chevalier de la Légion d'honneur* by the French government.

1906 Death of her brother, Alexander Cassatt.

1908 Last visit to United States.

1911–1912 Extended trip through Europe and Middle East with brother Gardner and family. Gardner dies after becoming ill in Egypt. Suffers nervous breakdown.

1914 Individual show at Durand-Ruel's, Paris. Awarded Gold Medal of Honor by Pennsylvania Academy. Stops work due to blindness.

1914–1918 Forced to evacuate Château Beaufresne during World War I. Degas dies in 1917.

1926 Dies at Château Beaufresne, June 14.

BIBLIOGRAPHY

BIDDLE, GEORGE, « Some Memories of Mary Cassatt,» *The Arts*, Volume 10, July-December, 1926.

BREESKIN, ADELYN D., *The Graphic Work of Mary Cassatt, A Catalogue Raisonné*, H. Bittner & Co., New York, 1948.

BREESKIN, ADELYN, D., *Mary Cassatt, A Catalogue Raisonné of the Oils, Watercolors and Drawings*, Smithsonian Institution Press, Washington D.C., 1970.

BRUENING, MARGARET, *Mary Cassatt*, Hyperion Press, New York, 1944.

BULLARD, E. JOHN, *Mary Cassatt, Oils and Pastels*, Watson-Guptill, New York, 1972.

CARSON, JULIA M. H., *Mary Cassatt*, David McKay Co., New York, 1966.

CASSATT, MARY, *Correspondence to Mrs. H. O. Havemeyer, 1900–1920*, (typescripts of original letters), National Gallery of Art, Washington D.C.

Mary Cassatt, Exhibition catalogue. Introduction by A. D. Breeskin, Foreword by J. Carter Brown, National Gallery of Art, Washington D.C., 1970.

Mary Cassatt, Pastels and Color Prints, Exhibition catalogue. Introduction by A. D. Breeskin, Foreword by Joshua C. Taylor, National Collection of Fine Arts, Smithsonian Institution Press, Washington D.C., 1978.

DEGAS, EDGAR, *Degas Letters*, edited by Marcel Guérin, Paris, 1931. Translated by Marguerite Kay, Studio Publications, New York. B. Cassier, Oxford, 1948.

The Graphic Art of Mary Cassatt, Exhibition catalogue. Introduction by A. D. Breeskin, Foreword by

Donald Kashan, The Museum of Graphic Art and Smithsonian Institution Press, New York, 1967.

HALE, NANCY, *Mary Cassatt*, Doubleday & Co., New York, 1975.

HAVEMEYER, LOUISINE W., *Sixteen to Sixty, Memoirs of a Collector*, Metropolitan Museum of Art, New York, 1930.

HAVEMEYER, LOUISINE W., « The Cassatt Exhibition,» *The Pennsylvania Museum Bulletin*, XXII, 113, May 1927.

HUYSMANS, J. K., *L'art moderne*, Paris, 1883, 1908. Reprint Gregg Int. Publishers Ldt, Farnborough, 1969.

Manet, Degas, Morisot and Cassatt, Exhibition catalogue. Introduction by A. D. Breeskin, Foreword by Lincoln Johnson, Baltimore Museum of Art, Baltimore, 1962.

PISSARRO, CAMILLE, *Letters to his Son Lucien*, edited by John Rewald, translated by Lionel Abel. Pantheon Books, New York, 1943.

REWALD, JOHN, *The History of Impressionism*, 4th rev. ed., New York, 1973.

SEGARD, ACHILLE, *Un peintre des enfants et des mères, Mary Cassatt*, P.P. Ollendorf, Paris, 1913.

SWEET, FREDERICK A., *Miss Mary Cassatt, Impressionist from Pennsylvania*, University of Oklahoma Press, Norman, 1966.

VOLLARD, AMBROISE, *Souvenirs d'un marchand de tableaux de Meissonnier à Picasso*, Paris. *Recollections of a Picture Dealer*, Constable, London, 1936.

WATSON, FORBES, *Mary Cassatt*, Whitney Museum, New York, 1932.

ILLUSTRATIONS



We wish to thank Mrs. Adelyn Breeskin, the owners of the pictures by Mary Cassatt reproduced in this book, as well as those collectors who did not wish to have their names mentioned:

MUSEUMS

FRANCE

Bibliothèque Nationale, Paris – Louvre Museum, Paris – Museum of the Petit-Palais, Paris.

UNITED KINGDOM

Glasgow Art Gallery.

U.S.A.

Baltimore Museum of Art – The Museum of Fine Arts, Boston – The Art Institute of Chicago – The Flint Museum of Arts, Michigan – The Nelson Atkins Museum, Kansas City – The Los Angeles County Museum of Art – The Norton Simon Foundation, Los Angeles – The Metropolitan Museum of Art, New York – The Minneapolis Institute of Arts – The New Britain Museum of American Art, Connecticut – The Chrysler Museum at Norfolk, Virginia – The Philadelphia Museum of Art – Museum of Art, Carnegie Institute, Pittsburgh – The Virginia Museum of Fine Arts, Richmond, Virginia – The Seattle Art Museum – St. Louis Art Museum – The Corcoran Gallery of Art, Washington, D.C. – The National Gallery of Art, Washington, D.C. – National Portrait Gallery, Smithsonian Institution, Washington, D.C. – The Wichita Art Museum, Kansas – The Sterling and Francine Clark Art Institute, Williamstown, Massachusetts – The Worcester Art Museum, Massachusetts.

PRIVATE COLLECTIONS

Mrs. Adelyn D. Breeskin, Washington, D.C. – E. G. Bührle Foundation, Zurich – Nathan Cummings, New York – Mr. and Mrs. Joseph H. Hirshhorn, Washington, D.C. – Mrs. Percy C. Madeira Jr., Berwyn, Pennsylvania – Mr. and Mrs. Paul Mellon, Upperville, Virginia – Everett D. Reese, Columbus, Ohio – Mrs. Ellen M. Schuppli, Avon, Connecticut – The Virginia Steele Scott Foundation, Pasadena, California.

PHOTOGRAPHS

E. Irving Blomstrann, New Britain, Conn. – Will Brown, Philadelphia – Bulloz, Paris – Walter Dräyer, Zurich – Studio Lourmel, Paris – Otto E. Nelson, New York – Eric Pollitzer, New York – Service de Documentation Photographique de la Réunion des Musées Nationaux, Paris – Elton Schnellbacher, Pittsburgh – John Tennant, Mt. Airy, Maryland – Frank J. Thomas, Los Angeles – A. J. Wyatt, Philadelphia.

Chemistry
A Laboratory Guide

About K12 Inc.

Founded in 1999, K12 Inc. is an elementary and secondary school service that combines rich academic content with powerful technology. K12 serves students in both public and private educational settings, including school classrooms, virtual charter schools, home schools, and tutoring centers. K12 provides comprehensive curricular offerings in the following subjects: Language Arts/English, History, Math, Science, Visual Arts, and Music. The K12 curriculum blends high quality offline materials with innovative online resources, including interactive lessons, teacher guides, and tools for planning and assessment. For more information, call 1-888-YOUR K12 or visit www.K12.com.

Book Staff and Contributors

Daniel Franck
Senior Content Specialist

Suzanne Montazer
Art Director

Julie Jankowski
Print Designer

Christopher Yates
Cover Designer

Jennifer Davis
Illustrations Editor

Patrick Keeney
Instructional Designer

Jeff Pitcher
Instructional Designer

Elia Ben-Ari
Text Editor

Mary Beck Desmond
Text Editor

Colette Corbin
Lab Tester

Alexandra E. Haase
Project Manager

Bror Saxberg
Chief Learning Officer

John Holdren
Senior Vice President for Content and Curriculum

Maria Szalay
Senior Vice President for Product Development

Tom DiGiovanni
Senior Director, Product Development

Kim Barcas
Creative Director

Jeff Burridge
Managing Editor

Sally Russell
Senior Manager, Media

Chris Frescholtz
Senior Project Manager, High School

Corey Maender
Program Manager, High School

Lisa Dimaio Iekel
Production Manager

John G. Agnone
Director of Publications

Illustration Credits

All illustrations © K12 Inc. unless otherwise noted

All photos © Scott Robinson/K12 Inc. unless otherwise noted

Cover: photo montage (fireworks) © Scott Cooley Photography/iStockphoto.com; (smelting) © Mikhail Olykainen/BigStockPhoto.com; (chemistry) © mrloz/iStockphoto.com

Contents: iii (chrome wheel) © Richard Hoffkins/Dreamstime.com; (ingredients) © Maxexphoto/Dreamstime.com; (fish pond) © Hillel Katzowicz/BigStockPhoto.com; (archaeological site) © Javier Trueba/Madrid Scientific Films/Photo Researchers, Inc.

Lab 1: (grass) © Jill Chen/iStockphoto.com

Lab 2: (fire) © Greg Nicholas/iStockphoto.com

Lab 3: (chrome wheel) © Richard Hoffkins/Dreamstime.com

Lab 4: (salt flats) © James Hooker/Dreamstime.com

Lab 5: (salt crystals) © Sylwia Horosz/Dreamstime.com

Lab 6: (ingredients) © Maxexphoto/Dreamstime.com

Lab 7: (hot-air balloon) © Hemera Technologies/Photos.com/Jupiterimages

Lab 8: (bucket of crabs) © Kheng Guan Toh/BigStockPhoto.com

Lab 9: (fish pond) © Hillel Katzowicz/BigStockPhoto.com; (hydrogen ion concentration map) © National Atmospheric Deposition Program/National Trends Network

Lab 10: (thermograph of coffee cup) © Nutscode/T Service/Photo Researchers, Inc.

Lab 11: (bread) © Magda Urawska/BigStockPhoto.com

Lab 12: (copper pots) © Joe Gough/BigStockPhoto.com

Lab 14: (archaeological site) © Javier Trueba/Madrid Scientific Films/Photo Researchers, Inc.

Contents

How to Use This Book

Lab 7

Gas Laws

If you lived during the time of Robert Boyle or Joseph Guy-Lussac, you might know that gases exist but you would have no idea what they are made of. So, what is the first thing you would study? You would study how gases behave and hope that your findings lead to an understanding of what a gas is. You would try to figure out the relationship between gas and temperature, for example, and see how the gas-temperature relationships vary between different kinds of gases. The result would be a series of laws that describe gases—and that is exactly what happened historically.

The gas laws were all discovered before the concept of atoms and molecules became established. The gas laws explain the relationship between the volume, temperature, and pressure of a gas. We know now that the gas laws can be explained by the kinetic theory of gases—that gases are made of molecules that move at rates that are dependent on the temperature and pressure of the gas, and that changes in the temperature, pressure, and volume of a sample of gas are all interrelated.

OBJECTIVES

- Determine how a change in temperature affects the volume of a gas.
- Determine values for quantities such as temperature, pressure, and volume for a gas liberated in a chemical reaction.

Question

How does a change in temperature affect the volume of a gas? How can you determine the temperature, pressure, and volume of gas liberated in a chemical reaction?

Observe

Balloons are wonderful gas containers that you can use to study gases. You know more about balloons than you think. What happens when hot air fills a balloon? The balloon expands. From your experience, what happens as a balloon is rapidly cooled?

How does heating the gas that fills a hot-air balloon affect the volume of that gas?

Lab 7 Gas Laws **25**

Observations lead to a hypothesis, which will be tested in an effort to answer the scientific question posed for each lab.

EXPERIMENT

Air is a mixture of gases, mostly nitrogen and oxygen. In this experiment, you will heat a balloon that has air in it and note any changes in volume. Then you will cool a balloon that has air in it and note any changes in volume.

Part 1 Heating a Balloon

Setup

1. Collect materials together in the place where you will perform the lab.

2. Create a data table with the following columns: Circumference of Balloon (cm); Circumference of Balloon After Heating (cm).

Procedure

1. Blow up a balloon to a size that it is roughly the size of your hand or slightly larger. Tie a knot in the end of the balloon.

2. Measure the circumference of the balloon. Place dots at 2 cm intervals around the balloon's circumference so that you can repeat the circumference measurement later.

MATERIALS

Heating a Balloon

roughly spherical balloon

black permanent marker

metric measuring tape

paper towels

common kitchen bowl large enough to hold an expanded balloon

tap water in a quantity to half fill the bowl

Materials needed to do the lab are clearly identified.

Step-by-step instructions show how to proceed, from preparing for the lab, through the experimental procedure to be followed, to analyzing results of the experiment.

Welcome to *Chemistry: A Laboratory Guide*

Chemistry is the study of matter. All that you see around you is made of matter. The wood of trees, the soil, water, a plastic bottle, a fleece sweater—all are forms of matter. Some of the things around you that you can't see, such as the gases that make up air, are also forms of matter. Using this laboratory manual, you will have a chance to study matter in a series of hands-on experiments.

One common element of every scientific discovery is the need to follow a certain procedure from start to finish. Every scientist uses a protocol or set of steps to figure out how to do an experiment, and to demonstrate to others that the experiment can be reproduced with reliable results. This lab manual takes you from the first to last step of all your experiments in chemistry. The procedure, and the materials required for you to follow it, are included in the instructions for conducting each experiment.

In each lab, you will make observations and consider your experience to try to answer a question. Once you have an idea about the answer, you will test it by performing an experiment to answer the question. You will find that every lab in this guide is a hands-on experience. In each experiment, you will collect materials and set up the equipment. Then you will perform the experiment and collect data for analysis.

A Note About Safety

Safety is the primary concern in any chemistry laboratory—from a complex multimillion dollar industrial lab to the one in your own kitchen. By following the safety procedures outlined in this book, you will have a safe learning experience while using this manual.

Many of the labs in this book are of a type called *microchemistry*. In microchemistry, people use small quantities of reactants and generate small quantities of products. Instead of racks of test tubes and large amounts of reactants and solutions, microchemistry employs smaller amounts of chemicals—often just a few drops. The reactions are the same as with larger quantities, but the experiments are decidedly safer.

The amounts of chemical used are very small, often much smaller than the allowable amounts for environmentally safe disposal. Nevertheless, be sure to follow all disposal instructions as written. When disposing of these small amounts down a drain, be sure to flush well with water. Clean all equipment used in the lab thoroughly with soap and water immediately after use, and always use clean equipment for the labs.

Safety Note Before beginning any lab, check the safety in the lab information on page 59 and the chemical warnings on pages 61–65.

Paper Chromatography

Research on chlorophyll, the green pigment in plants, led to the invention of chromatography.

A chemist often must separate a mixture into its component parts. If the mixture is a homogeneous one, the chemist will employ special procedures to separate the components. Many techniques for separating the parts of a mixture, including fractional distillation and various kinds of chromatography, can be used to separate mixtures that seem inseparable. Today you will tackle *paper chromatography.* In paper chromatography, the components of a mixture move up a column of paper as they are carried along by a mobile solvent. Some components of the mixture will move more rapidly up the paper than others. If the chemist stops the chromatography at the correct time, all the components of the mixture will be separated and will appear at different places along the paper.

The Russian botanist Mikhail Semyonovich Tsvet invented the first chromatography technique in 1900 while doing research on chlorophyll, a green pigment found in plants. In 1907 he demonstrated his chromatograph for the German Botanical Society. It so happens that Mikhail's surname, *tsvet,* means "color" in Russian, so his naming the procedure *chromatography* (literally "color writing") ensured that he, a commoner in Tsarist Russia, would be remembered.

Question

Using paper chromatography, how can you separate a homogeneous mixture into its component chemicals?

Observe

You can tell from experience in any kitchen that paper towels absorb liquids well. You can observe the liquid moving along the paper. Some types of paper are more effective than others at absorbing the liquid, and some liquids are absorbed faster and more efficiently than others. How might you apply those observations of how liquids are absorbed onto a substance to separating the components of a mixture?

Hypothesize

Write a hypothesis, based on your observations, that describes how the absorption of liquids onto paper might lead to the separation of parts of a mixture. Write your hypothesis as an "if-then" statement: "If a, then b."

In this experiment, you will observe how a mixture separates into its components during paper chromatography. First, you will use a simple apparatus that will show how different types of ink migrate up a piece of chromatography paper, carried along by a solvent. Then, you will use your laboratory materials to separate mixtures of various inks in various solvents. (Note: The materials for each part of this lab are listed separately.)

Procedure

Part 1 Observing Movement

1. With scissors, cut two strips of filter paper in half lengthwise so that each strip is about 1.2 cm wide and 10 cm long. You will need three strips in all.

2. Using the black marker, mark one filter-paper strip with a thick 0.5 cm diameter dot of black ink approximately 2 cm from one end of the strip.

3. Tape the other end of the strip to the center of the wooden dowel so that the strip will hang down when the dowel is held horizontally.

4. Repeat Steps 1–3, adding to the dowel a strip with a red dot and a strip with a green dot comparable to the first strip. Space the strips along the dowel approximately 10 cm apart.

5. Pour the denatured alcohol into the three beakers to a depth of about 1 cm.

6. Place the wooden dowel across the three beakers so that each strip of filter paper extends down into the cup and touches the surface of the alcohol without the dots entering the alcohol.

7. Cover the top of each beaker securely with the plastic wrap.

8. Allow the beakers to sit for 20 minutes.

9. Observe what happens on the filter-paper strips and record your results with drawings and written descriptions. The drawings and written descriptions will be part of your lab report.

Mark one filter-paper strip with a thick 0.5 cm diameter dot of black ink, as shown here.

Setup for Part I showing placement of dowel and filter-paper strip across a beaker

MATERIALS

Observing Movement

2.5 cm x 10 cm filter-paper strips – 2

metric ruler, 15 cm long

clear plastic adhesive tape

wooden dowel, 15 cm long by 0.5 cm in diameter

100 mL beakers – 3

approximately 30 mL denatured alcohol

clear plastic wrap

black permanent marker

red permanent marker

green permanent marker

scissors

Part 2 Exploring Chromatography

1 Cut six strips of filter paper in half lengthwise so that each strip is about 1.2 cm wide and 10 cm long. You will need 12 strips in all.

2 Set out two microplates. (Note: See Use and Care of the Microplate in Lab 2, page 7.) Place one strip of filter paper on the microplate, one each for rows 1–6 of each microplate. Place each filter-paper strip so that it touches the bottom of the well, and bend the strip at right angles to the length of the paper, as shown in the photo on the next page.

3 Remove the strips from the microplates for the moment.

4 Using the black marker, place a dot approximately 0.5 cm in diameter in the middle of the crease of four filter-paper strips. Do the same with red ink and green ink.

Note the movement of the colors in the ink for each of the dots.

5 Use the pipettes to fill the microplate wells indicated in Table 1 below with the substances or mixtures listed in the table. Use a separate pipette for each substance. These substances or mixtures are the solvents.

TABLE 1 Placement of Solvents in Microplates

Microplate	Ink Color	Microplate Well Number	Solvent
1	Black	1A	$\frac{1}{2}$ pipette water, $\frac{1}{2}$ pipette alcohol
1	Black	2A	1 pipette vegetable oil
1	Black	3A	1 pipette alcohol
1	Black	4A	1 pipette water
1	Red	5A	$\frac{1}{2}$ pipette water, $\frac{1}{2}$ pipette alcohol
1	Red	6A	1 pipette vegetable oil
2	Red	1A	1 pipette alcohol
2	Red	2A	1 pipette water
2	Blue	3A	$\frac{1}{2}$ pipette water, $\frac{1}{2}$ pipette alcohol
2	Blue	4A	1 pipette vegetable oil
2	Blue	5A	1 pipette alcohol
2	Blue	6A	1 pipette water

For Part 2, place the filter-paper strips in the microplate wells as shown here.

6 With a pencil, label each of the strips at the end opposite the dot: "WA" for the mixture of water and alcohol, "W" for water alone, "VO" for vegetable oil, and "A" for alcohol.

7 Mark the dot on the paper again to ensure that it is fresh.

8 Place strips into the corresponding wells (the "W" strip into the well with water only, for example). Lay the strips back along the tray and secure the entire assembly in the heavy plastic bag.

9 Observe what is happening on each strip and record your results by both drawing and writing. After you note that the solvents have moved almost the entire length of the papers, remove the plastic bag and the paper strips.

10 After all the dots have separated into different colors, measure the distance that each color migrated from the starting spot. Create a data table showing each color and each solvent and use the table to compare and contrast the movements of different colors.

11 Clean the apparatus.

Analyze

Read each question below carefully and answer each question thoroughly. It is better to show too much work than too little.

1. What changes in the appearance of the filter paper did you observe in Part 1 of the procedure?

2. What changes in the appearance of the filter paper did you observe in Part 2 of the procedure?

3. Which solvent caused the ink from the dots to move the most? Which solvent caused the ink from the dots to move the least?

4. What differences did you observe in how the different colored inks were separated?

5. What observations would lead you to believe that the ink is actually a mixture?

6. You are given an unknown type of clothing dye. How could you use the procedures in this lab to see if this dye is a mixture?

Properties of Substances

Substances can undergo physical and chemical changes. In a physical change, a substance is not changed chemically in any way. For example, if water boils, it will change state from liquid to gas, but its chemical makeup remains unchanged. If you mix vinegar and baking soda, a chemical change occurs. The ethanoic acid in vinegar reacts with the baking soda. Carbon dioxide gas is released. Those are chemical changes; that is, the change results in a change in the arrangement of atoms in the substances that are combined.

Knowledge of physical and chemical changes to substances is not just for the modern chemist. In the fifteenth century, *apothecaries* dispensed medical materials. Apothecaries sold simple chemical and herbal remedies, and even practiced simple medicine at a time when medicine was much different from what it is today. British writer Jonathan Keats, controversial seer Nostradamus, and famous turncoat Benedict Arnold were all apothecaries. And they all needed to understand the properties of substances, the nature of mixtures, and the differences between a physical and chemical change.

Question

What changes occur when chemicals are mixed, and which changes signal that a physical or chemical reaction has occurred?

Observe

From earliest times, humans observed that mixing substances sometimes resulted in changes to the substances. Some changes involved physical changes, such as altering the shape of a substance or its state. Other changes involved a chemical transformation of the original substances, and the release of heat and light as fire. What changes do you see in everyday life that result in heat being released or absorbed?

Hypothesize

Look at the substances in the materials list. Make an educated guess about what physical or chemical changes might occur when some of them are mixed. Write your hypothesis as an if-then statement such as, "If I mix water and chalk powder, then the chalk will dissolve but no chemical change will take place."

Is fire the result of a physical change or a chemical change?

EXPERIMENT

In this experiment, you will mix substances in individual wells of a microplate. Then, in each mixture you will observe changes that occur to the reactants. Finally, after allowing the liquid to evaporate, you will observe the product that is left behind and the changes, if any, that occurred to that substance. Put simply, for each well you will mix, observe, evaporate, and observe.

Use and Care of the Microplate

The microplate is the small-scale apparatus in which you will mix substances and observe results. It consists of 24 small holes, or *wells*. Each well is uniquely identified by its *address*, which is the column number and row letter in which it can be found. In the example below, the well being identified is in column 2 and row B. You would refer to this well as "well 2B." Your microplate takes the place of larger, more awkward test tubes, and is representative of how chemistry is done today in large laboratories.

You will need your microplates to be clean and usable for several experiments. After each experiment, the contents of the microplate should be flushed down a sink with generous amounts of water, or disposed of in other ways as directed. The microplate itself should then be washed out with a small amount of detergent, rinsed thoroughly with tap water, and dried. **Do not** put the microplate in an automatic dishwasher.

Each well in the microplate is uniquely identified by its address.

Setup

1. Create a data table with the following columns: Well, Observations. Title the table "Observations of Mixtures Immediately After Mixing." Leave enough room in the observations column to write up to two sentences about what you have seen.

2. Create a second data table with the following columns: Well, Observations. Title the table "Observations of Mixtures After Evaporation." Leave enough room in the observations column to write up to two sentences about what you have seen.

Part 1 Observations Upon Mixing

1. Crush one piece of chalk into a fine powder using the mortar and pestle.

2. Using the scoopula, fill well 1A of the microplate approximately one-fourth of the way with chalk. Using a pipette, slowly add 25 drops of distilled water to the chalk. Stir with a toothpick.

Crush one piece of chalk into a fine powder using the mortar and pestle.

24-well microplate

plastic microtip pipettes – 5

1 stick of chalk (CaCO₃)

mortar and pestle

approximately 10 g table salt (NaCl)

approximately 10 g potassium chloride (KCl)

approximately 10 g baking soda

approximately 10 g sugar

approximately 10 mL of 0.1 *M* NaOH solution

approximately 10 mL of 3 *M* citric acid solution

approximately 10 mL plain white vinegar

approximately 10 mL distilled water

approximately 10 mL vegetable oil

toothpicks – 24

hand lens

scoopula

household fan (optional)

continues on next page

Use the scoopula to put the chalk and other solids into the microplate wells.

The release of gas as shown here may be a sign of a chemical reaction.

③ Use your hand lens to examine what happens in the well.

④ In a sentence or two, record your observations in the data table that you created titled "Observations of Mixtures Immediately After Mixing."

⑤ Repeat Steps 1–4 in well 1B, using powdered chalk and 25 drops of citric acid solution. Use a clean pipette to add the citric acid solution. Stir with a clean toothpick.

⑥ Continue to repeat the mixing procedure, using the grid in Table 1 below as a guide to which wells to use to mix the various substances. For each solid, fill the well one-fourth of the way; for each liquid, use a pipette to add 25 drops to the well. Use a different pipette for each liquid and stir each mixture with a clean toothpick.

⑦ After you have created the mixtures, observed, and recorded your observations for all 24 mixtures, move on to Part 2.

TABLE 1 Guide to Mixing Chemical Ingredients

		1	2	3	4	5	6
		Chalk	NaCl	KCl	Baking Soda	Sugar	Vinegar
A	Distilled Water						
B	3 *M* Citric Acid						
C	Vegetable Oil						
D	0.1 *M* NaOH						

Part 2 Observations After Evaporation

1 Place the plate in a well-ventilated place where it will be undisturbed. Gentle air flowing over the microplate will help speed up evaporation. Use a fan if possible.

2 Allow enough time for the liquids to evaporate.

3 After the liquids evaporate, study each well with your hand lens.

4 In the data table "Observations of Mixtures After Evaporation," record your observations of the dry samples that are left behind. Consider such factors as change in crystal appearance.

5 Dispose of the samples as directed in the Setup for this lab. You may wash them down the drain with sufficient water.

Use your hand lens to examine what happens in each well.

Analyze

Answer each of the following thoroughly.

1. Go back to your observations tables and underline all observed changes that you noted that you think were physical changes.

2. Go back to your observations tables and either circle or highlight all observed changes that you think were chemical changes.

3. In considering your observations of the mixtures, look for similar patterns of behavior. Which pairs of substances produced almost the same results in each mixture that they were found in?

Reaction of Metals

OBJECTIVES

- Observe physical and chemical properties of transition metal ions in solution.

- Observe the results of mixing ammonia and hydrochloric acid with metal ions.

- Compare the reactions of transition metal ions with those of other metal ions.

Metals are substances that most people are familiar with, perhaps more than you even know. While you may agree that you see and use metals every day as utensils, tools, building materials, and shiny coatings, it might surprise you to know that metals dissolved in solutions are also extremely useful. For example, in solution, metals produce a wide spectrum of colors that are used in paints and pigments. In this lab, you will explore the basics of how metals in an aqueous solution react when mixed with other compounds.

Question

How do different metals act in solution and react with other compounds?

Observe

A quick look at the periodic table shows that there is a difference between metals and nonmetals. Find the transition metals in Groups 3–12. That large group contains some of the most useful and well-known elements. Pick a few of the transition metals that you know of, such as iron, and a few metals that are not transition metals, such as calcium in Group 2. What do you know about common uses of these metals? Examine the metals in Group 1, and also locate other metals beyond those in Group 12.

Hypothesize

Use your knowledge of the periodic table to write a hypothesis that describes how a transition metal might behave differently from a nontransition metal. Write your hypothesis as an if-then statement.

You see metals such as the chrome on this wheel every day.

This experiment involves mixing compounds that contain metals with solutions that contain ammonium hydroxide (a base) and hydrochloric acid (an acid). You will add the reactants to wells in the two microplates, stir with a toothpick, and observe the results. The critical work involves observing and comparing the reactions, looking at the periodic table, and trying to deduce some important facts about the reactivity of some metals.

Setup

Create a data table similar to the one below. Title the table "Observations After Mixing the Reactants."

TABLE 1 Observations After Mixing the Reactants

Microplate 1				
	1 KNO_3	**2** $Ca(NO_3)_2$	**3** NH_4VO_3	**4** $MnSO_4$
A (NH_4OH)				
B (HCl)				
C (Control)	KNO_3	$Ca(NO_3)_2$	NH_4VO_3	$MnSO_4$

Microplate 2				
	1 $Fe(NO_3)_3$	**2** $Co(NO_3)_2$	**3** $Cu(NO_3)_2$	**4** $Zn(NO_3)_2$
A (NH_4OH)				
B (HCl)				
C (Control)	$Fe(NO_3)_3$	$Co(NO_3)_2$	$Cu(NO_3)_2$	$Zn(NO_3)_2$

Procedure

1 Place 10 drops of KNO_3 in wells 1A, 1B, and 1C of microplate 1, as shown in the table above. Place 10 drops of $Ca(NO_3)_2$ in wells 2A, 2B, and 2C.

2 Continue this pattern of placing 10 drops in three wells for each of the compounds listed in the table.

3 Add 10 drops of NH_4OH to each well in row A of each microplate. In each case, mix thoroughly with a new, dry toothpick.

4 Add 10 drops of HCl to each well in row B. In each case, mix thoroughly with a new, dry toothpick.

continues on next page

24-well microplate – 2

goggles

gloves

toothpicks – 24

approximately 5 mL of 0.1 *M* solutions of the following chemicals:

potassium nitrate (KNO_3)

calcium nitrate ($Ca(NO_3)_2$)

ammonium vanadate (NH_4VO_3)

manganese sulfate ($MnSO_4$)

cobalt nitrate ($Co(NO_3)_2$)

iron nitrate ($Fe(NO_3)_3$)

copper nitrate ($Cu(NO_3)_2$)

zinc nitrate ($Zn(NO_3)_2$)

approximately 10 mL of 1.0 *M* ammonium hydroxide (NH_4OH)

approximately 10 mL of 3.0 *M* hydrochloric acid (HCl)

hand lens

5 Continue this pattern of placing 10 drops in the wells as shown in the table. Do not add anything to the control wells.

6 Observe the controls. Record your descriptions of the controls.

7 Observe rows A and B on each microplate with a hand lens. Record any variations from the controls by identifying the row and column (for example, 2B).

Note the color change in this well. What do you observe in the other wells?

Analyze

Answer each of the following thoroughly.

1. Make a general statement about the reactivity of the metals in this activity.

2. List each of the metals you used. Which compounds that you used do not contain transition metals?

3. Note the positions on each microplate of the metals in the compounds from columns 1–4. How do they compare to the positions of those metals in the periodic table?

4. Predict how the following metals in aqueous solution would behave if they were to be combined with NH_4OH and HCl: Na, Mg, Ti, Ag, and Cd. For example, describe whether you would expect a color change or a precipitate to form.

Salts: Precipitation Reactions

Common table salt's chemical name is sodium chloride, and its chemical formula is NaCl. But sodium chloride is only one kind of salt. Like all salts, it is an ionic compound formed when ions bond with each other. Table salt forms when a sodium ion (Na^+) and a chloride ion (Cl^-) form an ionic bond. But many other ions also combine to form salts. In this lab, you will explore some reactions that lead to the formation of those ionic compounds known as salts.

In ancient times, table salt was one of the most important resources for civilization. Salt was essential for preserving and seasoning food. Mining and transporting salt to population centers drove the development of some of the first roads, referred to as "salt roads." However, salt was not easy to come by, and so it was a highly valued trade item. Until the twentieth century, table salt was an important global resource that drove both national economies and wars. Knowledge about how salt forms and where to find it had an impact on the economic security and well-being of nations.

Question

How do various compounds react to form salts?

Observe

If a solid is produced when two liquids are mixed, the solid is referred to as a *precipitate*. This experiment may surprise you as you mix different aqueous solutions of compounds and find that precipitates form. Where do you think you might observe precipitates forming in your everyday experience?

Hypothesize

Write a hypothesis that describes how solutions may differ in terms of their ability to form a precipitate when mixed with other solutions. Write your hypothesis in the form of an if-then statement, and base it on your everyday observations.

The whitish solid that makes up this salt flat is an ionic compound.

MATERIALS

safety goggles

gloves

24-well microplate

toothpicks – 45

hand lens

approximately 10 mL each of the following chemicals:

0.1 M barium nitrate ($Ba(NO_3)_2$)

0.1 M aluminum chloride ($AlCl_3$)

0.1 M potassium chloride (KCl)

0.2 M sodium hydroxide (NaOH)

0.1 M magnesium sulfate ($MgSO_4$)

0.2 M sodium chromate (Na_2CrO_4)

0.2 M potassium chromate (K_2CrO_4)

0.2 M silver nitrate ($AgNO_3$)

approximately 20 mL each of the following chemicals:

0.1 M aluminum sulfate ($Al2(SO_4)_3$)

0.1 M magnesium chloride (MgCl)

0.1 M sodium sulfate (Na_2SO_4)

0.1 M barium chloride ($BaCl_2$)

0.1 M magnesium nitrate ($Mg(NO_3)_2$)

EXPERIMENT

In this experiment, you will mix aqueous solutions of differing chemical natures to observe which do or do not form a precipitate. A color change or the formation of a precipitate is a clear signal that a chemical reaction has occurred and a salt has formed.

Setup

1 Create a data table similar to the sample table shown below (Table 1), but with enough rows to include all the solutions listed for Sets 1–3 below and on the next page.

TABLE 1 Combinations of Solutions to Test for Reactions

Set	Well	Solution A	Solution B	Color Change? (yes/no)	Precipitate Formed? (yes/no)
1	1A	$Ba(NO_3)_2$	Na_2SO_4		
1	2A	$Ba(NO_3)_2$	$Al_2(SO_4)_3$		
1	3A	$Ba(NO_3)_2$	$Mg(NO_3)_2$		

Set 1

Well	Solution A	Solution B
1A	$Ba(NO_3)_2$	Na_2SO_4
2A	$Ba(NO_3)_2$	$Al_2(SO_4)_3$
3A	$Ba(NO_3)_2$	$Mg(NO_3)_2$
4A	$Ba(NO_3)_2$	MgCl
5A	$Ba(NO_3)_2$	$AlCl_3$
1B	Na_2SO_4	$Al_2(SO_4)_3$
2B	Na_2SO_4	$Mg(NO_3)_2$
3B	Na_2SO_4	$MgCl_2$
4B	Na_2SO_4	$AlCl_3$
1C	$Al_2(SO_4)_3$	$Mg(NO_3)_2$
2C	$Al_2(SO_4)_3$	$MgCl_2$
3C	$Al_2(SO_4)_3$	$AlCl_3$
1D	$Mg(NO_3)_2$	$MgCl_2$
2D	$Mg(NO_3)_2$	$AlCl_3$
3D	$MgCl_2$	$AlCl_3$

Use Table 1 above and the information here and on the next page (Sets 1–3) as a guide for creating your data table. Be sure to include enough rows so that you can list all the combinations of solutions that you will test for reactions. Split the table over more than one page if necessary to include all the combinations.

Set 2

Well	Solution A	Solution B
1A	KCl	$MgCl_2$
2A	KCl	Na_2SO_4
3A	KCl	NaOH
4A	KCl	$BaCl_2$
5A	KCl	$MgSO_4$
1B	$MgCl_2$	Na_2SO_4
2B	$MgCl_2$	NaOH
3B	$MgCl_2$	$BaCl_2$
4B	$MgCl_2$	$MgSO_4$
1C	Na_2SO_4	NaOH
2C	Na_2SO_4	$BaCl_2$
3C	Na_2SO_4	$MgSO_4$
1D	NaOH	$BaCl_2$
2D	NaOH	$MgSO_4$
3D	$BaCl_2$	$MgSO_4$

Set 3

Well	Solution A	Solution B
1A	$BaCl_2$	$Mg(NO_3)_2$
2A	$BaCl_2$	Na_2CrO_4
3A	$BaCl_2$	$Al_2(SO_4)_3$
4A	$BaCl_2$	K_2CrO_4
5A	$BaCl_2$	$AgNO_3$
1B	$Mg(NO_3)_2$	Na_2CrO_4
2B	$Mg(NO_3)_2$	$Al_2(SO_4)_3$
3B	$Mg(NO_3)_2$	K_2CrO_4
4B	$Mg(NO_3)_2$	$AgNO_3$
1C	Na_2CrO_4	$Al_2(SO_4)_3$
2C	Na_2CrO_4	K_2CrO_4
3C	Na_2CrO_4	$AgNO_3$
1D	$Al_2(SO_4)_3$	$AgNO_3$
2D	$Al_2(SO_4)_3$	K_2CrO_4
3D	K_2CrO_4	$AgNO_3$

2 Create a data table similar to Table 2 below, but with enough rows to include all the combinations of reactants that yielded a precipitate.

TABLE 2 Names of Precipitates Formed

Set	Reactants that Yielded a Precipitate	Suggested Name for the Precipitate , Positive Ion First (for example, barium sulfate)
1		
1A		
2A		
2		
2B		

Procedure

1 Place 10 drops of barium nitrate into well 1A of the 24-well microplate. Place 10 drops of sodium sulfate into the same well. Stir with a toothpick. Observe and record any changes in color or the formation of a precipitate. The formation of a precipitate clearly signals the formation of a product that does not dissolve in water.

A color change or formation of a precipitate is a clear signal that a chemical reaction has occurred and a salt has formed.

2 Repeat Step 1 with different chemicals in different wells, as specified in Table 1, "Combinations of Solutions to Test for Reactions." Mix the Set 1 compounds from the table first. Then proceed to mix the Set 2 and Set 3 compounds, washing the microplate thoroughly after each set. Use a new, dry toothpick for each well.

3 For each combination that gives a precipitate, write the word equations for the new compounds that are formed from the reactants in Table 2, Names of Precipitates Formed.

Analyze

Answer each of the following thoroughly.

1. Consider the combinations of compounds that resulted in precipitates. Using the periodic table, suggest what those compounds that resulted in precipitates have in common.

2. What compound was present in each of the wells of the microplate in which *no* reaction occurred?

Chemical Reactions

Chemical reactions are at the heart of chemistry. In this lab activity, you will investigate some of the many ways that chemical reactions occur.

In a *synthesis reaction*, two or more substances combine to form a more complex substance. These reactions may produce a gas, a precipitate, or a color change. The general form of a synthesis reaction can be written like this:

$$A + B \rightarrow C$$

In a *single displacement reaction*, part of one of the substances is exchanged to form new substances. A single displacement reaction looks like this:

$$AB + C \rightarrow A + BC$$

In a *double displacement reaction*, the reactants are typically ionic and the ions in the two reactants switch places to form two new products. In general, double displacement reactions look like this:

$$AB + CD \rightarrow AD + CB$$

Instead of smashing ionic powders together and expecting something to happen, chemists perform many reactions in solution—that is, they dissolve the reactants in water. That solution is referred to as an *aqueous solution* of that compound. In water the compound dissolves, resulting in positively charged and negatively charged ions that are available for the reaction. The positively charged ions are the *cations*, and the negatively charged ions are the *anions*. In double displacement reactions, you often know a reaction has occurred because one of the products is no longer in solution. Perhaps the color changed or a precipitate formed to signal that a reaction took place. In this lab, you will observe several reactions that take place when substances are mixed.

OBJECTIVE

- Observe results of different types of chemical reactions.

Salt has many uses, and it also has some interesting chemical properties.

Question

What visual evidence may tell you that chemical reactions have occurred?

Observe

If you put a teaspoon of table salt in water, you will notice that the salt dissolves. Dissolving in this case means that the Na^+ and the Cl^- ions dissociate—that is, they separate—and it is impossible for the eye to distinguish them as solid salt any longer. If the water were boiled away, what would happen? The salt would re-form into the white granular solid you are familiar with.

Hypothesize

After examining the chemical formulas of compounds used in this lab, write a hypothesis as an if-then statement to predict what will happen when each substance in the lab procedure is combined in solution.

EXPERIMENT

In this experiment, you will perform and observe single displacement and double displacement reactions. You will note that each reaction and each type of reaction provides different types of evidence that a reaction has occurred.
(Note: The materials for each part of this lab are listed separately.)

Part 1

Procedure

1. Fill the 250 mL beaker with water to the 125 mL mark.

2. Add 2 g of alum to the water and stir with a plastic spoon to dissolve the alum. This may take a moment or two of stirring. Record your observations.

3. Stir in 10 mL of ammonia. Record your observations.

 SAFETY NOTE Ammonia has strong fumes; do not breathe the fumes.

4. Allow the solution to stand for 5 minutes. Record your observations.

5. Dispose of the solution down the sink. Thoroughly rinse the beaker.

6. Fill the 250 mL beaker with water to the 125 mL mark.

7. Add 4 g of magnesium sulfate to the water. Stir to dissolve. This may take a moment or two of stirring. Record your observations.

8. Add 10 mL of ammonia to the beaker. **Do not stir.** Record your observations.

 SAFETY NOTE Ammonia has strong fumes; do not breathe the fumes.

9. Allow the solution to stand for 5 minutes. Record your observations.

10. Dispose of the solution down the sink. Thoroughly rinse the beaker and spoon.

Part 2 Single Displacement Reactions

Setup

1 Create a data table similar to Table 1 below.

TABLE 1 Observations for Selected Single Displacement Reactions

Well Number	Solids	Solutions	Observations
1A	Zinc	Copper sulfate	
2A	Aluminum	Copper sulfate	
3A	Zinc	Silver nitrate	
4A	Copper	Silver nitrate	

2 Roll up the aluminum foil into a ball so that it fits easily into a microplate well. Using what you have on hand, cut the copper wire so that 3–5 pieces fit easily into a microplate well.

Procedure

1 Using four wells from the 24-well microplate, arrange the solids in the respective wells as show in Table 1 above. Add half a scoopula of powdered zinc to the specified wells.

Setup for Part 2, Single Displacement Reactions, showing the solid samples before the solutions are added to the wells

2 Add approximately 25 drops of each solution listed in Table 1 to the specified well.

3 Record any color changes, precipitate formation, or gas production that you observe. If no precipitate or color change occurred, then *no* reaction occurred.

Single Displacement Reaction

5 g of powdered zinc

1 cm^2 piece of aluminum foil

4 cm length of copper wire

10 mL of 0.1 *M* copper sulfate ($CuSO_4$)

20 mL of 0.1 *M* silver nitrate ($AgNO_3$)

10 mL of 0.1 *M* zinc sulfate ($ZnSO_4$)

24-well microplate

scoopula

knife or other implement that will cut soft copper

Double Displacement
Reaction

10 mL of 0.1 *M* sodium
chloride (NaCl)

10 mL of 0.1 *M* copper sulfate
(CuSO$_4$)

20 mL of 0.1 *M* silver nitrate
(AgNO$_3$)

10 mL of 0.1 *M* phosphoric
acid (Na$_3$HPO$_4$)

10 mL of 0.1 *M* sodium
hydroxide (NaOH)

24-well microplate

Part 3 Double Displacement Reactions

Setup

Create a data table similar to Table 2 below.

TABLE 2 Observations for Selected Double Displacement Reactions

Well Number	Solids	Solutions	Observations
1A	NaCl	Copper sulfate	
2A	NaOH	Copper sulfate	
3A	Na$_3$HPO$_4$	Copper sulfate	
4A	NaCl	Silver nitrate	
5A	NaOH	Silver nitrate	
6A	Na$_3$HPO$_4$	Silver nitrate	

Procedure

1 Using a microplate, place 25 drops of NaCl solution into wells 1A and 4A, 25 drops of NaOH into wells 2A and 5A, and 25 drops of Na$_3$HPO$_4$ into wells 3A and 6A.

2 Using Table 2 as a guide, add 10 drops of CuSO$_4$ to wells 1A, 2A, and 3A and 10 drops of AgNO$_3$ to wells 4A, 5A, and 6A.

3 Note any color changes, precipitate formation, or gas production. If no precipitate or color change occurred, then *no* reaction occurred.

A chemical change can be observed here in the form of a color change.

Analyze

Answer each of the following thoroughly.

1. Write a balanced equation for each of the reactions that you performed. There were potentially 12 reactions in all, although all 12 combinations of substances may not have resulted in reactions.

2. What compound was present in each well throughout the experiment, but never underwent a chemical change?

Stoichiometry of Chemical Reactions

An industrial chemist often needs to produce a certain amount of a product in a chemical reaction. For example, a request may be, "Make 5 kg of sodium nitrite." To figure out how to make that much of a substance, the chemist must know what the reactants are and how much of them will be needed to do the job. Some mathematical calculations using the principles of *stoichiometry* will help the chemist predict quantities needed to produce 5 kg of sodium nitrate. Once the substance is produced, the amount of product will not be 100 percent of the predicted amount because no procedure is 100 percent efficient.

Question

How do you predict the mass and moles of products of a chemical reaction?

Observe

When you cook according to a recipe, you use set amounts of ingredients, such as 1 cup of flour, 1 cup of butter, and 1 cup of sugar. In the practice of chemistry, you do the same thing, but instead of grams or cups of a substance, you use *moles* of a substance. Using moles enables you to do a 1:1 comparison of the numbers of molecules of the substances involved. You do that because when thinking about a chemical reaction that will yield a product, you have to combine the reactants in the correct amount. For example, to produce one mole of water (H_2O) you need two moles of hydrogen and one mole of oxygen. The mole is the unit by which to compare the amount of one chemical to another.

Carrying out a chemical reaction is similar to following a recipe.

Hypothesize

Predict how the proper application of mole amounts will make a chemical reaction most efficient. Write your hypothesis as an if-then statement.

safety goggles

gloves

24-well microplates – 2

toothpicks – 27

0.1 *M* sodium hydroxide

0.1 *M* solutions (with phenolphthalein added as an indicator) of the following chemicals:

copper(II) nitrate (Cu(NO₃)₂)

iron(II) sulfate (FeSO₄)

iron(III) nitrate (Fe(NO₃)₃)

EXPERIMENT

You will determine the amounts of reactants that are needed to produce chemical reactions. Phenolphthalein turns pink in a solution that contains excess hydroxide ions (OH⁻). That color change and others will signal to you the extent of the chemical reaction that has occurred. You will visually notice the combination that gives you the greatest color change, and thus the best results.

Part 1 Reaction of Copper(II) Nitrate with Sodium Hydroxide

Setup

1 Collect materials together in the place where you will perform the lab.

2 Create a data table with the following columns: Well Number; Drops of Copper(II) Nitrate; Drops of Sodium Hydroxide; Observation of Color Change (yes or no, and identify the color if yes); and Observation of Precipitate (yes or no, and identify the color if yes). Title the table "Reaction of Copper(II) Nitrate with Sodium Hydroxide." Leave enough room in the observation column to write up to two sentences about what you have seen.

3 Place two microplates next to each other and identify nine wells, as shown in the photo on the next page.

 Note The reaction in this experiment is
 copper(II) nitrate + sodium hydroxide → copper + hydroxide ions + sodium nitrate

 Write out this equation using chemical formulas.

Procedure

1 Using nine microplate wells that you identified by letter and number, place 5 drops of Cu(NO₃)₂ in the first well, then 10 drops in the second well, 15 in the third well, and continue the pattern until you have put 45 drops in the last well.

2 Place 5 drops of NaOH in the well that you put 45 drops of Cu(NO₃)₂ into. Next place 10 drops of NaOH in the well that you put 40 drops of Cu(NO₃)₂ into, and so forth, so that each well contains a total of 50 drops of liquid.

3 Stir with a toothpick, using a clean toothpick for each well. Stir the mixtures thoroughly; otherwise, the reaction will take place unevenly and in small areas (see photo).

Stir the mixtures thoroughly and look for any color changes.

④ Observe any color changes or precipitate formation and record them in the table "Reaction of Copper(II) Nitrate with Sodium Hydroxide." Precipitates are best viewed by looking at the plate from the side.

⑤ Write your observations in terms of the chemical equation for the reaction.

Part 2 Reaction of Iron(II) Sulfate with Sodium Hydroxide

Setup

① Collect materials together in the place where the lab will be performed.

② Create a data table with the following columns: Well (identified by number of drops of $FeSO_4$ in the well); Drops of Iron(II) Sulfate; Drops of Sodium Hydroxide; Observation of Color Change (yes or no, and identify the color if yes); and Observation of Precipitate (yes or no, and identify the color if yes). Title the table "Reaction of Iron(II) Sulfate with Sodium Hydroxide." Leave enough room in the observation column to write up to two sentences about what you have seen.

Note The reaction in this experiment is
iron(II) sulfate + sodium hydroxide → iron + hydroxide ions + sodium sulfate

Write out this equation using chemical formulas.

Procedure

① Using nine wells that you identified by letter and number, place 5 drops of $FeSO_4$ in the first well, then 10 drops in the second well, 15 in the third well, and continue the pattern until you have put 45 drops in the last well.

② Place 5 drops of NaOH in the well that you put 45 drops of $FeSO_4$ into. Next place 10 drops of NaOH in the well that you put 40 drops of $FeSO_4$ into, and so forth, so that each well contains a total of 50 drops of liquid. Stir with a toothpick, using a clean toothpick for each well.

③ Observe any color changes or precipitate formation and record them in the table "Reaction of Iron(II) Sulfate with Sodium Hydroxide." Precipitates are best viewed by looking at the plate from the side.

④ Write your observations in terms of the chemical equation for the reaction.

Part 3 Reaction of Iron(III) Nitrate with Sodium Hydroxide

Setup

1 Collect materials together in the place where the lab will be performed.

2 Create a data table with the following columns: Well (identified by number of drops of $Fe(NO_3)_3$ in the well); Drops of Iron(III) Nitrate; Drops of Sodium Hydroxide; Observation of Color Change (yes or no, and identify the color if yes); and Observation of Precipitate (yes or no, and identify the color if yes). Title the table "Reaction of Iron(III) Nitrate with Sodium Hydroxide." Leave enough room in the observation column to write up to two sentences about what you have seen.

> **Note** The reaction in this experiment is
> iron(III) nitrate + sodium hydroxide → iron + hydroxide ions + sodium nitrate
>
> Write out this equation using chemical formulas.

Procedure

1 Using nine wells that you identified by letter and number, place 5 drops of $Fe(NO_3)_3$ in the first well, then 10 drops in the second well, 15 in the third well, and continue the pattern until you have put 45 drops in the last well.

2 Place 5 drops of NaOH in the well that you put 45 drops of $Fe(NO_3)_3$ into. Next place 10 drops of NaOH in the well that you put 40 drops of $Fe(NO_3)_3$ into, and so forth, so that each well contains 50 drops of liquid. Stir with a toothpick, using a clean toothpick for each well.

3 Observe any color changes or precipitate formation and record them in the table "Reaction of Iron(III) Nitrate with Sodium Hydroxide." Precipitates are best viewed by looking at the plate from the side.

4 Write your observations in terms of the chemical equation for the reaction.

Analyze
. .

Answer each of the following thoroughly.

1. Write balanced chemical equations for each of the three reactions that you performed and observed.

2. Phenolphthalein turns pink in a solution that contains excess hydroxide ions. How does this information help you determine which of the reactants is in excess in the reactions?

3. How do these experiments show that the molar amounts of the reactants produce different yields of the products?

4. Was your hypothesis incorrect, partially correct, or totally correct? If not totally correct, then rewrite your hypothesis now as a more definite if-then statement.

Gas Laws

If you lived during the time of Robert Boyle or Joseph Gay-Lussac, you might know that gases exist, but you would have no idea what they are made of. So, what is the first thing you would study? You would study how gases behave, and hope that your findings lead to an understanding of what a gas is. You would try to figure out the relationship between gas and temperature, for example, and see how the gas-temperature relationships vary between different kinds of gases. The result would be a series of laws that describe gases—and that is exactly what happened historically.

The gas laws were all discovered before the concept of atoms and molecules became established. The gas laws explain the relationship between the volume, temperature, and pressure of a gas. We know now that the gas laws can be explained by the kinetic theory of gases—that gases are made of molecules that move at rates that are dependent on the temperature and pressure of the gas, and that changes in the temperature, pressure, and volume of a sample of gas are all interrelated.

Question

How does a change in temperature affect the volume of a gas? How can you determine the temperature, pressure, and volume of gas liberated in a chemical reaction?

Observe

Balloons are wonderful gas containers that you can use to study gases. You know more about balloons than you think. What happens when hot air fills a balloon? The balloon expands. From your experience, what happens as a balloon is rapidly cooled?

How does heating the gas that fills a hot-air balloon affect the volume of that gas?

Hypothesize

Write a hypothesis in if-then form that predicts what will happen if a balloon filled with air is cooled. Write an additional hypothesis that predicts what will happen if the gas in a balloon is heated.

EXPERIMENT

Air is a mixture of gases, mostly nitrogen and oxygen. In this experiment, you will heat a balloon that has air in it and note any changes in volume. Then you will cool a balloon that has air in it and note any changes in volume. In a third procedure, you will create a chemical reaction in three balloons, and then quantitatively analyze the results of your experiment. (Note: The materials for each part of this lab are listed separately.)

Part 1 Heating a Balloon

Setup

1 Collect materials together in the place where you will perform the lab.

2 Create a data table with the following columns: Circumference of Balloon (cm). Circumference of Balloon After Heating (cm). Title the table "Data on Heated Balloon."

Procedure

1 Blow up a balloon to a size that it is roughly the size of your hand or slightly larger. Tie a knot in the end of the balloon.

2 Measure the circumference of the balloon. Place dots at 2 cm intervals around the balloon's circumference so that you can repeat the circumference measurement later. Record the balloon's circumference in your data table for Part 1.

3 Allow hot tap water to run for 30 seconds or more. Fill a bowl half full with hot tap water and record the temperature in your data table for Part 1.

Measure the circumference of the balloon with the measuring tape.

MATERIALS

Heating a Balloon

roughly spherical balloon

black permanent marker

metric measuring tape

paper towels

common kitchen bowl large enough to hold an expanded balloon

tap water in a quantity to half fill the bowl

4 Submerge one-fourth to one-third of the balloon in the hot water. After 3 to 5 minutes, measure the circumference along the black dots you placed and record the circumference of the balloon. Remove the balloon from the water and measure the temperature of the hot water. Record the temperature in your data table.

Part 2 Cooling a Balloon

Setup

1 Collect materials together in the place where you will perform the lab.

Measure the circumference of the balloon again after it has been submerged in the hot water.

2 Create a data table similar to Table 1 below, and title it "Data on Chilled Balloon."

TABLE 1 Data on Chilled Balloon

Observations	Data
Initial temperature of air in the balloon (°F)	98.6
Initial temperature of air in the balloon (°C)	
Initial temperature of air in the balloon (K)	
Circumference of balloon at beginning (cm)	
Volume of balloon at beginning (cm³)	
Refrigerated temperature of air in the balloon (°F)	0
Refrigerated temperature of air in the balloon (°C)	
Refrigerated temperature of air in the balloon (K)	
Circumference of balloon after refrigeration (cm)	
Volume of balloon after refrigeration (cm³)	

MATERIALS

Procedure

1 Blow up a balloon so that it is roughly the size of your hand or slightly larger. Tie a knot in the end of the balloon. Measure the circumference of the balloon. Record the circumference in your data table for Part 2. Place dots at approximately 2 cm intervals around the balloon's circumference so that you can repeat the circumference measurement later.

2 Place the balloon in the freezer section of your refrigerator. Leave it there for at least 30 minutes.

3 Remove the balloon from the freezer and quickly measure the circumference along the black dots you placed. Record the circumference of the balloon in your data table.

What do you think will happen to the cirumference of the balloon after you put it in the freezer?

4 Assume that the initial temperature of the air in the balloon is the same as your normal body temperature, 98.6°F. The final temperature will be 32°F or 0°C. Convert the initial and final temperature of the air in the balloon to Celsius and kelvin units. Use the formula $°C = \frac{5}{9}(°F - 32)$, where °F = the temperature in degrees Fahrenheit and °C = the temperature in degrees Celsius. Also use K = °C + 273, where K = the temperature in kelvins.

5 Calculate the volume of the balloon by using the formula $V = \frac{4}{3}\pi r^3$, where r is the radius of the balloon and can be found from the formula $r = \frac{C}{2\pi}$.

6 Plot a graph of volume vs. temperature in K with the two data points that resulted from your experiment. Draw a straight line connecting the two points, thus assuming a linear relationship between volume and temperature.

Part 3 Gas Given Off by a Reaction

Setup

1 Collect materials together in the place where you will perform the lab.

2 Create a data table with columns numbered 1, 2, and 3, and with the following rows: Circumference of Balloon (cm), Volume of Balloon (cm³). Title the table "Sizes of Balloons After Reactions."

Procedure

1 Using a mortar and pestle, crush two antacid tablets into a powder and place the powder into a balloon. Repeat, putting four tablets in a second balloon and six tablets in a third balloon. Number the balloons as 1, 2, and 3, respectively. (Hint: Use a funnel or roll a piece of paper into a conical shape. Place the pointed end in the balloon and then pour the ground tablets into the balloon.)

2 Pour approximately 10 mL of vinegar into the graduated cylinder. Gently attach the first balloon to the graduated cylinder. Quickly turn the cylinder over so that the vinegar pours into the balloon. Immediately tie a knot in the end of the balloon. (Hint: It is easier to tie balloons when your hands are dry.) Repeat this step with the other two balloons.

3 Shake the balloons.

4 After 10 minutes, measure the circumference of each balloon and record it in your data table for Part 3, as you did in the previous parts of the lab. (Hint: Shape the balloon to make it as spherical as you can before measuring.)

5 Calculate the volume for each balloon as you did in Part 2 of the lab.

6 Make a graph of volume vs. number of tablets used in the reaction in each balloon.

Analyze

Answer each of the following thoroughly.

1. Were your hypotheses correct? If they were, what data confirms that your hypotheses were correct? If they were not, then rewrite your hypotheses so that they are correct.

2. Extend the line on your graph from the first part of the experiment all the way through the *x-axis*; in other words, find the *x*-intercept of the graph. This intercept corresponds to where the volume would be zero and the temperature can be no lower, or would be absolute zero.

3. Absolute zero is 0 K. Compare your results to those expected. How close to absolute zero was your intercept?

4. What conclusions can you make about the relationship between the volume of a gas and its temperature?

5. What conclusions can you make about the relationship between the volume of a gas and its pressure?

6. Consider the parts of the experiments that you have just performed, and possible variables that you have not accounted for. As you did the procedures, it is possible that the atmospheric pressure may have changed. If it did change over the course of your experiment, then how would your results have been affected?

Lab 8

Factors Affecting Solution Formation

OBJECTIVE

- Determine the effect of particle size and temperature on solubility.

When a solute dissolves in a solvent, a number of factors affect how fast and completely the solution forms. What at first may seem purely academic—factors that affect solution formation—has practical applications, too.

The Chesapeake Bay is fed by freshwater from the many rivers that flow into it. The bay becomes increasingly salty with increasing proximity to the ocean, as salts enter from land sources or are added by ocean waters. What factors affect how quickly and thoroughly salts dissolve in the fresher waters of Chesapeake Bay? Temperature is one factor in determining how salty the water is at any one point in the bay. During the summer, the salinity of the bay increases as the temperature rises and water evaporates more quickly. The summer change in salinity allows migration of saltwater species such as crabs, eel, and stinging jellyfish from the ocean up into the bay. The biologists who study the salt characteristics of the bay have to understand all the factors that affect solution formation.

Question

What are the effects of temperature and solute particle size on solubility?

Changes in the amount of salt in solution affect the migration of bay species.

Observe

Suppose you want to sweeten some lemonade. Which would sweeten it faster, a lump of sugar or a spoonful of granulated sugar? Would a sugar cube dissolve faster in hot lemonade or cold lemonade? If you know the answer—well, go ahead and see if you are right. After having made this observation you can ask the question: What are the factors that affect how fast a substance dissolves?

Hypothesize

Write a hypothesis about what you think will happen to a solute's dissolution rate if the solute has a larger particle size as compared to smaller particle size. Write a second hypothesis discussing the relationship between temperature and solubility.

EXPERIMENT

In this experiment, you will first dissolve table salt (NaCl) in water, noting how long it takes salt of different particle sizes to dissolve. Then you will explore the time needed for salt to dissolve in water at different temperatures.

Part 1 Effects of Particle Size on Solution Formation: No Agitation

In Parts 1 and 2, you will dissolve a salt tablet and 5 g each of coarse- and fine-grained salt in the 50 mL vials.

MATERIALS

50 mL vials with lids – 3

pencil that will mark plastic

10 g fine-grained salt

25 g coarse-grained salt

salt pellets (NaCl) – 3

distilled water

electronic balance

250 mL beaker

ice

paper towels

stopwatch (or clock with second hand)

Setup

1. Collect materials together in the place where you will perform the lab.

2. Create a data table with the following columns: Vial Number, Time for Salt to Dissolve (sec). Title it "Table 1: Effects of Particle Size of Salt on Solubility with No Agitation."

3. Label the vials 1, 2, and 3.

In Part 3, you will observe the effects of temperature on the solubility of measured samples of salt, again using the 50 mL vials.

Procedure

1. Put one salt tablet in vial 1.

2. Using the electronic balance, measure out 5 g of coarse-grained salt on a piece of paper towel and pour it into vial 2. Then measure and add 5 g of fine-grained salt into vial 3 in the same way.

3. Pour 20 mL of tap water into each vial.

4. Measure and record the length of time it takes for the salt to dissolve completely in each vial. Allow at least 45 minutes to see if the salt dissolves completely.

5. Empty the vials and clean them thoroughly with tap water.

Part 2 Effects of Particle Size on Solution Formation: With Agitation

Setup

1. Create a data table with the following columns: Vial Number, Time for Salt to Dissolve (sec). Title it "Table 2: Effects of Particle Size of Salt on Solubility with Agitation."

2. Label the vials 1, 2, and 3.

Procedure

1. Put one salt tablet in vial 1.

2. Using the electronic balance, measure out 5 g of coarse-grained salt on a piece of paper towel and pour it into vial 2. Then measure and add 5 g of fine-grained salt to vial 3 in the same way.

3. Pour 20 mL of room-temperature water into each vial.

4. Replace the lids and shake each vial gently for 5 seconds every minute until the salt has totally dissolved.

5. Measure and record the length of time it takes for the salt to dissolve completely in each vial.

6. Empty the vials and clean them thoroughly with tap water.

Part 3 Effects of Temperature on Solution Formation

Setup

1. Collect materials together in the place where you will perform the lab.

2. Create a data table with the following columns: Vial Number, Time for Salt to Dissolve (sec). Title it "Table 3: Effect of Temperature and Agitation on Solubility of Salt."

3. Label the vials 1, 2, and 3.

Procedure

1. Using the electronic balance, measure out three 5 g samples of coarse-grained salt and pour 5 g into each of the three vials.

2. Prepare some ice water by placing ice or crushed ice in a 250 mL beaker and then adding 25 mL of water to the beaker.

3. Fill vial 1 with 20 mL of the ice water. Replace the lid and shake the vial gently for 5 seconds every minute until the salt has completely dissolved. Observe and record the time needed for the salt to dissolve.

4. Fill vial 2 with 20 mL of tap water. Replace the lid and shake the vial gently for 5 seconds every minute until the salt has completely dissolved. Observe and record the time needed for the salt to dissolve.

5. Fill vial 3 with 20 mL of hot tap water. Be careful not to burn or scald your hands. Replace the lid and shake the vial gently for 5 seconds every minute until the salt has completely dissolved. Observe and record the time needed for the salt to dissolve.

7:30 hot

8:30 Cold

10:00 normal

Analyze

Answer each of the following thoroughly.

1. Describe the results that you found in Part 1 of this lab. Was your hypothesis about the effects of particle size on solution formation correct?

2. Solids that are granular can be packaged in many different shapes. Which of the following do you think would take the longest to dissolve, and why: a cube of salt, a pellet (sphere) of salt, or a torus (donut) of salt? Assume all contain the same mass of salt.

3. Soap is a solid that can dissolve in water. Based on what you observed in the lab, explain what factors would lead you to *not* use powdered soap when bathing or showering? When doing laundry, why might you use powdered soap or even liquid detergent instead of a large piece like a bar of soap?

4. Describe the results that you found in Part 3 of this lab. Was your hypothesis about the effects of temperature on solubility correct?

5. Using your understanding of atoms and molecules, and of the kinetic theory of matter, explain the results of each part of your experiment. In other words, what was happening in each vial?

Titration: Testing Water Quality

OBJECTIVE

- Apply the technique of titration to determine the acidity or alkalinity of a sample of water.

In this experiment, you will perform a test to determine the alkalinity of two samples of water. Each sample has been prepared by adding sodium carbonate (Na_2CO_3) to it. When added to water, sodium carbonate undergoes the following reaction:

$$Na_2CO_3 + 2H_2O \rightarrow 2Na^+ + 2OH^- + H_2CO_3$$

The OH^- ions make the solution basic. When you add a phenolphthalein indicator to a basic solution it turns pink. It will lose its pink color if an acid is added to reduce the pH below 8.3. The phenolphthalein acts as an indicator, and in this activity its color changes at pH 8.3.

After you add the phenolphthalein, you will add a dilute solution of sulfuric acid drop by drop to the sample until the pink color disappears. By knowing how much acid you added you can determine how much acid it takes to reduce the pH to 8.3. You will then add a second indicator to the solution and continue to add drops of acid until the pH is 4.5. A second color change, this time from green to red, will indicate that a pH of 4.5 has been reached.

The procedure just described—the drop-by-drop addition of an acid or a base to determine pH—is called a *titration*. Titrations just like the one you are doing are used by environmental professionals at ponds, rivers, and lakes to test water quality. The technique is useful when, for example, you need to know if acid rain is affecting a lake.

Titration is a useful tool that can assist in evaluating water quality in ponds, streams, rivers, and lakes.

Question

How can the process of titration be used to measure some aspects of water quality?

Observe

You have probably heard the term *acid rain*. When certain industrial practices release pollutants into the air, those pollutants can travel long distances before they fall to earth. If the acidic chemicals then find their way into streams and lakes, the acids can change the chemistry of the lake and affect the living things that are in it. Most lakes are basic enough to buffer the acids from rain for a while, but lakes will suffer if they become too acidic over time. In an optional activity at the end of this lab exercise, you will have the opportunity to research the effects of acid rain on lands and lakes near you.

Hypothesize

Write a hypothesis that predicts how titration with an acid can be used to determine the pH of the samples of water. Write your hypothesis as an if-then statement.

EXPERIMENT

In this experiment, you will conduct titrations and determine the concentration of carbonate ions in two water samples, using the kind of alkalinity test kit that environmental professionals use.

Procedure

Note Follow the directions in this lab procedure, not the directions on the inside of the alkalinity test kit.

1. Using water sample A, fill the sample vial from the alkalinity test kit to 25 mL.

2. Add 3 drops of Phenolphthalein Indicator. Swirl to mix. The sample should turn and remain a pinkish red. More drops of indicator may be necessary to achieve a color change. If needed, add another drop, swirl, and check to see that the pinkish-red color remains.

Follow the procedure steps. When you add the 3 drops of Phenolphthalein Indicator to the sample, the sample should turn a pinkish red.

Observe for changes in color of the sample as you proceed with the titration steps.

3 Add 1 drop of Alkalinity Titrant Low. Then swirl, observe for change, and then add the next drop. This titrant is a 0.12 N solution of sulfuric acid in water— the equivalent of a 0.06 M solution of sulfuric acid.

4 Continue the titration. Count the number of drops until the color changes completely from red to colorless. Record the number of drops as P alkalinity. This is the number of drops it takes to bring the pH of the sample down to 8.3.

5 Use the pH paper to check that the pH of the sample is 8.3.

6 Add 3 drops of the Total Alkalinity Indicator. This is a second indicator solution that will turn red when the pH is 4.5. Swirl to mix. The sample should turn green.

7 Add 1 drop of Alkalinity Titrant Low. Then swirl, observe for color change, and then add the next drop. Count the number of drops until the color change from green to red occurs completely.

8 Record the number of drops that you added in Steps 7 and 4 as T alkalinity.

9 Use the pH paper to check that the pH of the sample is now 4.5.

10 Repeat Steps 1–9 with water sample B.

Optional Activity

Find a source of water such as a lake or a pond near you, and repeat the procedure. You may also use tap water. Depending on your location, the water you test may not be alkaline enough to give results. Use a strip of pH paper to determine the pH of the water. If the pH is well below 7.5, that confirms that it would take much more of the Phenolphthalein Indicator than prescribed in the procedure to cause your sample to turn pink.

Modern industrial practices affect the acidity of the rain that falls. Study this map and note the pH of the rain that falls near you and in other areas. Think about how you could apply your experience with this lab exercise to situations out in the environment.

Analyze

Thoroughly answer each of the following.

1. What is the primary function of a titration?

2. Calculate the alkalinity of each sample in parts per million (ppm) of $CaCO_3$, as shown on the test kit. What did you find the alkalinity to be for your water sample from the optional activity in parts per million?

3. According to your results, which sample is more acidic, sample A or B? Explain.

4. According to your results, which sample would serve as a better buffer, and therefore a better environment for aquatic life? Explain.

5. Is it as critical for your tap water to be a good buffer as it is for the water at the nearest lake to be a good buffer? Why or why not?

6. Because of certain modern industrial practices, rain that falls is often acidic. Refer to the map above. Find the data station nearest to your home. What is the acidity of rain in your area, as measured in this data set? How would testing such as that done in this lab exercise be valuable in real-world situations?

Heat Transfer

Suppose a piece of ice exists at 0°C. If you add heat, the temperature of the ice remains at 0°C. But as you continue to apply heat, there is finally enough heat to break the bonds between the water molecules in ice, and the water changes from its solid state to its liquid state. In other words, the ice will melt. The energy (in joules) needed to melt one gram of a solid is the *enthalpy of fusion* (J/g) for that material. For example, the energy it takes to melt one gram of ice is the enthalpy of fusion for water. Enthalpy of fusion is also referred to as *heat of fusion* or *specific melting heat*. (The heat of fusion can also be shown in kJ/mol.)

In this exercise, you will use simple calorimeters to measure the enthalpy of fusion for water in J/g. If you want to study the movement of heat, you have to work with a closed system—one that is isolated from its environmental surroundings. Here you will do that as well as possible, using some plastic cups as calorimeters to create a system where the transfer of thermal energy can take place with minimal outside influence.

OBJECTIVES

- Observe and use a closed system in which heat transfer takes place.
- Understand the construction and limitations of a simple calorimeter.
- Calculate the heat released in a phase change.

Question

What is the enthalpy of fusion of water?

Observe

It is so common it is taken for granted. A glass of water or soda is too warm, so you put two or three ice cubes in the glass. The energy dance begins as the ice gains thermal energy, changing its phase from solid to liquid. The energy that is transferred to the ice from the surrounding liquid cools the liquid. That movement of energy is an example of heat: the flow of thermal energy from one place to another.

Heat is the movement of thermal energy from one place to another.

Hypothesize

Write a hypothesis about how heat flows in the system where ice and liquid water are mixed. Write your hypothesis as an if-then statement.

100 mL graduated cylinder

plastic foam cups with lids – 4

thick rubber bands – 2

scale

thermometer

approximately 50 g crushed ice

50 mL distilled water

plastic stirring rod

EXPERIMENT

In this experiment, you will construct two calorimeters and allow for heat transfer between known amounts of solid water and liquid water. By observing the temperature change of the water, you will be able to calculate how much heat is absorbed by the ice. Once you know that you can calculate water's enthalpy of fusion.

Setup

1 Collect materials together in the place where you will perform the lab.

2 Create a data table similar to Table 1 below, and title it "Data and Observations of Heat of Fusion of Water Trials."

TABLE 1 Data and Observations of Heat of Fusion of Water Trials

Observations	Trial 1	Trial 2	Trial 3
Mass of cup 1 (empty; in grams)			
Mass of cup 1 with water (g)			
Mass of water (g; calculated)			
Beginning temperature of water in cup 1 (°C)			
Final temperature of water in cup 1 (°C; calculated)			
Change in water temperature (°C; calculated, positive value)			
Mass of cup 2 (empty; in grams)			
Mass of cup 2 with ice (g)			
Mass of ice (g; calculated)			
Mass of cup 1 and water and ice (g)			
Mass of ice remaining (g; calculated)			
Mass of ice that has melted (g; calculated)			
Heat that is needed to melt the ice (To calculate the number of joules needed, use the equation $q = mC\Delta T$ from Step 14.)			
Enthalpy of fusion for each trial (J/g) (Take the number of joules needed to melt the ice and divide it by the mass of the ice that melted.)			

Procedure

1 Place a rubber band around one cup as shown in the photo (below, left). This will allow that cup to fit snuggly inside another cup without touching the bottom of the other cup. It also isolates the top cup from the surrounding air.

2 Place the cup inside a second cup. Label this cup assembly "cup 1." See the photo (below, left) for an example.

3 Punch a small hole in a cup lid for the cup 1 assembly so that you can put a thermometer snuggly through it.

4 Repeat Steps 1–3 to create a second calorimeter, labeling it "cup 2."

5 Measure and record the mass of each empty calorimeter (cups 1 and 2) without the lids.

6 Put 50 mL of distilled water in cup 1. Cover it with the lid. Record and measure the total mass of cup 1 with the water.

7 Insert a thermometer into cup 1 through the hole you created in its lid (see photo below, right). Record the initial temperature of the water. Remove the thermometer.

Place a rubber band around one of the two cups for each cup assembly.

The thermometer is inserted through the hole you make in the cup assembly's lid.

8 Fill cup 2 with crushed ice and pour out any extra water so there is no liquid water left in the calorimeter. Find the mass of the ice and record it on the data table.

9 Carefully add the ice from cup 2 to the water in cup 1. Stir the water and ice mixture for 1 minute.

10 Measure the temperature of the mixture after stirring, and record it in your data table. Make sure to set the thermometer in the middle of the ice-water mixture. The temperature should be very close to, if not exactly, 0°C. Measure the mass of cup 1 with the ice and water and record it in your data table.

continues on next page

⑪ Pour out the liquid, and then measure and record the mass of cup 1 with only the ice.

⑫ Discard the water, clean the cups, and repeat the steps until you have completed three trials. By doing three trials you will be able to average your results.

⑬ Calculate the mass of water, mass of the original amount of ice, change in water temperature, mass of ice remaining, and mass of ice melted, and record them in your data table.

⑭ Calculate the heat needed to melt ice using $q = mC_p\Delta T$, where

- q is the heat absorbed, J

- m is the mass of water in g

- C_p is the specific heat of liquid water = 4.18 J/g × °C

- ΔT is the temperature change in °C.

Calculate the energy needed per gram of ice to melt the ice by taking the value that you just found and dividing it by the mass of ice melted in g. This value is the enthalpy of fusion for H_2O in J/g.

Analyze

Answer each of the following. If a calculation is asked for, show all of your work.

1. Calculate the average heat of fusion of ice by averaging your results for all three trials.

2. Calculate your percent error for each trial, given that the accepted value for the enthalpy of fusion of water is 334 J/g. Remember that percent error is the absolute value of the difference between your value and the accepted value, divided by the accepted value, with the result expressed as a percent.

3. List three sources of error that would account for the differences between your values and the accepted value. Some of your focus should be on considering that heat transfer should only have taken place between the water and the ice in the calorimeter.

4. In this experiment you did three trials. Why was it suggested that you do three trials, not fewer and not more?

Reaction-Rate Factors

The rate of any chemical reaction—the amount of time it takes for the reaction to reach equilibrium—is subject to outside factors that can speed up or slow down the reaction. Temperature, pressure, and the presence of catalysts are but three factors that affect the rate of a chemical reaction. In this lab, you will test how varying amounts of reactants affect the rate of a reaction.

When all three reactants in this experiment are mixed, several things happen. First a reaction liberates iodine (I_2), as shown by the following equation:

$$S_2O_8^{-2} + 2I^- = I_2 + 2SO_4^{-2}$$

Then the iodine reacts with thiosulfate ions, as shown by this equation:

$$2S_2O_3^{2-}(aq) + I_2(aq) \rightarrow S_4O_6^{2-}(aq) + 2I^-(aq)$$

The iodine is now free in the solution. If there is starch in the solution, the free iodine will react with starch to produce a blue color that indicates the reaction has reached equilibrium.

In this experiment, you will tackle the issue of adjusting reactants so that the time it takes for a reaction to reach equilibrium changes. The end point of the reaction is when the blue color appears. Reactions such as those in this lab exercise, where the time can be used to study the rates of reaction, are sometimes called *clock reactions*.

Question

How might the time it takes for a reaction to occur be affected and regulated?

Observe

You have observed factors that affect chemical reactions. For example, consider the making of bread. To the ingredients for bread, a baker adds yeast. Yeast is a single-cell fungus that uses the sugars in the bread mixture to cause chemical reactions to occur within the yeast cell. Many reactions occur in a yeast cell between taking in the sugar and finally releasing the waste product carbon dioxide. But it is the carbon dioxide that makes the bread rise. Anyone who bakes knows that if you put the bread mixture in a cold place, the dough will barely rise, if at all. If you put it in a very hot oven, the bread mixture will not rise because it's too hot. Bread dough placed in a warm environment will rise. The rates of all the reactions that occur inside the yeast cell are dependent on outside factors—most critically, temperature. The rates of the reactions you will study in this exercise will be determined by the amounts or concentrations of reactants.

It takes many reactions influenced by various factors to make bread.

Hypothesize

Write a hypothesis, based on your observations, that describes how the rate of a reaction might be affected by changing the amounts or concentrations of reactants. Write your hypothesis as an if-then statement.

MATERIALS

safety goggles

gloves

25 mL graduated cylinders – 3

100 mL beaker

pipettes – 4

stirring rod

stopwatch

400 mL solution A:
0.20 *M* potassium iodide (KI)

300 mL solution B:
0.0050 *M* sodium thiosulfate
($Na_2S_2O_3$)

bottle of powdered ammonium
persulfate (($NH_4)_2S_2O_8$) – enough
to make 400 mL of 0.1 *M*
solution

distilled water

soluble starch

small labels – 9

EXPERIMENT

In this experiment, you will create seven mixtures, and observe the amount of time needed for a reaction to take place by noting a change in color.

Setup

Note Before you begin, all solutions should be kept at room temperature.

1 Create a data table with the following columns: Mixture; Time for Blue to Appear, Trial 1 (sec); Time for Blue to Appear, Trial 2 (sec). Title the table "Times for Reactions." Leave enough room in the observation column to write up to two sentences about what you have seen.

2 On the lab area in front of you, place the bottles of potassium iodide solution, sodium thiosulfate solution, and ammonium persulfate powder. Label them A, B, and C, respectively. Obtain three graduated cylinders and place one in front of each of the bottles. Label the graduated cylinders to match the substance bottles A, B, and C; that is, you will have pairs of bottles and graduated cylinders labeled A, B, and C. Finally, obtain a beaker that you will use during the procedure to mix the reactants from each graduated cylinder.

As shown here, label your solutions and graduated cylinders to match.

3 Ammonium persulfate does not ship well in solution, so you will have to make up this solution yourself. Using a graduated cylinder, add 400 mL of water to the bottle of powdered ammonium persulfate. Shake the bottle gently. Be sure that all the powder dissolves. Now you have a 0.1 *M* solution of ammonium persulfate to be used in the next part of the lab. This is solution C.

Procedure

1. Using Table 1 below as a guide, create each of the component solutions to be used as reactants for mixture 1. Pour the specified amount of each component into the corresponding cylinders (solution A into cylinder A, for example); doing so will prevent the solutions from being contaminated. (Hint: Use pipettes to help measure accurately, and use a different pipette for each solution.)

You will make up the ammonium persulfate solution before beginning the procedure.

TABLE 1 Components for Mixtures in Experiment

Mixture	Amount of Solution A, 0.2 M Potassium Iodide (mL)	Amount of Water to be Mixed with Solution A in Cylinder A (mL)	Amount of Solution B, 0.005 M Sodium Thiosulfate (mL)	Amount of Solution C, 0.1 M Ammonium Persulfate (mL)	Amount of Water to be Mixed with Solution C in Cylinder C (mL)
1	20.0	0	10.0	20.0	0
2	15.0	5.0	10.0	20.0	0
3	10.0	10.0	10.0	20.0	0
4	5.0	15.0	10.0	20.0	0
5	20.0	0	10.0	15.0	5.0
6	20.0	0	10.0	10.0	10.0
7	20.0	0	10.0	5.0	15.0

continues on next page

2 Pour 10 mL of solution B into a clean 100 mL beaker. Add 5 drops of starch solution. Pour the contents of cylinders A and C into the beaker and start the stopwatch, stirring the mixture occasionally. When the solution turns color, stop the stopwatch. Record the elapsed time in the data table. Some solutions may change quickly, whereas others may take several minutes to change color.

Each mixture will be observed and timed for color change in the 100 mL beaker.

3 Rinse the beaker, the graduated cylinders, and the stirrer thoroughly with tap water.

4 Repeat Steps 2 and 3 until you obtain two approximately equal reaction times. You will have enough materials to attempt three full trials.

5 Continue the process described in Steps 1–4 until you have created all seven reaction mixtures and have recorded all the reaction times.

Analyze

Answer each of the following thoroughly.

1. Which of the reaction mixtures produced the fastest time for the reaction?

2. Which of the reaction mixtures produced the slowest time for the reaction?

3. How does concentration of reactants affect reaction rate?

4. What role does starch play in this reaction?

5. What are the negative ions from each of the solutions that were used in this experiment?

6. Solution A in reaction mixtures 2, 3, and 4 was diluted. What was the purpose of diluting the solution? What is the result when the molarity of the solution is reduced?

Electroplating

Electroplating is a type of electrolysis in which the cathode becomes covered with a thin film of metal. Metal ions flow from the anode, where they are oxidized, to the cathode, where they are reduced from ions to atoms. Electroplating is used to place the shiny chrome on car bumpers and to put the silver covering on silver-plated utensils. For example, to silver-plate a spoon, ions of silver that formed at the anode are deposited as silver atoms onto the spoon, which is the cathode.

Italian chemist Luigi V. Brugnatelli is the founder of modern electrochemistry, having developed the process in 1805, after his friend Alessandro Volta invented the battery. In the late 1800s, higher currents became available and the massive production of electroplated materials became possible.

Today, we take electroplated objects for granted and use them in everyday life. Plated jewelry is one example of an application that is standard in many manufacturing processes. In this experiment, you will gain insight into the process by which such jewelry and other objects are made.

Question

How does the process of electroplating coat an object with a thin film of metal?

Observe

From silverware to engine parts, you can find objects that are coated with metals. Covering materials with a thin film of metal makes them resist rusting, achieve a desired look, and last longer. Think of the fences, car parts, jewelry, and other objects in your everyday life where a material was covered with a thin sheet of metal.

How do you coat an object, such as a pot or pan, with a thin layer of metal?

Hypothesize

Write a hypothesis that describes how an object could be coated with a metal. Use the terms *oxidation*, *reduction*, *anode*, and *cathode* in your hypothesis. Write your hypothesis as an if-then statement.

MATERIALS

safety goggles

gloves

alligator clips – 4 (2 red, 2 black)

250 mL beaker

6-volt battery

coin (not a penny)

nail (not galvanized)

steel wool (or iron wool)

copper wire – 2 pieces,
approximately 30 cm each

copper strip,
0.25 mm x 1 cm x 5 cm

100 mL of 1 M copper sulfate
solution ($CuSO_4$), – 2

paper towels

EXPERIMENT

In this experiment, you will electroplate an object using an electroplating technique and an electrolytic cell. You will then remove the plating by reversing the direction of the flow of electrons from that cell.

Gather your materials before beginning the lab.

Setup

1 Create a data table like Table 1 below, and title it "Table 1: Observations of the Copper-Plating of Coin."

2 Create a data table like Table 2 below, and title it " Table 2: Observations of the Copper-Plating of Nail."

TABLE 1 Observations of the Copper-Plating of Coin

Observation Time	Observations: Condition of Coin
After 10 min	
After 10 min with the current reversed	
After 15 min with the current reversed	

TABLE 2 Observations of the Copper-Plating of Nail

Observation Time	Observations: Coin to Nail
After 3 min	
After 5 min	
After 10 min	

3 Thoroughly clean the coin and the nail with steel wool. An additional or alternative method for cleaning the metal is to coat it with a thin layer of catsup, let it sit for 60 sec, and then wipe, rinse, and dry it off.

Procedure

SAFETY NOTE Wear goggles and gloves to do this lab exercise.

1 Using a black alligator clip, securely attach a length of copper wire to the object as shown in the photo below.

With a black alligator clip, attach a length of copper wire to the coin.

2 Polish the copper strip thoroughly with the steel wool. Use a red alligator clip to attach the 30-cm length of copper wire to the strip of copper.

3 Pour 100 mL of 1 M copper sulfate ($CuSO_4$) solution into a 250 mL beaker. Submerge the copper strip on one side of the beaker and the coin on the other side, as shown in the photo on the right. Doing this is made easier by bending the wire at the point where it crosses the lip of the beaker. The coin and strip should be partially submerged. Submerge the alligator clips as little as possible, otherwise they may accidentally become electroplated.

The coin and strip, but not their alligator clips, should be partly submerged in the beaker (you don't want the clips to become electroplated).

continues on next page

SAFETY NOTE **The wires should never touch each other at any point.**

4 Connect the wire attached to the copper strip to the positive terminal of the battery using a red alligator clip. In the same way, connect the coin to the negative terminal of the battery using a black alligator clip. Be sure all connections are secure.

5 Allow the electroplating process to run for 10 minutes.

6 Lift each wire out of the $CuSO_4$ and record your observations in Table 1.

7 Reverse the connections by exchanging the alligator clips and the wires on the battery. Record your observations in Table 1 after 10 minutes and again after 15 minutes.

8 Properly dispose of your materials and thoroughly rinse the 250 mL beaker with tap water.

9 Pour the second 100 mL bottle of 1 *M* copper sulfate solution into the washed 250 mL beaker.

10 Repeat Steps 1–5 of the above procedure with a nail instead of a coin to copper-plate the nail. Instead of using an alligator clip on the nail, wind the copper wire around the nail two or three times. Record your observations in Table 2 after 3, 5, and 10 min of electroplating.

Once conncections are secure, the electroplating process begins.

Analyze

Answer each of the following thoroughly.

1. Sketch your electrolytic cell. Using arrows, show the direction and movement of electron flow when a current flows.

2. Sketch your electrochemical cell. Using arrows, show the direction and movement of electron flow when the cathode is not electroplated.

3. Suggest two substances other than the nail that could have been used for both the anode and the cathode and would have worked in the electroplating process.

4. Which pieces of equipment and materials are involved in the reduction reaction that occurred in your system during the plating of the coin?

5. Which pieces of equipment and materials are involved in the oxidation reaction that occurred in your system during the plating of the nail?

Modeling Organic Compounds

Gasoline, motor oil, and plastics are just a few of the hundreds of organic compounds we come across in daily life. Carbon and hydrogen form the atomic basis for organic compounds. Compounds that contain only carbon and hydrogen are called *hydrocarbons*. *Alkanes* are hydrocarbons that have only single bonds. *Alkenes* and *alkynes* are unsaturated hydrocarbons, which contain double or triple bonds. Hydrocarbons can also be cyclic in structure. Oxygen and other elements are important in many organic compounds such as alcohols.

Many hydrocarbons exist as *isomers* of one another. Isomers are two or more chemical compounds that have the same chemical formula but differ in the arrangement of their atoms. Isomers were first detected in 1827, when Friedrich Wöhler prepared cyanic acid and noted that although its formula was identical to that of fulminic acid, its properties were quite different.

In 1849, Louis Pasteur separated tiny crystals of tartaric acid into their two mirror-image forms. The individual molecules that made up each type of crystal were isomers, too.

Question

Can you model organic compounds to provide information about their structure?

Observe

The chemical formula for octane is C_8H_{18}. What does that formula tell you? Yes, it has 8 carbon atoms and 18 hydrogen atoms. Just as important, what does the formula *not* tell you about octane? You're right if you answered that the formula does not tell you how the atoms are arranged in the compound octane. In thinking about organic compounds, remember that each carbon atom forms four bonds. Observe the simplest of all organic molecules, methane, in the illustration of that molecule shown here. It has one carbon atom. How many hydrogen atoms are bonded covalently to the single carbon atom in methane? Are all the bonds single bonds?

In this activity, you will create models of some molecules to increase your understanding of the arrangement of atoms in a molecule and the variation in how those atoms are arranged.

Hypothesize

Write a hypothesis that predicts how organic molecules may be modeled using colored plastic foam balls and pipe cleaners or other simple materials.

- **Create models of organic compounds.**
- **Explore isomers and functional groups of organic compounds.**

How many hydrogen atoms are bonded covalently to the single carbon atom in methane?

molecular modeling kit

paper

pencil

EXPERIMENT

In this activity, you will create ball-and-stick models of straight chain alkanes. Remember, an alkane is an organic molecule composed of only carbon and hydrogen and structured with only single bonds. Later in the activity, you will create models of isomers of heptane.

Procedure

1 From the modeling kit, obtain one black ball. Insert four bond sticks at equal angles as far apart from each other as possible around the black ball, as shown in the photo.

> **Note** All black balls, representing carbon atoms, must have four pipe cleaners sticking out of them. Also remember that the hydrogens have to be arranged so that they are as far apart from one another as possible.

2 Attach a yellow ball to each of the pipe cleaners. You have just created a methane model. What is the chemical formula of methane?

3 Sketch the model you have just made and write its chemical formula next to the sketch. Use a solid (filled) circle to represent carbon atoms and open circles for hydrogen atoms.

Methane assembly: one black ball, four yellow balls, four pipe cleaners

4 Repeat Steps 1–3 so that you have two methane molecules.

5 Use the two methane molecules to create an alkane with two carbon atoms. Be sure each carbon atom has four bonds. This model represents ethane. What is the chemical formula of ethane?

6 Sketch the model you have just created.

7 Repeat Steps 1–3 so that you have another methane molecule.

8 Create an alkane with three carbon atoms. Be sure each carbon atom has four bonds. You have just modeled propane. What is the chemical formula of propane?

Alkane assembly with three carbon atoms

9 Sketch the model you have just created.

10 Repeat Steps 9–11, making each molecule longer by adding one carbon atom. Then sketch the result. Continue this process until you have a molecule with 10 black balls, representing decane.

11 Write the chemical formula for each molecule you produced in Step 13. Sketch each alkane.

Add to the chain by adding another carbon with four bonds, until you have a 10-carbon molecule.

Heptane molecule model

12 Re-create the models that you created for hexane and methane. Create a heptane molecule by attaching the black ball of the methane to one of the interior black balls of the hexane. That means rearranging some of the yellow balls. Be sure each carbon atom has four bonds. You have created one of the isomers of heptane. Sketch the model you have just made. Write a description of how the two isomers differ.

13 Reestablish your models of methane and hexane. Then create two new isomers of heptane. Sketch each molecule when you are finished.

14 Using pencil and paper, figure out how many isomers of heptane are possible.

Analyze

Answer each of the following thoroughly.

1. How many possible isomers of heptane are there?

2. Which is the smallest of the hydrocarbons that you made that could have an isomer? Sketch what the model of that isomer would look like.

3. The first four models of alkanes that you created are of molecules that are gases at room temperature. Refer to Table 1 below and note by looking at the boiling points that the rest of the alkanes are liquids at room temperature and have increasing boiling points. Consider your models, and infer what might contribute to the increase in boiling point as the carbon chains get larger.

TABLE 1 Boiling Points of Alkanes

	Molecular Formula	Boiling Point (°C)	Number of Structural Isomers
Methane	CH_4	−61.0	1
Ethane	C_2H_6	−88.5	1
Propane	C_3H_8	−42.0	1
Butane	C_4H_{10}	0.5	2
Pentane	C_5H_{12}	36.0	3
Hexane	C_6H_{14}	68.7	5
Heptane	C_7H_{16}	98.5	9
Octane	C_8H_{18}	125.6	18
Nonane	C_9H_{20}	150.7	35
Decane	$C_{10}H_{22}$	174.1	75

Calculating Half-Life

Note the picture of an archaeological site that opens this lab. Is there any way to determine the age of the wood in this picture? As you know, the process of radioactive dating can do just that.

What is the scientific basis for radioactive dating? One dating technique involves taking a once-living substance and comparing the amounts of two isotopes of carbon in it. Carbon-14, written as ^{14}C, is an isotope of carbon that is radioactive. Carbon-12, written as ^{12}C, is a nonradioactive isotope of carbon. It is the most common isotope of carbon in the environment. Trees that take in carbon dioxide (CO_2) get mostly ^{12}C as part of their CO_2, but they also take in small amounts of ^{14}C. Once a tree is cut down, however, it no longer absorbs carbon dioxide. The ^{14}C in the wood decays over time because ^{14}C is radioactive; over time, its amount in the wood decreases. By contrast, the amount of ^{12}C does not decrease because it is not radioactive. By determining the ratios of the two isotopes—one ratio in the environment and another ratio in the wood—scientists can date the wood. Knowing the half-life of ^{14}C—that is, how long it takes for radioactive decay to reduce the mass of radioactive ^{14}C by one-half, is essential to this process.

OBJECTIVES

- Define *half-life*.
- Recognize the symbol for half-life.
- Calculate how much of a sample of a radioactive substance remains after a certain number of half-lives have passed.

What does half-life have to do with establishing the age of things?

Question

How can half-life be used to determine the age of an object?

Observe

Perhaps you have seen moldy bread or a moldy orange in your kitchen. The amount of mold and the appearance of the orange give you a clue as to how long the bread or orange has been sitting in warm, damp conditions. In a similar way, scientists evaluate the age of some substances by calculating how much of certain radioactive materials have decayed. You have learned that the rate of decay for any radioactive substance is measured by its half-life—that is, how long it takes for one-half of the entire radioactive sample to change into its nonradioactive form.

Hypothesize

Write a hypothesis that describes how the amount of decayed substance can be used to determine the age of a substance that contains some radioactive materials.

100 of the same coins, such as pennies

plastic box with lid

either

pencil

graph paper

lined paper

calculator

or

graphing calculator or other graphing technology, such as a spreadsheet program

EXPERIMENT

In this activity, you will first explore working with the mathematics of half-lives. Then you will take on the role of a radioactivity detective and solve a problem by applying your half-life knowledge to a practical scientific problem.

Advance Prep (1 day ahead)

Obtain 100 of the same coins of any kind, and a plastic box with a lid. Place the coins in the box so that they all have the "heads" side facing up.

Setup

1. Create a data table with the following columns: Trial Number, Number of Heads. The table should have enough rows to include eight trials plus Trial 0. The number of heads for Trial 0 will be 100. Title the table "Results of Coin Flips." You will repeat this part of the experiment three times, so leave columns for three "Number of Heads" results.

2. Create a data table like Table 1 below, and title it "Analysis of Decay."

TABLE 1 Analysis of Decay

Time Passed (Half-Lives)	Time Passed (Years)	^{14}C Atoms at the Beginning of the Half-Life	^{14}C Atoms at the End of the Half-Life
0	0	1,000,000	
1	5,750		
2			
3			
4			
5			
6			
7			
8			

Place all coins in the box with the heads side facing up.

Procedure

Modeling Half-Life with a Coin Flip

1 Shake the box and empty the coins onto the table. Separate the heads from the tails. Count the number of heads. Each head represents 1 atom out of the sample of 100 that has not decayed. Record your result for Trial 1 in the Results of Coin Flips table.

2 Take the heads from Trial 1 and repeat Step 1. Then, continue to repeat until you have completed eight trials.

3 Plot a graph of number of heads (*y*-axis) vs. trial number (*x*-axis). Begin at Trial 0 and assume that you started with 100 heads. Briefly describe how this experiment models radioactive decay and half-lives.

4 Repeat the experiment two more times to ensure that you have representative data.

Extending the Coin-Flip Model

1 Scientists have determined that the half-life of ^{14}C is 5,750 years. Use that information to complete the Analysis of Decay table, which begins with 1,000,000 atoms of ^{14}C.

2 Create a graph of number of ^{14}C atoms vs. time.

3 Think about it: A piece of wood is found and is thought to perhaps be from an ancient fire circle. Scientists find that the wood contains an amount of ^{14}C that is approximately $\frac{1}{16}$ of current atmospheric ^{14}C levels. Determine approximately how many years ago the tree was chopped down to be used for firewood.

4 Write a paragraph that describes your thought process in obtaining your answer.

Analyze

Answer each of the following thoroughly.

1. Describe in a paragraph how the first part of this exercise models the radioactive decay of I million atoms.

2. What is the general shape of your graph?

3. A student has 25 heads left from the original sample of 100. Approximately how many trials has the student done? What if 10 heads were left?

4. How old is the wood, approximately?

5. Archeologists find bone material from what seems to be a human leg. They find after analysis that the ^{14}C content is $\frac{1}{2}$ of the current amount of ^{14}C found in the environment. Approximately how old is the bone?

6. Why is ^{14}C dating a good method to use for dating a human leg bone, but not so good a method for dating a dinosaur leg bone?

Safety in the Lab

Scientists understand that conducting experiments involves a certain amount of hazard and risk. They have identified certain safety practices and guidelines that address the hazards and risks involved in laboratory work. Follow these practices and guidelines, and use common sense, to ensure your safety in the laboratory.

Lab Setup

- Make sure your lab area has adequate ventilation. When possible, open windows; otherwise, turn the fan switch on your thermostat to the ON position. Set up an electric fan to help ventilate the lab area.

- Keep drawers and cabinets closed to prevent physical hazards.

- Identify a location with easy and immediate access to fresh, running water. This is important for flushing eyes and skin in case of contact with chemicals.

- If you are using an area where food is prepared or consumed, secure all food items in such a way as to avoid contamination.

- Keep a fire extinguisher in the lab area and know how to use it.

- Post the number to the nearest poison control center near a telephone. You can find this number by calling the national poison control number: **1-800-222-1222**.

Personal Protection

- Wear gloves throughout lab preparation, the entire lab procedure, and during cleanup when working with chemicals. Always dispose of the used gloves before leaving the lab area.

- Wear clothing you can remove easily in case of an accident. Clothes should cover the body from the neck to at least the knees.

- Wear closed-toe and closed-heel shoes. Do not wear high heels, shoes made of woven materials, or sandals in the lab area.

- Tie back long hair, and remove jewelry before entering the lab area.

Lab Protocol

- If possible, have an adult or peer present while conducting all labs.

- Never ingest anything in the lab. Eating, drinking, and chewing gum are not allowed.

- Do not ingest, taste, or smell any chemicals.

- Flames are not allowed in the lab area when using flammable gas or liquids.

- Keep chemical and solution containers closed until they are needed.

- Assemble laboratory apparatus away from the edge of working surfaces.

- Never pipet by mouth.

- Do not shake filled test tubes or beakers, unless directed to do so in the lab procedure.

- Never place materials on the floor, unless directed to do so in the lab procedure.

- Never leave an experiment unattended, unless directed to do so in the lab procedure.

- Always check glassware, and discard any with chips, breaks, or cracks in a safe manner.

- Clean up broken glassware as soon as it is safe to do so, and discard in a safe manner.

- Clean glassware before returning it to storage.

- Always wash your hands thoroughly with soap and water after cleanup and before eating or drinking.

- Clean up spills immediately.

- Always discard used and spilled chemicals and solutions down the drain, diluted with plenty of water.

FIRST AID IN CASE OF ACCIDENT

Be sure to seek professional help in case of any chemical accident.

If you inhale gases
Immediately move away from your laboratory to a place with fresh air.
If you swallow any chemicals, rinse your mouth with water. Drink a large amount of fresh water. Do not induce vomiting. Call 911 and the poison control center immediately. The telephone number is 1-800-222-1222.

If you get any chemicals in your eyes
Rinse your eyes immediately with fresh water. Flush your eyes thoroughly. Call for medical help immediately.

If chemicals come in contact with your skin
Rinse off the area for at least 3 minutes. Dry the skin and check for any reddening of the skin. Call for medical help if any area of the skin seems damaged.

If you are burned
Rinse the area thoroughly with water. Do not apply ointments or other remedies to the burn. Cover the burn with a gauze bandage. If the burn is serious, call for immediate medical help.

If you are cut
Do not rinse with water unless the cut is dirty. Apply a bandage. Seek medical attention if the cut is serious. Have a doctor remove any splinters that are part of the cut.

General Procedures

Follow these general procedures each time you conduct an experiment. They will help you develop good lab practices.

Setting Up and Maintaining Your Lab Area

- Read through the entire procedure before beginning any lab.
- Review the list of materials prior to any lab because you may need to supply several items. Gather all materials in your lab area before beginning any lab.
- Set up a lab area where you can organize your materials and have room to set up your lab. (For most labs, a countertop or table will work well.)
- Always keep a copy of the Safety in the Lab guidelines in your lab area. Follow all procedures in the Lab Setup section of these guidelines.
- When using measuring utensils in several steps, wash and dry the utensils between steps.
- If you do not complete a lab, store all materials out of the reach of small children or pets until you are ready to complete the lab. Notify everyone in the home that you are conducting an experiment, and tell them not to touch it.

Cleaning Up Your Lab Area

- Clean up and properly store materials after each lab. (Materials and equipment are reused in labs.)
- Thoroughly clean your hands, as well as surfaces, containers, and like items, with soap and water. Thoroughly dry materials before storing them.

Taking Good Measurements

Take careful measurements during a lab, and repeat tests until you are confident about your results. If you think there is an error (for example, you may not be certain you started the stopwatch at the right time or you think you miscounted the time), do the procedure again.

Length: Measure in centimeters (cm) or tenths of a centimeter, depending on the detail you are able to observe.

Time: Measure in seconds (s) or minutes (min).

Temperature: Measure in degrees Celsius (°C).

Volume: Measure in milliliters (mL).

Mass: Measure in grams (g).

Recording Data

Use a data table to record your data. Make sure your data table is prepared before you do the lab. You may use scratch paper to record your data during the lab, and then transfer your data to a computer for a final report.

Plotting Data

Plot the independent variable on the x-axis (horizontal) and the dependent variable on the y-axis (vertical).

Trend Lines

Use trend lines to show the general relationship between the independent and dependent variables. Trend lines may be straight or show a curve, but they are not an attempt to connect every point on a graph.

Chemical Warnings

Chemical	Amount	Strength	Warning	Warning Note
Alkalinity Sample A *Lab 9*	60 mL			Not for human consumption. Use under adult supervision. Avoid eye/skin contact. Flush with water immediately.
Alkalinity Sample B *Lab 9*	60 mL			Not for human consumption. Use under adult supervision. Avoid eye/skin contact. Flush with water immediately.
Alum *Lab 5*	2 g			Harmful if swallowed. Causes irritation. Do not ingest or inhale. Avoid eye and skin contact: flush with water. Wear appropriate safety equipment.
Aluminum chloride *Lab 4*	10 mL	0.1 *M*	Toxic	Harmful if swallowed. Causes irritation. Do not ingest or inhale. Avoid eye and skin contact: flush with water. Wear appropriate safety equipment.
Aluminum sulfate *Lab 4*	20 mL	0.1 *M*	Toxic	Harmful if swallowed. Causes irritation. Do not ingest or inhale. Avoid eye and skin contact: flush with water. Wear appropriate safety equipment.
Ammonia *Lab 5*	20 mL	Household		Harmful if swallowed. Causes irritation. Do not ingest or inhale. Avoid eye and skin contact: flush with water. Wear appropriate safety equipment.
Ammonium hydroxide *Lab 3*	10 mL	1.0 *M*	Corrosive	Harmful if swallowed. Causes irritation. Do not ingest or inhale. Avoid eye and skin contact: flush with water. Wear appropriate safety equipment.
Ammonium persulfate reagent *Lab 11*	9.128 g		Toxic	Harmful if swallowed. Causes irritation. Do not ingest or inhale. Avoid eye and skin contact: flush with water. Wear appropriate safety equipment.
Ammonium vanadate *Lab 3*	5 mL	0.1 *M*	Toxic	Harmful if swallowed. Causes irritation. Do not ingest or inhale. Avoid eye and skin contact: flush with water. Wear appropriate safety equipment.
Barium chloride *Lab 4*	20 mL	0.1 *M*	Toxic	Harmful if swallowed. Causes irritation. Do not ingest or inhale. Avoid eye and skin contact: flush with water. Wear appropriate safety equipment.

Chemical	Amount	Strength	Warning	Warning Note
Barium nitrate *Lab 4*	10 mL	0.1 *M*	Toxic	Harmful if swallowed. Causes irritation. Do not ingest or inhale. Avoid eye and skin contact: flush with water. Wear appropriate safety equipment.
Calcium nitrate *Lab 3*	5 mL	0.1 *M*		Harmful if swallowed. Causes irritation. Do not ingest or inhale. Avoid eye and skin contact: flush with water. Wear appropriate safety equipment.
Citric acid *Lab 2*	10 mL	3 *M*		Not for human consumption. Use under adult supervision. Avoid eye/skin contact. Flush with water immediately.
Cobalt nitrate *Lab 3*	5 mL	0.1 *M*	Toxic	Harmful if swallowed. Causes irritation. Do not ingest or inhale. Avoid eye and skin contact: flush with water. Wear appropriate safety equipment.
Copper(II) nitrate *Lab 3*	5 mL	0.1 *M*	Toxic	Harmful if swallowed. Causes irritation. Do not ingest or inhale. Avoid eye and skin contact: flush with water. Wear appropriate safety equipment.
Copper(II) nitrate w/phenolphthalein *Lab 6*	25 mL	0.1 *M*	Toxic	Harmful if swallowed. Causes irritation. Do not ingest or inhale. Avoid eye and skin contact: flush with water. Wear appropriate safety equipment.
Copper sulfate *Lab 5*	20 mL	0.1 *M*	Toxic	Harmful if swallowed. Causes irritation. Do not ingest or inhale. Avoid eye and skin contact: flush with water. Wear appropriate safety equipment.
Copper sulfate *Lab 12*	2 x 100 mL	1 *M*	Toxic	Harmful if swallowed. Causes irritation. Do not ingest or inhale. Avoid eye and skin contact: flush with water. Wear appropriate safety equipment.
Denatured alcohol *Lab 1*	2 x 20 mL		Flammable	Harmful if swallowed. Causes irritation. Do not ingest or inhale. Avoid eye and skin contact: flush with water. Wear appropriate safety equipment.
Hydrochloric acid *Lab 3*	10 mL	3.0 *M*	Corrosive	Harmful if swallowed. Causes irritation. Do not ingest or inhale. Avoid eye and skin contact: flush with water. Wear appropriate safety equipment.

Chemical	Amount	Strength	Warning	Warning Note
Iron(II) sulfate w/phenolphthalein *Lab 6*	25 mL	0.1 *M*	Toxic	Harmful if swallowed. Causes irritation. Do not ingest or inhale. Avoid eye and skin contact: flush with water. Wear appropriate safety equipment.
Iron(III) nitrate w/phenolphthalein *Lab 6*	25 mL	0.1 *M*	Toxic	Harmful if swallowed. Causes irritation. Do not ingest or inhale. Avoid eye and skin contact: flush with water. Wear appropriate safety equipment.
Iron nitrate *Lab 3*	5 mL	0.1 *M*	Toxic	Harmful if swallowed. Causes irritation. Do not ingest or inhale. Avoid eye and skin contact: flush with water. Wear appropriate safety equipment.
Magnesium chloride *Lab 4*	20 mL	0.1 *M*		Harmful if swallowed. Causes irritation. Do not ingest or inhale. Avoid eye and skin contact: flush with water. Wear appropriate safety equipment.
Magnesium nitrate *Lab 4*	20 mL	0.1 *M*		Harmful if swallowed. Causes irritation. Do not ingest or inhale. Avoid eye and skin contact: flush with water. Wear appropriate safety equipment.
Magnesium sulfate *Lab 4*	10 mL	0.1 *M*		Harmful if swallowed. Causes irritation. Do not ingest or inhale. Avoid eye and skin contact: flush with water. Wear appropriate safety equipment.
Magnesium sulfate *Lab 5*	4 g			Harmful if swallowed. Causes irritation. Do not ingest or inhale. Avoid eye and skin contact: flush with water. Wear appropriate safety equipment.
Manganese sulfate *Lab 3*	5 mL	0.1 *M*		Harmful if swallowed. Causes irritation. Do not ingest or inhale. Avoid eye and skin contact: flush with water. Wear appropriate safety equipment.
Potassium chloride *Lab 2*	10 g			Harmful if swallowed. Causes irritation. Do not ingest or inhale. Avoid eye and skin contact: flush with water. Wear appropriate safety equipment.
Potassium chloride *Lab 4*	10 mL	0.1 *M*		Harmful if swallowed. Causes irritation. Do not ingest or inhale. Avoid eye and skin contact: flush with water. Wear appropriate safety equipment.

Chemical	Amount	Strength	Warning	Warning Note
Potassium chromate *Lab 4*	10 mL	0.2 *M*	Toxic	Harmful if swallowed. Causes irritation. Do not ingest or inhale. Avoid eye and skin contact: flush with water. Wear appropriate safety equipment.
Potassium iodide *Lab 11*	400 mL	0.2 *M*		Harmful if swallowed. Causes irritation. Do not ingest or inhale. Avoid eye and skin contact: flush with water. Wear appropriate safety equipment.
Potassium nitrate *Lab 3*	5 mL	0.1 *M*		Harmful if swallowed. Causes irritation. Do not ingest or inhale. Avoid eye and skin contact: flush with water. Wear appropriate safety equipment.
Silver nitrate *Lab 4*	10 mL	0.2 *M*	Toxic	Harmful if swallowed. Causes irritation. Do not ingest or inhale. Avoid eye and skin contact: flush with water. Wear appropriate safety equipment.
Silver nitrate *Lab 5*	20 mL	0.1 *M*	Toxic	Harmful if swallowed. Causes irritation. Do not ingest or inhale. Avoid eye and skin contact: flush with water. Wear appropriate safety equipment.
Sodium chloride *Lab 5*	10 mL	0.1 *M*		Harmful if swallowed. Causes irritation. Do not ingest or inhale. Avoid eye and skin contact: flush with water. Wear appropriate safety equipment.
Sodium chloride, coarse *Lab 8*	25 g			Harmful if swallowed. Causes irritation. Do not ingest or inhale. Avoid eye and skin contact: flush with water. Wear appropriate safety equipment.
Sodium chloride, fine *Lab 8*	10 g			Harmful if swallowed. Causes irritation. Do not ingest or inhale. Avoid eye and skin contact: flush with water. Wear appropriate safety equipment.
Sodium chloride, pellet *Lab 8*	3			Harmful if swallowed. Causes irritation. Do not ingest or inhale. Avoid eye and skin contact: flush with water. Wear appropriate safety equipment.
Sodium chromate *Lab 4*	10 mL	0.2 *M*	Toxic	Harmful if swallowed. Causes irritation. Do not ingest or inhale. Avoid eye and skin contact: flush with water. Wear appropriate safety equipment.
Sodium hydroxide *Lab 2*	10 mL	0.1 *M*		Harmful if swallowed. Causes irritation. Do not ingest or inhale. Avoid eye and skin contact: flush with water. Wear appropriate safety equipment.

Chemical	Amount	Strength	Warning	Warning Note
Sodium hydroxide *Lab 4*	10 mL	0.2 *M*	Toxic	Harmful if swallowed. Causes irritation. Do not ingest or inhale. Avoid eye and skin contact: flush with water. Wear appropriate safety equipment.
Sodium hydroxide *Lab 5*	10 mL	0.1 *M*		Harmful if swallowed. Causes irritation. Do not ingest or inhale. Avoid eye and skin contact: flush with water. Wear appropriate safety equipment.
Sodium hydroxide *Lab 6*	20 mL	0.1 *M*		Harmful if swallowed. Causes irritation. Do not ingest or inhale. Avoid eye and skin contact: flush with water. Wear appropriate safety equipment.
Sodium phosphate *Lab 5*	10 mL	0.1 *M*		Harmful if swallowed. Causes irritation. Do not ingest or inhale. Avoid eye and skin contact: flush with water. Wear appropriate safety equipment.
Sodium sulfate *Lab 4*	20 mL	0.1 *M*		Harmful if swallowed. Causes irritation. Do not ingest or inhale. Avoid eye and skin contact: flush with water. Wear appropriate safety equipment.
Sodium thiosulfate *Lab 11*	300 mL	0.005 *M*		Harmful if swallowed. Causes irritation. Do not ingest or inhale. Avoid eye and skin contact: flush with water. Wear appropriate safety equipment.
Soluble starch *Lab 11*	30 mL	1%		Harmful if swallowed. Causes irritation. Do not ingest or inhale. Avoid eye and skin contact: flush with water. Wear appropriate safety equipment.
Zinc nitrate *Lab 3*	5 mL	0.1 *M*	Toxic	Harmful if swallowed. Causes irritation. Do not ingest or inhale. Avoid eye and skin contact: flush with water. Wear appropriate safety equipment.
Zinc sulfate *Lab 5*	10 mL	0.1 *M*		Harmful if swallowed. Causes irritation. Do not ingest or inhale. Avoid eye and skin contact: flush with water. Wear appropriate safety equipment.
Zinc, powdered *Lab 5*	5 g			Harmful if swallowed. Causes irritation. Do not ingest or inhale. Avoid eye and skin contact: flush with water. Wear appropriate safety equipment.

Periodic Table

Atomic number — 1
Symbol — H
Name — Hydrogen
Average atomic mass — 1.0079

Cu	Solid
Br	Liquid
Ar	Gas
Am	Not found in nature

Group 1
1A

| Period 1 | 1 H Hydrogen 1.0079 | | | | | | | | |

Group 2
2A

| Period 2 | 3 Li Lithium 6.941 | 4 Be Beryllium 9.0122 |
| Period 3 | 11 Na Sodium 22.990 | 12 Mg Magnesium 24.305 |

	Group 3 3B	Group 4 4B	Group 5 5B	Group 6 6B	Group 7 7B	Group 8 8B	Group 9 8B
Period 4	21 Sc Scandium 44.956	22 Ti Titanium 47.90	23 V Vanadium 50.941	24 Cr Chromium 51.996	25 Mn Manganese 54.938	26 Fe Iron 55.847	27 Co Cobalt 58.933
Period 5	39 Y Yttrium 88.906	40 Zr Zirconium 91.22	41 Nb Niobium 92.906	42 Mo Molybdenum 95.94	43 Tc Technetium (98)	44 Ru Ruthenium 101.07	45 Rh Rhodium 102.91
Period 6	71 Lu Lutetium 174.97	72 Hf Hafnium 178.49	73 Ta Tantalum 180.95	74 W Tungsten 183.85	75 Re Rhenium 186.21	76 Os Osmium 190.2	77 Ir Iridium 192.22
Period 7	103 Lr Lawrencium (262)	104 Rf Rutherfordium (261)	105 Db Dubnium (262)	106 Sg Seaborgium (263)	107 Bh Bohrium (264)	108 Hs Hassium (265)	109 Mt Meitnerium (268)

Period 4: 19 K Potassium 39.098 | 20 Ca Calcium 40.08
Period 5: 37 Rb Rubidium 85.468 | 38 Sr Strontium 87.62
Period 6: 55 Cs Cesium 132.91 | 56 Ba Barium 137.33
Period 7: 87 Fr Francium (223) | 88 Ra Radium (226)

Lanthanide Series

| 57 La Lanthanum 138.91 | 58 Ce Cerium 140.12 | 59 Pr Praseodymium 140.91 | 60 Nd Neodymium 144.24 | 61 Pm Promethium (145) | 62 Sm Samarium 150.4 |

Actinide Series

| 89 Ac Actinium (227) | 90 Th Thorium 232.04 | 91 Pa Protactinium 231.04 | 92 U Uranium 238.03 | 93 Np Neptunium (237) | 94 Pu Plutonium (244) |

Nonmetals

- Noble gases
- Halogens
- Other nonmetals

Metalloids

Metals

- Alkali metals
- Alkaline earth metals
- Transition metals
- Other metals

			Group 13 3A	Group 14 4A	Group 15 5A	Group 16 6A	Group 17 7A	Group 18 8A
								2 **He** Helium 4.0026
			5 **B** Boron 10.81	6 **C** Carbon 12.011	7 **N** Nitrogen 14.007	8 **O** Oxygen 15.999	9 **F** Fluorine 18.998	10 **Ne** Neon 20.179
Group 10 8B	Group 11 1B	Group 12 2B	13 **Al** Aluminum 26.982	14 **Si** Silicon 28.086	15 **P** Phosphorus 30.974	16 **S** Sulfur 32.06	17 **Cl** Chlorine 35.453	18 **Ar** Argon 39.948
28 **Ni** Nickel 58.71	29 **Cu** Copper 63.546	30 **Zn** Zinc 65.38	31 **Ga** Gallium 69.72	32 **Ge** Germanium 72.59	33 **As** Arsenic 74.922	34 **Se** Selenium 78.96	35 **Br** Bromine 79.904	36 **Kr** Krypton 83.80
46 **Pd** Palladium 106.4	47 **Ag** Silver 107.87	48 **Cd** Cadmium 112.41	49 **In** Indium 114.82	50 **Sn** Tin 118.69	51 **Sb** Antimony 121.75	52 **Te** Tellurium 127.60	53 **I** Iodine 126.90	54 **Xe** Xenon 131.30
78 **Pt** Platinum 195.09	79 **Au** Gold 196.97	80 **Hg** Mercury 200.59	81 **Tl** Thallium 204.37	82 **Pb** Lead 207.2	83 **Bi** Bismuth 208.98	84 **Po** Polonium (209)	85 **At** Astatine (210)	86 **Rn** Radon (222)
110 **Ds** Darmstadtium (269)	111 **Rg** Roentgenium (272)	112 **Uub** Ununbium (277)		114 **Uuq** Ununquadium				

When the average atomic mass is shown in parentheses, it means that this is the mass number of the most stable isotope. For these elements the average atomic mass cannot be determined.

63 **Eu** Europium 151.96	64 **Gd** Gadolinium 157.25	65 **Tb** Terbium 158.93	66 **Dy** Dysprosium 162.50	67 **Ho** Holmium 164.93	68 **Er** Erbium 167.26	69 **Tm** Thulium 168.93	70 **Yb** Ytterbium 173.04
95 **Am** Americium (243)	96 **Cm** Curium (247)	97 **Bk** Berkelium (247)	98 **Cf** Californium (251)	99 **Es** Einsteinium (252)	100 **Fm** Fermium (257)	101 **Md** Mendelevium (258)	102 **No** Nobelium (259)

Tables of Measurement

LENGTH

METRIC SYSTEM	ENGLISH SYSTEM
1 centimeter (cm) = 10 millimeters (mm)	1 foot (ft) = 12 inches (in.)
1 decimeter (dm) = 10 centimeters (cm)	1 yard (yd) = 36 inches (in.)
1 meter (m) = 10 decimeters (dm)	1 yard (yd) = 3 feet (ft)
1 meter (m) = 100 centimeters (cm)	1 rod (rd) = 16 ½ feet (ft)
1 dekameter (dam) = 10 meters (m)	1 mile (mi) = 5280 feet (ft)
1 kilometer (km) = 1000 meters (m)	1 mile (mi) = 1760 yards (yd)

WEIGHT AND MASS

METRIC SYSTEM	ENGLISH SYSTEM
1 gram (g) = 1000 milligrams (mg)	1 pound (lb) = 16 ounces (oz)
1 kilogram (kg) = 1000 grams (g)	1 ton (T) = 2000 pounds (lb)
1 metric ton (t) = 1000 kilograms (kg)	

CAPACITY

METRIC SYSTEM	ENGLISH SYSTEM
1 liter (L) = 1000 milliliters (mL)	1 pint (pt) = 2 cups (c)
1 dekaliter (daL) = 10 liters (L)	1 quart (qt) = 2 pints (pt)
1 kiloliter (kL) = 1000 liters (L)	1 gallon (gal) = 4 quarts (qt)
	1 peck (pk) = 8 quarts (qt)
	1 bushel (bu) = 4 pecks (pk)

USEFUL MEASUREMENT EQUIVALENTS

Length	Weight and Mass
1 inch = 2.54 centimeters	1 oz = 28.35 grams
1 foot = 12 inches = 30.48 centimeters	1 pound = 16 ounces = 453.59 grams
1 yard = 3 feet = 36 inches = 91.44 centimeters	1 ton = 2000 pounds = 907 kilograms

Volume
1 quart (liquid) = 2 pints = 32 fluid ounces = 946 milliliters (0.946 liter)